THE LIGHT OF EARLY ITALIAN PAINTING

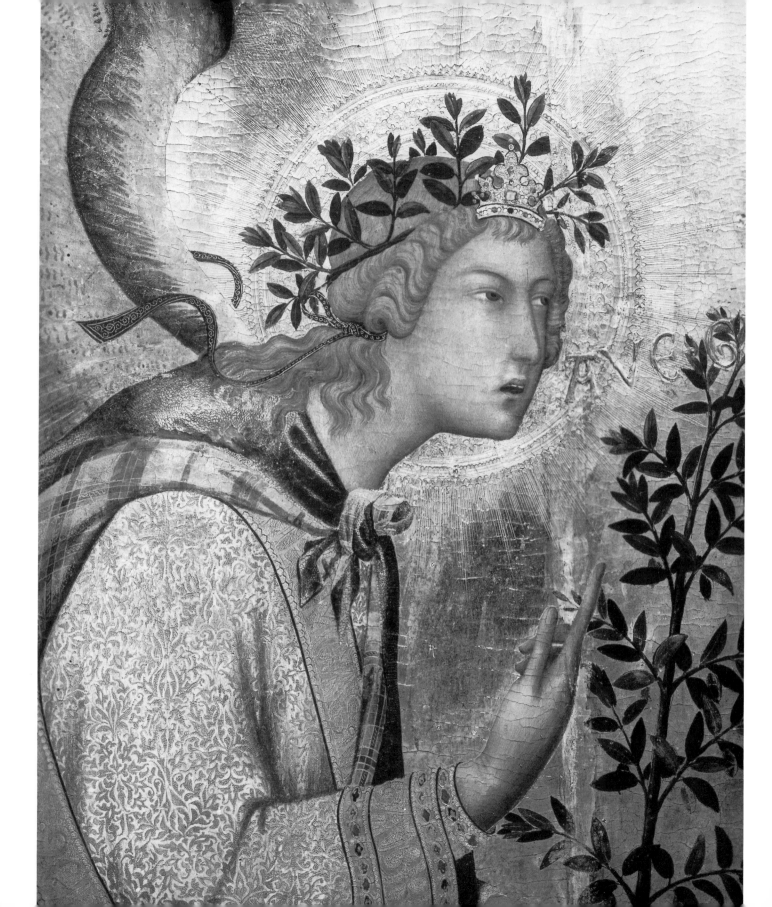

THE LIGHT OF EARLY ITALIAN PAINTING

Paul Hills

Yale University Press · New Haven & London

To my parents

Designed by Faith Brabenec Hart
Filmset in Monophoto Apollo and printed in Great Britain by
Jolly & Barber Ltd, Rugby, Warwickshire

Library of Congress Cataloging-in-Publication Data
Hills, Paul.
 The light of early Italian painting.

 Bibliography: p.
 Includes index.
 1. Mural painting and decoration, Gothic—Italy—
Tuscany. 2. Mural painting and decoration, Italian—
Italy—Tuscany. 3. Light in art. I. Title.
ND2756.T9H55 1987 751.7′3′09455 86–22454
ISBN 0-300-03617-5
ISBN 0-300-04698-7 (pbk)

(frontispiece) Simone Martini, *The Angel Gabriel* (detail from the *Annunciation*, col.pl.XXIV).

ACKNOWLEDGEMENTS

In writing this book I have received support from many quarters. I recall with gratitude conversations with painters, particularly David Jones, Martin Eldridge, Edmund Fairfax-Lucy and Timothy Hyman. To friends and colleagues in England and Italy I am indebted for ideas, information and practical help. I extend my thanks to Roger Jones, Norman Land, Beverly Brown, Roger Tarr, James Lawson, Melinda Lesher, Dana Goodgal, Joy Thornton, Andrew Morrogh, Ann Hepper, Richard Gutch, Rosemary Upton, Chris Fischer, Robin Simon, Christopher Lloyd, Joanna Cannon, Dillian Gordon, Christa Gardner von Teuffel, Howard Burns, Kay Sutton and Michael Rosenthal. Conversations with Anthea Callen greatly enlarged my understanding of colour. Julian Gardner and John Shearman directed my research over many years and offered invaluable encouragement and criticism. Jennifer Montagu, Rupert Hodge, Luisa Vertova, Gianvittorio Dillon, Alan Watson and Loveday Gee helped me to obtain photographs. My research in Florence was made possible by the award of a European Studentship by the Leverhulme Foundation and a Fellowship by the Fondazione Roberto Longhi. Finally, it is with pleasure that I recall that it was my parents who introduced me to the light of Italy and the art of the Renaissance.

Paul Hills

PHOTOGRAPHIC ACKNOWLEDGEMENTS

Author 13, 48, 49, 73, 74
Berlin, Staatliche Museen Preussischer Kulturbesitz Gemäldegalerie 72
Florence
 Alinari 11, 14, 15, 17, 25, 51, 62, 69, 70
 Archivio Fotografico della Soprintendenza per i Beni Artistici 4, 5, 6, 8, 10, 39, 40, 42,
 43, 44, 45, 46, 47, 50, 55, 57, 68, 75, 77, 78, 81, 82, 83, 84
 Luigi Artini 36, 61, 63
 Scala I, II, III, IV, V, VI, VII, VIII, IX, X, XI, XII, XIII, XIV, XV, XVI, XVII, XVIII, XIX,
 XXI, XXII, XXIII, XXIV, XXV, XXVII, XXVIII, XXVIX, XXXI, XXXII
London
 The British Library 37
 By courtesy of the Trustees of the British Museum 1
 The Conway Library, Courtauld Institute of Art 16
 The Conway Library, copyright Julian Gardner 58, 59
 The Mansell Collection frontispiece, 12, 18, 38
 Reproduced by courtesy of the Trustees of the National Gallery XX, XXX, 71, 76
 Victoria and Albert Museum (Crown Copyright) 53, 67, 79, 80
Naples, Soprintendenza per i Beni Artistici 64
Padua, Museo Civico 20, 21, 22, 23, 24, 26, 27, 28, 29, 30, 31, 32, 33, 34, 35
San Diego, Fine Arts Gallery 41
Siena
 Foto Grassi 9, 60
 Soprintendenza per i Beni Artistici 2, 3, 7, 54, 65

CONTENTS

PREFACE

This book does not provide a treasure-hunt for the first cast shadows in Italian painting. It treats light as a universal element in visual art, equally present when two colours are juxtaposed as when an artist paints a highlight or a shadow. Most cultures have used representational systems that did not involve description of recognizable sources of light. Light is usually taken for granted as universal medium of visibility rather than imitated. The preoccupation with representing light that is characteristic of the Western tradition from the Renaissance to the Impressionists is a peculiarity. This book examines the origins of that peculiar preoccupation in the period 1250 to 1430. I do not attempt to chart the acquisition of descriptive skills as a linear unfolding. Each chapter focuses on a different aspect of light. The emphases in the chapter on pattern in Sienese painting are very different from those in the chapter on Giotto. I hope that my shifting viewpoint will frustrate any attempt to interpret the sequence of chapters as embodying a progression or advance.

Whereas the writer on linear perspective can measure whether a painter's orthogonals lead to a vanishing point, and therefore can pronounce on whether the perspective is 'correct' or 'incorrect', the writer on light has no such yardsticks. The problem (or is it an advantage?) is compounded when writing about works of art made some six hundred years ago. Their colours and tones are no longer what the artist intended. Almost every painting is a corrupt text, dulled and damaged, repainted and restored. Undoubtedly there are pitfalls in responding to the colour and light of paintings that have undergone such vicissitudes, but to admit defeat by sidestepping the painterly qualities of Early Italian art would, I believe, be a tragic impoverishment.

The territory is relatively uncharted. The major contributions have been made by German writers such as Theodor Hetzer, Hans Jantzen and, more recently, Ernst Strauss.[1] Wolfgang Schöne, in his wide ranging *Uber das Licht in der Malerei*,[2] offered a complex terminology for describing light in painting, but English writers have been wary of his distinctions. Unfortunately Schone failed to distinguish between highlights conceived as reflection and highlights conceived as modelling, an omission that was pointed out in Ernst Gombrich's brilliant article 'Light, Form and Texture in XVth Century Painting'.[3] The major English contribution to our subject, John Shearman's doctoral thesis, 'Developments in the Use of Colour in Tuscan Paintings of the Early Sixteenth Century', remains substantially unpublished; important material is accessible in his articles 'Leonardo's Colour and Chiaroscuro' and 'Isochromatic Colour Composition'.[4] Moshe Barasch's *Light and Color in the Italian Renaissance Theory of Art* has little to say

1

about practice, but includes a valuable bibliography of texts on colour.[5] For the Early Renaissance, James Ackerman's 'On Early Renaissance Color Theory and Practice' offers a useful survey.[6]

In recent years David Lindberg has enlarged our understanding of mediaeval optics.[7] Thanks to his scholarly editing, the texts of the major treatises are now readily available. I have also drawn widely on modern discussions of colour and the psychology of perception. Still the most useful account of colour is David Katz's *The World of Colour*.[8] For light and illumination the best introduction is Rudolph Arnheim's chapter in *Art and Visual Perception*:[9] for more recent theories of perception the books by James Gibson should be consulted.[10]

The volume of information on technique is growing faster than ever before, but the twentieth century has yet to find a critic and historian who can assimilate this information and present it with the subtlety and understanding of Charles Eastlake.[11] Though nearly half a century old, the contributions of D.V. Thompson remain indispensible.[12] For fresco, Eve Borsook's *Mural Painters of Tuscany*, especially in the enlarged second edition, is invaluable.[13]

A word of explanation as to the scope of this study: it makes no attempt at a comprehensive history of Early Italian painting. My pre-eminent concern is with monumental fresco where there is a connection between pictorial space and the space of the ambient, and between pictorial light and real light. Thus manuscript illumination is not discussed. The Giottesque tradition, leading through Taddeo Gaddi to Masaccio, gets the lion's share of attention, though Sienese panels and those of Gentile da Fabriano receive detailed consideration. It is hoped that the reader will be offered enough ways of thinking about light to fill in the gaps. My emphasis is on Tuscany, which should not be taken as a denial of significant exploration of light in the painting of other centres. Venice, with its links to the Byzantine tradition, deserves a study on its own. Closer to the Giottesque tradition is the painting of Bologna and the surrounding area of Emilia-Romagna. The chiaroscuro of Vitale da Bologna is remarkable. Further north, Tommaso da Modena, in his frescoes at Treviso, and Altichiero, in his frescoes in Verona and Padua, are observant in their representation of light and shadow.

I conclude with Masaccio because his work sums up the relationship between man and light uncovered by Cavallini and Giotto around 1300. As Vasari knew, the Brancacci Chapel became the classroom for the artists of the High Renaissance. Masaccio's sense of the breadth and universality of light – so different from the particularity of the Netherlandish painters – took several generations to absorb. After his death new factors come to the fore – the interaction between Netherlandish and Italian painting, the refinement of the oil medium, the advance of critical theory, and the new role of drawing in the gestation of paintings. These factors only modify a well-established tradition. The rediscovery of pictorial light as correlative of pictorial space had been made before 1428.

2

I. Surface Light and Pictorial Light in Thirteenth-Century Painting

From antique illusionism to mediaeval pattern

Between 1250 and 1430 Italian artists rediscovered pictorial space and pictorial light. In the altarpiece of St Francis in Santa Croce (col.pl.II) any light is dependent upon the modelling of individual form and the reflectiveness of burnished gold. In the Madonna by Masaccio from the church of the Carmine in Pisa (col.pl.XXX) light is a directed stream in space. Falling laterally from the left at an angle of about forty-five degrees, Masaccio's light is independent of the solid bodies it strikes. It is an external force. Solid bodies interrupt its flow. Shadows are cast across space: the right-hand wing of the throne is shaded by the head of the Madonna. By spanning the intervals, directed light and cast shadows make space real to a degree that was beyond the ken of artists in the thirteenth century. The remarkable formal and expressive power of Masaccio's light was fundamental to the Renaissance tradition. The purpose of this book is to consider the nature of the Western conception of pictorial light and to explore its origins and development from the mid-thirteenth century.

The depiction of space by means of linear perspective has been discussed and re-discussed, whereas pictorial light has received scant attention. How the two go hand in hand may be illustrated by further consideration of Masaccio's Madonna. The architecture of the throne is presented in frontal symmetry, foreshortened according to a vanishing point on the central axis of the arched panel, while the lateral illumination that grazes across the surfaces at a tangent to the spectator's line of vision modifies this symmetry by dividing each form into illuminated and shaded halves. Within the ordered symmetry of the monochrome throne – as firm and monumental as Roman architecture – the living figures, Virgin, Holy Child and angels, insinuate by turn of body or tilt of head their capacity for self-generated movement. By anchoring, linear perspective heightens our sense of the fixity of things. Directional light, consistent throughout the height, breadth and depth of space, establishes changes of tone as changes in the orientation of a surface.

This pictorial light has not simply been thrown over a pre-determined arrangement of figures: it is a factor that governs their placement. If the Child is held too close to his Mother's breast, he will be overshadowed by her; if the Mother sits too far back in the winged throne, distracting shadows will fall on her shoulder. This simple point is important. For if cast shadows link object and ambient in a spatial continuum, they

also draw attention to the breathing spaces between one object and another. Like linear perspective, directional light divides as well as links, connecting figures or objects across space without visible touching. Released from the necessity of making physical connection, the painter of light uncovers spaces that are eloquent of mental or spiritual communion.

One reason why art historians have preferred to emphasize perspective rather than light as the foundation of the Renaissance achievement is that the scope of perspective is the more easily defined. Light is at once universal and elusive. Whether we are looking at a gold chalice, the thirteenth-century altarpiece of St Francis, or Masaccio's Madonna, light is necessarily involved as the agent that mediates between the thing seen and the eye, but whether we are conscious of light as object of vision varies in each case, and also varies according to our own interests or mental set. The altarpieces differ from the chalice in that their pigmented surfaces may describe light as well as being visible by virtue of light. But, unlike in the case of perspective, accident and intention are not easy to distinguish. The lustrous splendour of a chalice is real, not simulated. In the twelfth century the actual splendour of the altar vessels delighted the eyes of Abbot Suger of St Denis.[1] In the case of the altarpiece of St Francis the lustre of burnished gold coexists alongside the rudimentary descriptions of light implied by the modelling. Here we come up against the bewildering duality of light as agent and object of vision. As agent it is a natural phenomenon, subject to the laws of physics: as object – belonging to pictorial content – it undergoes transformation into a visual language. Highlight and shading in thirteenth-century panel painting are coded as a set of signs which only remotely resemble their referents in the visual world; nevertheless they can only convey their message by interaction with the physical light that strikes the panel and rebounds into the eyes of the viewer. Those writers who subject 'the language of art' to an analysis of the functioning of signs derived from a literary model tend to overlook this interaction. They overlook the fact that light mediates between the structures embodied in the pigmented surface and the processes of cognition. The duality of light as universal agent and potential object of vision cannot be paralleled in the linguistic model.

During the period surveyed in this book – *circa* 1250 to 1428 – painters made strides in their ability to match appearances in paint, but these gains were absorbed in a context in which works of art were esteemed as bright and glittering objects. The fascination of Early Italian painting lies in this interplay between surface and pictorial light, between light as actual and light as simulated. This study, therefore, will be concerned with optics, with the physics of light, and with the language of signs.

Light is as necessary to vision as breathing is to life; yet, just as for much of the time we are unaware of our breathing, so we do not always attend to the light by which we see. Before tackling the question how light can be simulated or described in painting, we should consider how light impinges upon consciousness. Leaving aside, for the present, subjective factors such as habits of attention and mood, what are the objective or external factors which arouse awareness of light? Foremost amongst them is a dominant direction of light from a concentrated source, such as the sun. By casting shadows this helps us to distinguish between objects and the light that strikes them. Lustre, little mirror images or reflections of light playing over shiny surfaces, also

4

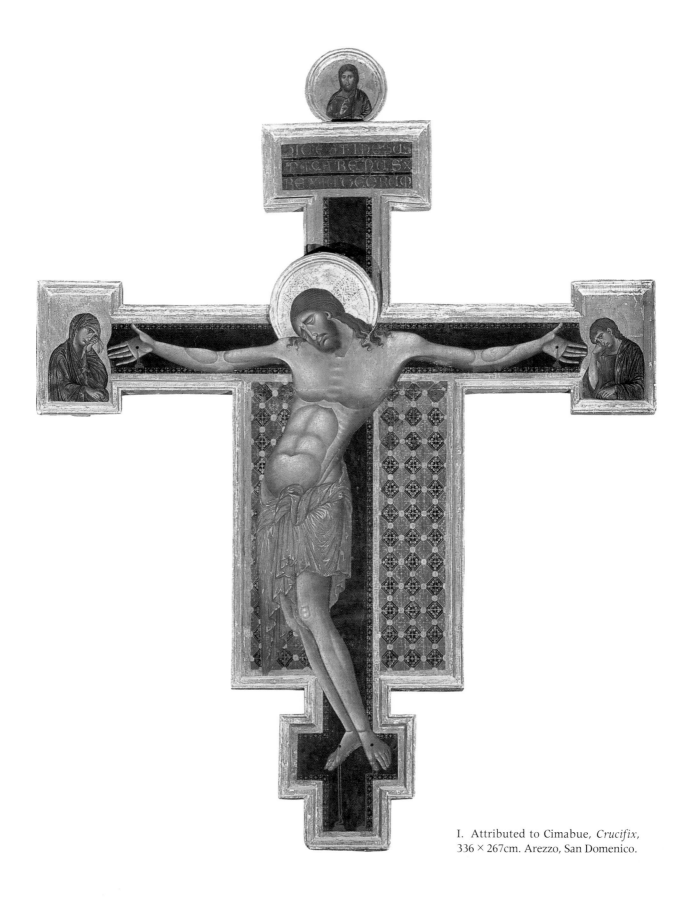

I. Attributed to Cimabue, *Crucifix*,
336 × 267cm. Arezzo, San Domenico.

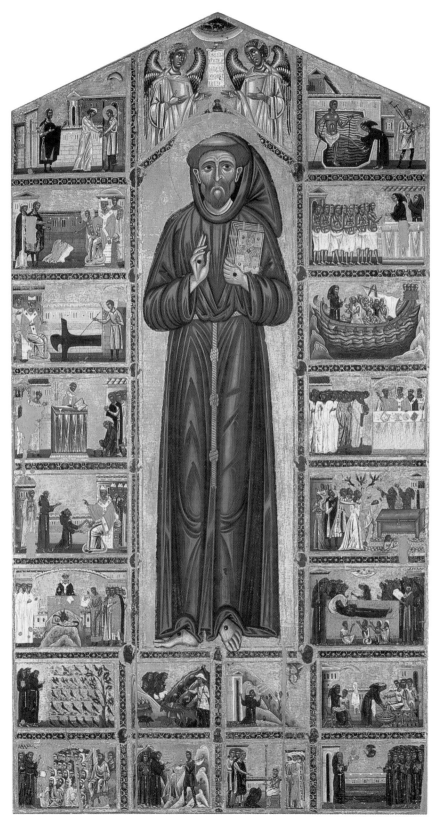

II. Bardi St Francis Master: *St Francis Altarpiece*, 234 × 127cm. Florence, Santa Croce, Bardi Chapel.

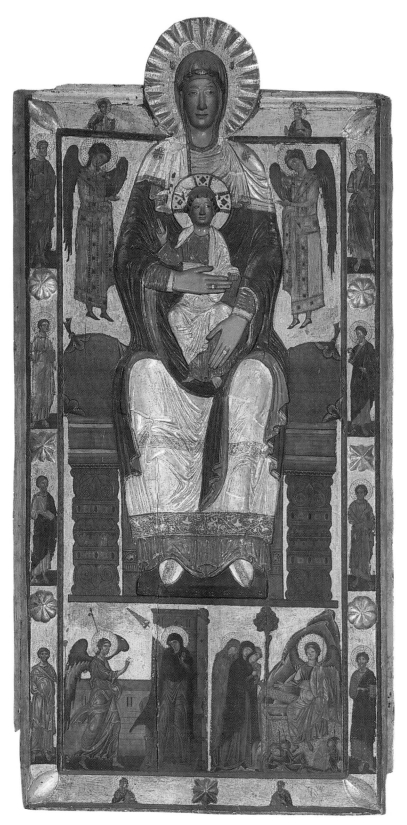

III. Attributed to Coppo di Marcovaldo, *Madonna and Child, Annunciation and Maries at the Tomb*, 250 × 123cm. Florence, Santa Maria Maggiore.

advertises the presence of light. On an overcast day illumination may not be sensed because the light lacks a dominant direction and its source is too widespread to induce noticeable lustre. On the other hand, diffused light if strongly coloured, as by a red sunset, stresses illumination because of the unfamiliar hue it lends to familiar objects.[2]

The term 'illumination' will be used when the presence of light makes itself felt. The description of light in painting means a conscious attempt to recreate this quality of presence. It is a presence we encounter in the art of antiquity. In landscapes, the Pompeian wall paintings for example (col.pl.IV), illumination is a source of pictorial order and an element of the arcadian content.[3] How is this done? First it should be noted that the scenes on the walls are conceived as if observed from a great distance. Linear perspective does not provide unambiguous information about the orientation of surfaces; the orthogonals of buildings hardly converge. In this distant view the insistence and distinctions of local colours are diminished and the painter successfully brings all the shadows and all the lights into mutual association and common contrast. The tone of a surface may be more heavily dependent upon whether it is facing the light or whether it is in shadow than upon its local colour as known from close inspection. In fact the painter is thoroughly cavalier towards the 'normal' colours of objects so that the pattern of tones that is due to the illumination of the moment will predominate over the less variant structure or pattern due to distinctions of local colour. A lateral light appears to illuminate approximately half each solid and casts a long shadow beside it. Since the insistence of the local colour has been diminished, the point at which the attached shadow on the object ends and the cast shadow on the ground begins is indistinct. Thus objects are set within but not divorced from a spatial continuum. The convention makes use of a dominant directional source of light (rather than the diffused light of the sky), and our sense of the solidity of the objects in the landscape is inseparable from our awareness of the directed light that reveals the change in orientation of their planes as they pass from light to shadow. The interdependence of orientation and pictorial light sustains the spectator's awareness of illumination, ever renewing delight in its transfiguring power. None of the pictorial clues describing illumination is redundant in a reading of the scene.

Whereas the substance of Pompeian landscapes dissolves in a haze of golden light and lavender shadow, the portraits in a wax medium from Roman Egypt (fig.1) confront us with a face to face encounter with a fellow human being.[4] Here is no idyllic distance veiling reality but a close, abiding physical presence captured under an illumination that will change as surely as the sun must set. The duality of illumination and form, the one transient the other enduring, may be seen as metaphor for the duality of body and soul. The mobility of light is expressive of the speed and liveliness of the emotions and the intellectual faculty. If such portraits were funerary, not done from life, they triumph over the stillness of death. How is this liveliness achieved? The colours of lips, eyebrows and hair are stated with force. Black hair and dark eyes are common. The flesh is positively tanned, usually a reddish brown, darker for men than for women. These assertive local colours establish an emphatic structure that is modified but never obliterated by the strong, clearly directed incident light. Highlights show up against the deep hue of flesh. The edges of shadows, such as those cast by the nose, tend to be abrupt, not blended with the flesh tone or the lights. These edges of cast shadows are

IV. First-century B.C. wall painting from Pompeii, *Idyllic landscape with pastoral scene*. Naples, Museo Nazionale.

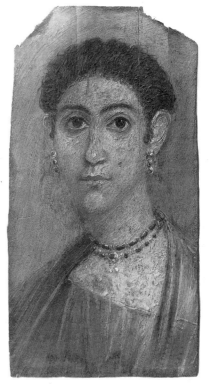

1. Portrait of a young lady in encaustic from Hawara in Roman Egypt, second century. London, British Museum.

9

readily distinguished from the softer transitions in the modelling of the flesh as it curves back from a frontal plane such as between the cheek and jaw. Soft as these recessional transitions may be, they are not of the kind that the late fourteenth-century writer of a painter's manual, Cennino Cennini, would have approved as 'blended like smoke'.[5] The entire surface is broken by lively handling of the brush, or in some cases the spatula-like instrument described by Pliny as a *cauterium*.[6] The thick medium is ridged and furrowed. Bright points of lustre are jotted in with controlled impasto. Roughness of facture establishes a tactile paint surface, yet it also creates an interval between actual surface and descriptive content.[7] Lights and darks are broken by minute corrugations in the impasto, which provokes a capricious – and therefore lifelike – play of light hovering over, rather than fixed upon, the features of those portrayed.

Facture suggests no such distinction between paint surface and descriptive content on the St Francis altarpiece of the Bardi Chapel. And neither do the framing conventions allow any interval between surface and illusion. Unlike Pompeian landscapes, the Franciscan narratives do not float free, vignette fashion, in a field of white or other yielding, atmospheric colour. Hedged by ribbon borders, the strips of ground plane assert their adherence to the surface of the panel.

It would take us beyond the field of our inquiry to consider all the reasons why so many of the illusionistic techniques mastered by the painters of antiquity were lost, disregarded or transformed between the period of the later Roman Empire and the thirteenth century, but, acknowledging that a complex metamorphosis is being over-simplified, a few general remarks may be helpful. For the painters of antiquity, light was essential to the description of space.[8] The shadows cast by directional light revealed the orientation of surfaces. The mutation of colours due to the scattering of light over distance expressed the separation of viewer and the scene conjured for viewing. Space was important as the arena for action and for repose, and antique art conceived both as subject to time. Since light in nature changes hour by hour, season by season, pictorial light was an important reminder of the passage of time.

As painting turned from the rendering of narrative action or meditation to the embodiment of transcendent symbols, so space, light and time lost their primary importance. Configurations of tone, formerly signifiers of illumination, became progressively more removed from their original signification. Pictorial highlight and shadow, far from appearing to express the uniqueness of moment and the individuality of person, as in the portraits from Roman Egypt, became absorbed in the invariant structure of the subject. Looking at ninth-century Christian art the viewer does not readily perceive any distinction between relatively permanent structure of the subject – shape and distinct local colour – and the essentially temporary modifications due to illumination: both are subsumed in the mode of presentation.[9] As form and colour became governed increasingly by laws of bilateral symmetry, so the armature of lights was pressed into the same mould. No longer attentive in their modelling to consistency in rendering the dominant direction of light, the painters had discarded, unwittingly perhaps, an essential clue to the extrinsic quality of illumination as separate from the objects illuminated. Neither could light, or rather its pictorial analogue, modelling, any longer indicate the orientation of surfaces. The armature of lights and darks, symmetrically applied over uniform laying-in colours, reverted to two-dimensional pattern.

10

It would be wrong to suppose that the painter of the Bardi St Francis altarpiece was uninterested in light. He is heir to a tradition that prized the brightness and brilliance of the work of art as an object. Burnished gold leaf asserts the density and the preciousness of the panel, creating the illusion that the sacred image is presented on a support of solid gold. Not only does this deny any notional interval between actual surface and illusory forms, but it also overwhelms any spatial implications of pictorial light by brilliance of surface. To understand how this esteem for luminosity of surface complicated renewed attempts to describe light within space in later thirteenth-century painting, we should first consider what thirteenth-century man would have meant if he said that he could see light.

Meaning of terms in the thirteenth century

Latin provided two terms meaning light, *lux* and *lumen*, which were translated into Italian as *luce* and *lume*. The Franciscan theologian St Bonaventura gives a clear description of *lux* and its derivatives *lumen* and *color*: '*Lux* can be considered as threefold, that is in itself, and in transparent media, and as terminated at the limits of the perspicuous: in the first mode it is *lux*, in the second *lumen*, in the third the hypostasis of colour.'[10] *Lux* is the source of light and its very substance; *lumen* is the diffusion or radiation of light; and *color* is light materialized on the surface of solid bodies that halt the passage of *lumen*. *Color* in such a view is obviously a visual quality, but the visual manifestations of *lux* and *lumen*, the source and radiation of light, are more elusive.[11] The English student of optics, theologian and Archbishop of Canterbury John Pecham, in a discussion of the appearance of firelight by day and by night, notes how under the right conditions the eye may distinguish between the source of light, the flame, and the radiance around it (*diffuse lumine*).[12] Such a visible manifestation of *lumen* was exceptional. Normally it acted as an invisible agent, revealing the world without revealing itself. Whereas we know that light as energy is invisible, thirteenth-century authorities thought that light in its purest state existed corporeally,[13] and while students of optics and theologians accepted the corporeal essence of light, neither believed that light could be seen in its purest bodily form. Such a vision could only occur through Divine Grace – in the words of the psalmist, 'et in lumine tuo videbimus lumen' (In thy light shall we see light).[14]

In addition to *lux*, *lumen* and *color*, there was a manifestation of light which was undoubtedly visible, namely *splendor*. For Pliny, *splendor* was the same as *fulgor*, that is the brightness or effulgence of a surface; it was distinct from *lumen*, which was an invisible agent consisting of species in space.[15] In the second half of the thirteenth century a Franciscan, Bartolomeo da Bologna, distinguished between *lux*, *lumen* and *splendor*. After describing in his *Tractatus de Luce* how rays are generated by a source of light (*lux*), and how this diffusion of light through space is called *lumen*, he adds: 'However, when rays emanating from a luminous body reach another body that is smooth, polished and shining, such as a sword or gilded panel (*tabulam deauratam*), and rebound back from that body this is called *splendor*. And by such reflections on a polished and shining body the light (*lumen*) in space is multiplied and such multiplication of light is properly called *splendor*.'[16] The choice of a gilded panel as exemplary of objects which produce *splendor* tells us something of how contemporaries would have categorized the lustrous reflections that played over the burnished gold of the Bardi St

Francis altarpiece and dazzled the eyes of worshippers. We must beware of supposing that there would be a direct influence of learned treatises on optics and the metaphysics of light on the workshop procedures of painters, since for them the imitation of earlier artistic models rather than reference to visual experience was the dominant influence. Nevertheless, there appears to be a genuine congruence between those workshop procedures and the view that the visual manifestation of light takes the form of *color* and of *splendor* or lustrous reflections. The relationship between splendour of surface and modelling with highlights over a relatively uniform laying-in colour will be considered later, but first we must turn our attention to the epistemological status of light.

The reliability of vision: Franciscan optics

It has become a commonplace that St Francis of Assisi rejoiced in vision, for it revealed the beauty of God's creation. The Canticle to the Sun testified to his wholehearted acceptance of visual sensation, and his Institution of the Crib at Greccio injected a literal realism into devotional imagery.[17] Francis's delight in the world he beheld with his bodily eye is recorded by his friend and biographer, Thomas of Celano. As a true disciple of the saint, Thomas in turn took note of external appearance and recorded it for posterity. No Evangelist saw fit to offer a portrait of Christ as Thomas did of Francis:

> He was of middle height, inclining to shortness; his head was of moderate size and round; his face somewhat long and prominent, his forehead smooth and small; his eyes were black, of moderate size, and with a candid look; his hair was dark, his eyebrows straight; his nose symmetrical, thin, and straight: his ears upright, but small; his temples smooth . . . His teeth were set close together, white and even; his lips thin and fine, his beard black and rather scanty, his neck slender; his shoulders straight, his arms short, his hands attenuated, with long fingers and nails; his legs slight, his feet small, his skin fine, and his flesh very spare.[18]

Such an inventory is not drawn up out of idle curiosity. It is offered so that the believer can form a vivid mental image. It belongs to precisely the same world of Franciscan devotion as the *Meditations on the Life of Christ*.[19] In that popular text the physical events of Christ's life are described with startling directness as though by an eyewitness: a picture is painted in words.

Christ had taught by parables, yet narrative had long taken a subordinate place compared to the transcendent symbols of Christian art. The Franciscan movement re-established the value of narrative rich in human incident. It seized upon imagery with which the believer could empathize. Whereas the events of Christ's life may have seemed remote in time and space, for Italians the events of Francis's life took place in familiar places and the memory of them lived on. All the more reason, therefore, for painters of the late thirteenth century to pursue a new degree of authenticity when they depicted those events in panel or fresco. And as Francis's life became mythologized as parallel to that of Christ, so the realism appropriate to the one close in time became expected in the rendering of its great foretype.

The ambition to render the visible world with some degree of accuracy presupposes a belief that it is a worthwhile thing to do. In Christian Europe before the late twelfth century it would not have been considered spiritually rewarding to pay close attention

to the physics of light or to the physiology of human vision. True knowledge, it was believed, following what was originally a Platonic doctrine, could not be gained from the senses, because they were by nature fallible and because the objects of sensory perception, belonging to the material world, were but dim reflections of reality. To perceive the eternal reality, which lay behind the accidental and changing aspects of the world of matter, required the gift of intuition – a contemplation, or 'looking into', which sees beyond appearances. However, there was one area of science where the unaided human intellect could hope to achieve certainty, namely the science of numbers, or mathematics. If it could be demonstrated that one of the senses operated according to mathematical or geometrical principles its trustworthiness was enhanced.[20]

The major thirteenth-century students of vision, such as Robert Grosseteste (c.1168–1253), John Pecham (c.1235–1292) and Roger Bacon (c.1214–1292), without discarding the view that the senses are unreliable, sought to distinguish degrees of reliability and to draw conclusions from these. In optics this meant distinguishing how far vision could take place according to the most elementary geometrical principles. Since the most elementary geometrical relationship between two points is a straight line, if vision is to be reliable it must follow a straight line from a point in the eye to a point on an object. The nature of the connection, and whether light was first emitted by the eye (the extromission theory) or whether it reached the eye from the object (the intromision theory), was hotly debated,[21] but all investigators believed that light propagates itself along straight lines and that the rays involved in vision are straight unless reflected by a surface or refracted by passing into a medium of different density. Vision by reflected or refracted rays since it does not take place along a straight line must be less reliable than direct vision – a geometrical bias for which there is a commonsense foundation, since images seen in mirrors, or sticks appearing bent where they pass from air into water, can deceive; however, the doctrine was applied by the thirteenth-century writers far beyond the realm of commonsense, since it was taken into account that the eye itself refracts all the rays which enter it.[22]

Since all rays which pass from one medium into another of different density are refracted at the surface except those that strike it perpendicularly, the only ray which reaches the interior of the eye unrefracted is the one at the very centre of the visual cone. The more oblique the angle of vision, the greater the refraction of the rays upon entering the eye and the less reliable the information which their light conveys. Whereas vision by these refracted rays conveys only the accidental aspect of things, vision by the central unrefracted ray can function like intuition in giving a true understanding of reality.[23] In the context of traditional mediaeval epistemology this was a bold claim. Like St Francis's delight in visual sensation, it may have given some support to the notion of representational art. Mimesis had become philosophically respectable.

Metaphorical interpretation of vision and of light

Thirteenth-century understanding of the physiology of vision and the physics of light was governed by a philosophical framework. It is not my intention to discuss the mediaeval metaphysics of light in all its ramifications, but to stick to those aspects that rather than being purely figurative can be related to science or visual experience. Two tenets of the light metaphysics may be singled out. One is the power of a luminous body

to reveal itself at the same time as it reveals other things. Here was an endless source of metaphor, such as we have already noted in the words of Psalm 36, 'In thy light shall we see light'. Perhaps the most explicit statement of the idea is to be found in the writing of the first-century Alexandrian philosopher Philo, where he has Moses say to God: 'As light is not known by something else, but is its own evidence, so none can reveal Thee save Thou thyself alone.'[24]

The second tenet is the consubstantiality and indivisibility of a ray of light and its source. Just as the sun sends forth rays, emanations of its substance, without loss of integrity, so the divine Logos, or Word, is an emanation from God, capable of penetrating into every corner of the universe, while remaining at one with God, its source.[25]

The reflection of light provided an alternative to this metaphor of ray and source. In speaking of the Word, or of Wisdom, as a reflection of the eternal Light, the directness of the relationship was played down for the sake ·of expressing the unapproachable and incomprehensible nature of him who can but be seen as in a glass darkly.[26] The scholastics commonly referred to the Church and to Mary as reflecting the light of Christ – likening them to the moon which reflects the light of his sun upon the world.[27] This was in line with the Neo-platonic tradition favouring reflection as metaphor for the indirect apprehension of truth.

Thanks to the expositions of Grosseteste, Bacon, Witelo and Pecham, phenomena such as the reflection and refraction of light became more precise sources of metaphor. The writer of St John's gospel and St Augustine had used the multiplication of light as image of the infusion of grace: Roger Bacon gave it a rationale within the framework of geometry and the physiology of the eye.[28] With knowledge of such texts, Dante describes his vision in the *Divine Comedy* in accordance with the principles of thirteenth-century optics: that it is seen with his eyes – 'io vidi' – is a constant refrain, and he certainly believed that the greater its optical veracity the closer it would come to intimating spiritual reality. When, in the twenty-third canto of the Paradiso, he describes how the dazzling brilliance of light at first overpowered his eyes, he is using a fact of optics to show how mortals can only approach gradually towards knowledge of God. The tricks played upon him during his journey by distance, by feeble or by bright light, or by the angle of vision, are telling illustrations of man's proneness to error. Like the writers on optics, Dante does not reject the information derived from human vision, but performs an act of self-observation, learning where vision is fallible so that he may be better equipped to eliminate the deceptive and discern the true.[29] Dante, like St Francis, is prepared to learn from the power of sight.

It will by now be clear that when thirteenth-century students of optics spoke of seeing light they distinguished between the source of light and the emanation of light, and they distinguished between the participation of light in colour and the vision of light in its purest corporeal form or essence. One further point is important for our consideration of thirteenth-century painting. According to the traditional mediaeval view, light manifests itself in varying degrees of purity: the purer the manifestation of light, the greater the *claritas*, which in Thomas Aquinas's definition was, along with integrity and proportion, one of the three fundamental constituents of beauty.[30] According to a

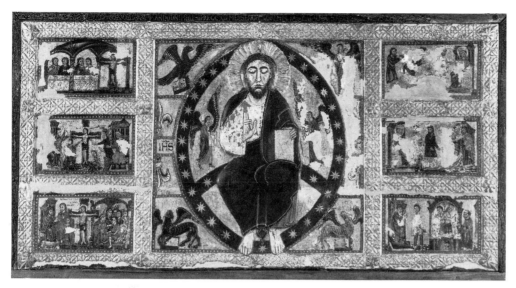

2. Antependium with *The Redeemer Blessing, symbols of the Evangelists, and stories of the Cross*, 1215, 103 × 196 cm. Siena, Pinacoteca.

3. (below) *Story of the Cross* (detail of fig. 2).

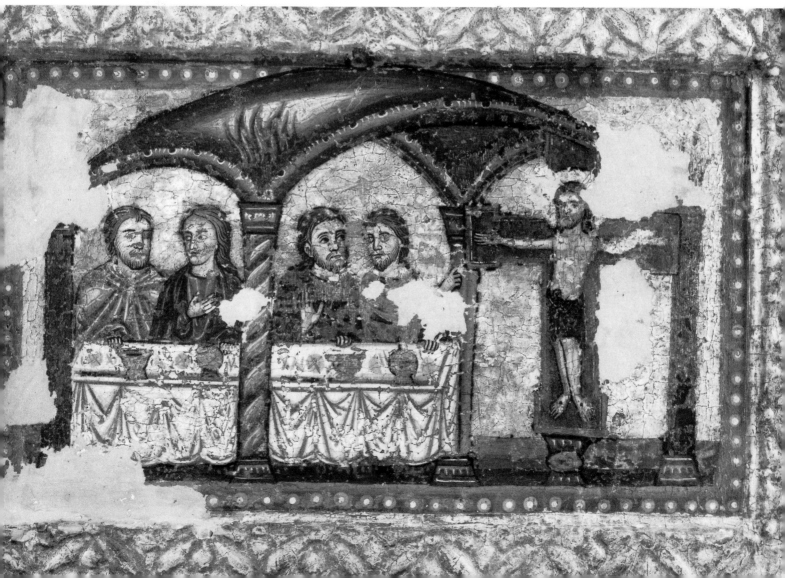

cosmogeny popularized by the writings of Grosseteste, light is the first corporeal form, and the material world the product of the self-propagation of a primaeval point of light. Whereas in our mundane view shadow plays a crucial role in sharpening our perception of light's brightness and direction of fall, the mediaeval cosmology conceived of shadow simply as a diminutive of light rather than its complement in the material world. Although we may be sceptical that craftsmen-painters knew, let alone understood, such exalted metaphysics, its aesthetic consequences were pervasive. In mediaeval poetry – and here Dante is an exception – the splendour, lustre and brilliance of light tend to be celebrated in isolation; when shadow is introduced it is not as something cast by a solid object which interrupts the light but as something belonging to a separate gloomy 'realm'. The clarity of light, which could mean its brilliance, its purity or its transparency, was an attribute of the beautiful and the good: *scuro* had no place beside *chiaro*.[31]

Surface and space: 'claritas' versus illumination

The mediaeval esteem for the brightness or *claritas* of light was quite naturally affiliated with esteem for the material preciousness of objects of veneration. The origin of Italian panels as imitations of precious objects, particularly antependia in metalwork, enamel and sculpture, very much conditioned the panel painter's conception of pictorial light. To cite one example, the antependium of the *Redeemer* in the Siena Pinacoteca (fig.2) is evidently based upon a metalwork prototype similar to the silver *paliotto* of the *Redeemer* in the Duomo at Città di Castello.[32] The narratives in the painting are framed by a ribbon of vermilion approximately three-quarters of an inch wide, which is punctuated by white dots surrounded by less dense white circles (see detail in fig.3). The effect is that of a point of lustre on a shiny boss with a flare of light around it. At what moment this pictorial substitute for the studs and knobs on metalwork was devised is hard to say, but there is no denying its popularity. The identical pattern of red ribbon with white dots and flares crops up in an antependium attributed to the Bigallo Master, the St Zenobius panel in the Opera del Duomo in Florence (figs. 4 & 5).[33] Unlike the tonal modelling with which Giotto created the illusion of directional light on the fictive mouldings that frame the narratives in the Scrovegni Chapel, the imitation of lustre can obey the pattern-maker's preference for symmetry without denying its significance as light. Even if the red ribbon with white dots and flares was repeated without consciousness of its source as an imitation of metalwork, it still retained an effective brilliance. The Duecento painter substituted colour contrasts for the unmatchable luminary contrasts of metalwork. By placing his white dots on a field of intense vermilion he simulates the free-floating, hard-to-focus quality of lustre. Such things were done by intuition, but the disappearance of the red ribbon pattern around 1300 is a tell-tale sign of a shift in attention from the brilliance of lustre to the spatial implications of the stable, tonal highlight, *lume*.

The state of play before that shift of attention was completed may be illustrated by an altarpiece attributed to Coppo di Marcovaldo. Like the antependium of the *Redeemer* in Siena, the *Madonna and Child* in Santa Maria Maggiore in Florence (col.pl.III) combines hieratic figures in relief with narrative scenes painted on the flat surfaces of the panel.[34] On the raised borders figures of saints are separated by gilded rosettes which catch the light like metalwork. The entire surface of the wooden panel, whether flat or in relief,

16

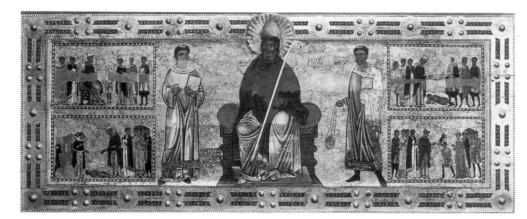

4. The Bigallo Master, *St Zenobius and scenes from his life*, 109 × 274 cm. Florence, Museo dell'Opera del Duomo.

5. (below) The Bigallo Master, *St Zenobius casting out a Devil* (detail of fig. 4).

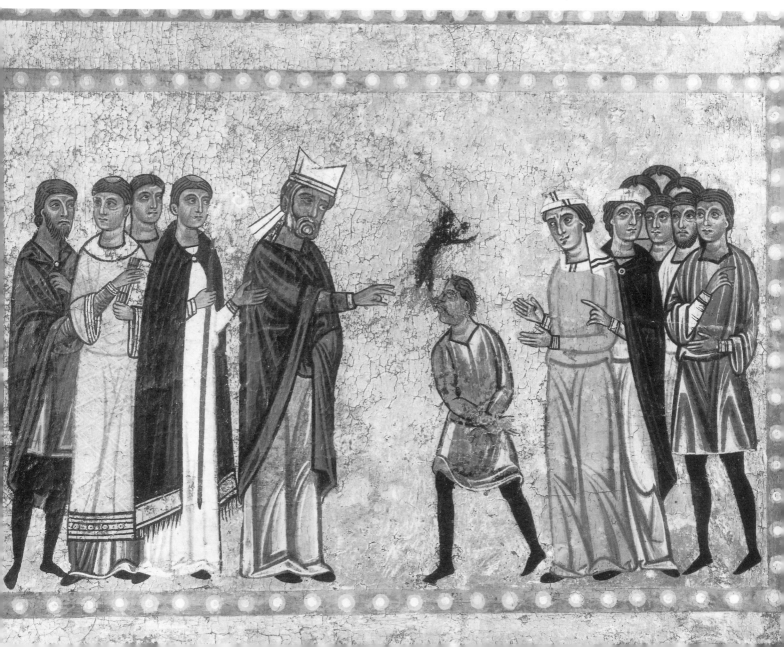

is covered in pigment or gold leaf. On the relief this gilded and pigmented surface is actually the surface of what is represented, and just as the worshipper may touch the slipper of the Madonna, so the light that strikes the raised surfaces touches the Madonna and Holy Child. The mobility and mutability of the lustre playing over the sacred figures, moving as the worshipper moves, adds life to the image. In few panels prior to the 1290s does the frame act as the foremost boundary or threshold *behind* which an illusion is presented, instead the figures tend to overlap the frame as if the panel and its frame were a supporting backdrop.[35] In the absence of any notion of a picture plane, the lustre moving over the surface – an effect impossible to capture in a still photograph – could be experienced as a personal link between the worshipper's eyes and the sacred image. And in the Proper Preface to the Mass from Christmas to the Epiphany the devout were reminded, in words of great beauty, how the eyes afford ascent from the material to the spiritual world: 'For through the mystery of the Word made flesh the new light of thy brightness has shone upon the eyes of our mind, so that as we see God in visible form, we are through Him caught up into love of things invisible.'[36] On a panel such as that in Santa Maria Maggiore the light of Christ's brightness could literally shine upon the eyes; and this physical light entering the eyes would have been intuitively understood as metaphor for spiritual illumination. In the words of Christ's Sermon on the Mount, 'The light of the body is the eye: if therefore thine eye be single, thy whole body shall be full of light' (Matt. 6:22).

Awareness of the link between the light reflected by the work of art and the eye viewing it was dealt a blow by Alberti when he wrote *Della pittura* in 1436. To say this may seem perverse, since it is well known that Alberti likened a painting to an intersection of the pyramid of rays of light that has its apex in the eye and its base on the things seen. But Alberti's emphasis is on the moment when the painter must choose his intersection, selecting a specific viewing distance, a fixed centre, *and a particular position of lights*.[37] Once made, this intersection cannot be altered. The picture plane is then established as a fixed boundary, and the frame is like a window that defines its foremost limit; what is seen through the window will not change for every viewer but is fixed for eternity both in its perspective and in its lighting. Above all, the vagaries of surface light, especially the lustre of burnished gold, are to be minimized because they threaten the painter's absolute control over tone and spatial illusion. Stretching a point, we might regard Alberti as father of the misguided branch of museumology that seeks to standardize and regulate the illumination of works of art so that their appearance is unchanging for every viewer. By contrast, Suger, the twelfth-century abbot of St Denis, was profoundly conscious of the personal – and mutable – link between reflected light and the eye, as for instance where he writes of the splendour of gleaming gold and gems being more powerfully received by the eyes in a small rather than a large church.[38] In the following century John Pecham gave a scientific explanation for the impressiveness of lustre when he pointed out that light reflected from a surface can become stronger than directly incident light because of the convergence, or aggregation, of the rays.[39]

Looking at the panel attributed to Coppo di Marcovaldo, the actual lustrous highlights that follow the ribbed surfaces of the relief are similar to the painted highlights that model the figures on the flat surfaces. Early treatises on the preparation and application of colours suggest that this may not be altogether fortuitous.

18

Mediaeval treatises on colour are strikingly repetitive.[40] Formulae in the Lucca manuscript of the eighth century, or the *Mappae clavicula* of the eighth or ninth century, recur again and again, using the same form of words, through the twelfth, thirteenth and fourteenth centuries, right down to the Bolognese manuscript of the fifteenth century.[41] Most of the instructions concern the manufacture of colours; a smaller amount of space is devoted to the application of pigments in painting. The first notable list of colour combinations for shading and lightening colours occurs in an anonymous short tract, *De coloribus et mixtionibus*, which is found as an addendum to a twelfth-century manuscript of the *Mappae clavicula*.[42] This addendum circulated widely in the workshops of painters and illuminators. Its recipes for mixtures and for tempering are paraphrased in a twelfth or thirteenth-century manuscript, *Compendium artis picturae*.[43] They are copied more extensively and faithfully in the prose book which was added, probably in the early thirteenth century, to the two tenth-century verse books of Eraclius's *De coloribus et artibus Romanorum*.[44]

These three sources describe how to lay in a colour, how to draw upon it, and how to place the lights on it. The modelling with a darker tone over a basic drapery colour is expressed by the verb *incidere*, which means literally to incise and is a term taken over from gem carving, or engraving on glass or metal. The adoption of a term from carving suggests how closely the painters conceived of their linear modelling with a dark tone as analogous to gouges in the surface: the modelling furrows on ivories offer a likely prototype. The retention of the term *incidere* may have been encouraged by the painters' habit of sketching in their compositions with fine incisions down the centre of the darkest part of the drapery fold – as on the *St Luke* in the Uffizi (fig.6), attributed to the mid-thirteenth-century Magdalen Master. Increasingly in the fourteenth century and predominantly in the fifteenth – most conspicuously in Baldovinetti – the incisions are used to divide the light from the dark tones, rather than lying in the centre of one or the other. The analogy with carving was almost certainly forgotten by the end of the fourteenth century when Cennini used the verb *ritagliare* to denote the fine incision of contours.[45]

In most of the treatises on colours the instructions for applying the darks are congruent with those for the lights. Both are applied over a uniform laying-in colour, both are distinct from it, and both are linear. If the darks represent gouges in the surface, the lights mark the summits; and together they symbolize the protrusion and recession of a relief. Whereas the use of the verb *incidere* (to incise) is comprehensible within this system, the verb *matizare*, which is used to denote the placing of the lights on the protrusions of the form, is puzzling. It occurs in the *De coloribus et mixtionibus*, in the *Compendium artis picturae*, and in the third book of Eraclius, then disappears without trace in later mediaeval Latin and in Italian.[46] For the *matizatura*, the addition of the lightest tone, pure white lead is most often recommended. Its hiding power was advantageous, as highlights and shadows were laid over, rather than beside, the laying-in colour.

All the manuals on colour recommend a positive distinction between the laying-in colour and the modelling colours. A wide range of shifts of hue was possible between the laying-in colour and the shading colour that is drawn over it. A smaller range of changes is suggested to distinguish the laying-in colour from the *matizatura* or

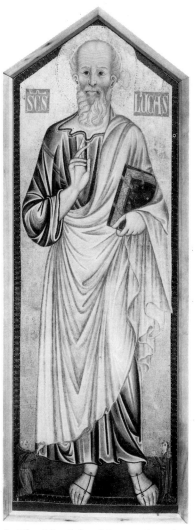

6. The Magdalen Master, *St Luke*, 122 × 45 cm. Florence, Uffizi.

19

V. Twelfth-century apse mosaic, *Triumph of the Cross.* Rome, San Clemente.

highlight: in the 'Table of Colours used in Modelling' I have listed the colour combinations where *matizatura* is not achieved by the use of unadulterated white lead.

TABLE OF COLOURS USED IN MODELLING

Source	Laying-in colour	Incidere	Matizare
Er. DCM	Azure with white lead = lily-green	Azure	White lead, and when dry cover with claro croco (clear saffron)
Er.	Orpiment and indigo = lily-green	Black	Orpiment
DCM	Orpiment and black = cornflag green	Black	Orpiment
Er.	Orpiment	Vermilion	White orpiment
Er. DCM	Orpiment	Vermilion	et ipsi matizatura non est, qui stercorat (muddies) alios colores
Er.	Ochre	Vermilion	White (and ?) ochre
Er.	Orpiment and azure or indigo; or ochre with indigo or green; = 'vergaut'	Brown (bruno) or black	Orpiment or bisetum
Er.	Green	Black	Bisetum
Er.	Brunum	Black	'Vergaut', or minium (red lead) and brunum
Er. DCM	Indigo	Black	Azure or 'vergaut' or bisetum
Er. DCM	Pure vermilion	Brunum or dragon's blood	Orpiment or minium
Er. DCM	Dragon's blood and orpiment	Brunum or dragon's blood	Orpiment
Er. DCM	Carminium	Brunum	Minium
Er.	Folium (turnsole blue)	Brunum	Bisetum folii
Er. DCM	Brunum	Black	Azure or minium
Er.	Brunum and white = 'pulchra rosa'	Brunum	White or bisetum folii
Er. DCM	Brunum and minium	Black	Red minium
CAP	Brazil lake over sinoper or minium	Indigo or black	Minium or azure and white
CAP	Lake: same as for brazil		
CAP	Viridem croceum (yellow-green)	Green	Orpiment
DCM	Gold on parchment	Ink or indigo	Orpiment

VI. Pietro Cavallini, *Apostles* (detail from the *Last Judgement*). Rome, Santa Cecilia.

Sources: Er. = Eraclius, *De coloribus et artibus Romanorum*; DCM = *De coloribus et mixtionibus*; CAP = *Compendium artis picturæ*.

20

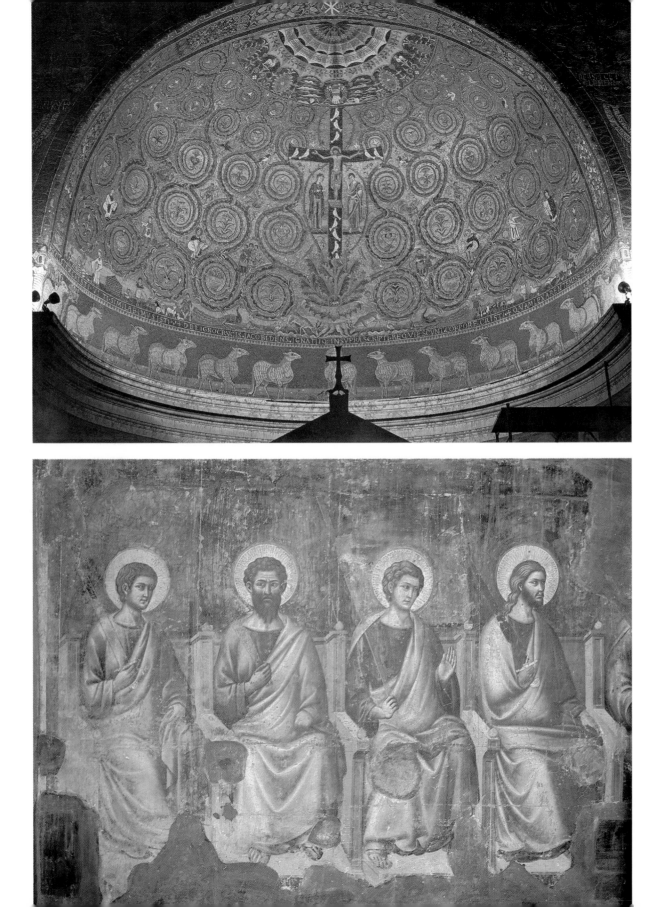

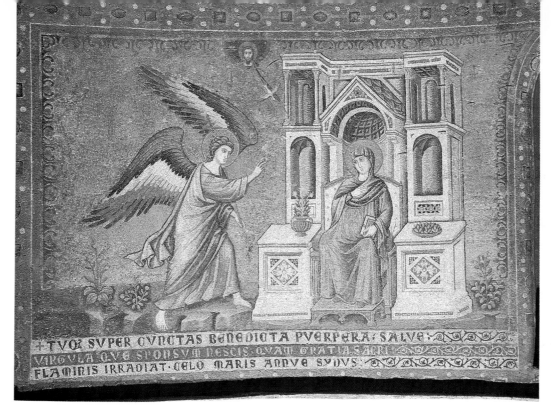

+ TVOE SVPER CVNCTAS BENEDICTA PVERPERA · SALVE ·
VIRGVLA QVE SPONSVM NESCIS OVAM GRATIA SACRI
FLAMINIS IRRADIAT · CELO · MARIS ANNVE SYDVS ·

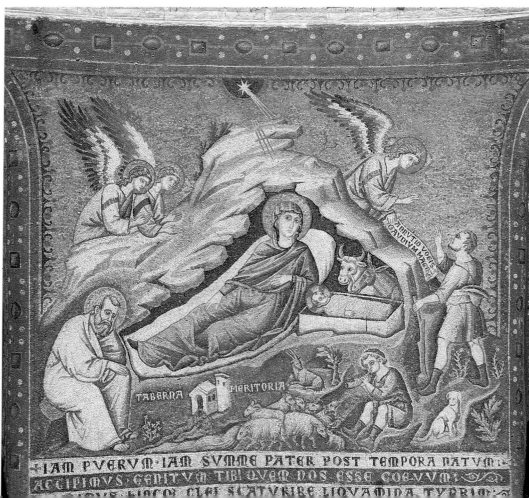

+ IAM PVERVM · IAM SVMME PATER POST TEMPORA NATVM ·
ACCIPIMVS GENITVM TIBI OVEM NOS ESSE COEVVM ·

VII. (facing page) Pietro Cavallini, *Annunciation*. Rome, Santa Maria in Trastevere.

7. Workshop of Guido da Siena, *Scenes from the lives of SS. Francis, Bartholomew, Clare and Catherine*, 121.5 × 71 cm. Siena, Pinacoteca.

The modelling system described in these lists originated in manuscript illumination, and it should be borne in mind that some of the combinations are exclusively for that medium. Normally the illuminator laid two coats of colour over every form. Theophilus, writing in the early twelfth century, directs that the first coat must be very thin and the second thicker, a lesson repeated by Master Peter of St Omer in the fourteenth century.[47] Modelling is achieved by superimposing rather than by gradation within a single layer of paint; where the thick second coat lies over the first it usually conceals it. In treatises prior to Cennini there are no instructions for blending the laying-in colour with the lights. Even rounded shapes are to be modelled with breaks rather than by continuous gradation, and frequently these breaks are reinforced by changes of hue. Far from imitating natural illumination, such modelling embodies a simple code for distinguishing convex surfaces from flat ones.

Conveniently for us, Theophilus explains the code. After describing how to make a rainbow band of colours ranging from light to dark, he indicates where it should be

VIII. (facing page) Pietro Cavallini, *Nativity*. Rome, Santa Maria in Trastevere.

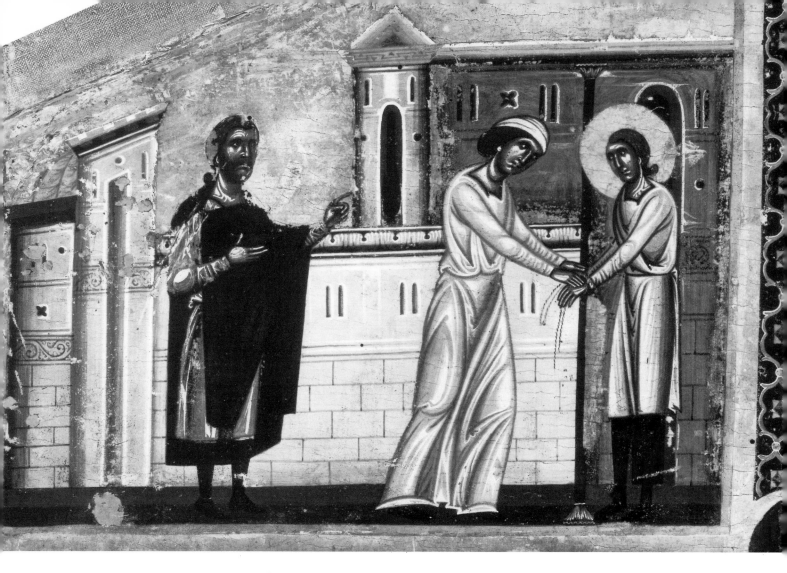

8. Bardi St Francis Master, *St Francis banished by his Father* (detail from the *St Francis Altarpiece*, col.pl.II).

applied: 'By this method, round and rectangular thrones are painted, drawings round borders, the trunks of trees with their branches, columns, round towers, seats and whatever you want to appear round. Arches upon columns in houses are also portrayed in the same way – but in one colour range, so that white is on the inside and black on the outside.'[48] In the absence of perspectival clues as to recession and shape, this conceptual modelling is essential. Thus in paintings such as those from the workshop of Guido da Siena (fig.7), flat walls are highlit down one vertical edge and shaded along the opposite one, whereas the convex wall of a tower is neatly differentiated by the placement of a white highlight down its centre. Since the cornices and string-courses on the buildings, whether flat or round, are equally horizontal, the placing of the highlight assumes special significance. 'Round towers are painted in yellow ochre in such a way that there is a white brush stroke in the middle', instructs Theophilus.[49] Again, a central highlight on a tower can be seen in the top-left scene on the altarpiece of St Francis in the Bardi Chapel (fig.8).

24

Highlights as tonal modelling or reflections

Although there can be little doubt that the modelling conventions employed in the altarpiece of the Madonna and Child in Santa Maria Maggiore or that of St Francis in the Bardi Chapel in Santa Croce are dictated by conceptual habits, we may still wonder what the lightest tone – the *matizatura* – may signify. In common usage, 'highlight' refers to two separate phenomena.[50] Either it can mean the lightest tone on the gradation of light and shade on an object, or it can refer to the reflection of a light source. Tonal highlights are stable; they do not change their position on an object as the observer moves; they reveal the shape of the object and the direction of incident light; they blend with the local colour rather than obliterate it. Lustre or a reflection, on the other hand, is unstable; it shifts its position on an object as the spectator moves; it is an equivocal guide to the direction of light; and where it is most concentrated as a mirror image of the light source it conceals the local colour. Since lustre varies in intensity according to the texture of the reflecting surface, its presence or absence informs of texture.

The highlights we have been considering approximate more closely to lustre than to stable tone. They obliterate – thanks to the hiding power of white lead – the local colour; they do not blend smoothly with it at the edges. Their location does nothing to indicate a consistent direction of light, and their dynamic linearity may even seem like a painter's attempt to capture the mobility of lustre – a mobility the painters would have noted on their models, antependia in metalwork and enamel.

When mediaeval theologians praised *splendor* as the manifestation of the link between the eye and the object gazed upon, they reinforced the painters' habits.[51] Yet it may be that it was the divine associations of *splendor* that led to the reservation of lustrous highlights for special situations. With the spread of narrative – as exemplified in the Franciscan stories – attention shifted to the stable, spatially informative, tonal highlight. For mundane situations it was apt because less charged with the spiritual associations of dazzling light. Saints might be modelled in the glorious splendour of lustrous highlights – bright mirrors of the eternal source of light: for ordinary mortals the tonal highlight would suffice. The arrival from Byzantine art of the technique of chrysography (modelling in striations of gold leaf) was catalyst to this polarization.

Chrysography: highlight as symbol

By applying slivers of gold leaf over an oil mordant the panel painter could replace *matizatura* with a web of golden highlights that physically reflect the light. Long in use in Byzantine mosaics and enamels, chrysography seems to have been introduced into Tuscany by Coppo di Marcovaldo in the mid-thirteenth century (see fig.9).[52] From a technical point of view it was convenient to highlight with gold where white lead would have been detrimental to the underlying colour. Verdigris and orpiment are chemically incompatible with white lead. Vermilion, the trumpet of the mediaeval palette, was rarely modelled with white; the colour manuals recommend lightening it with orpiment or minium,[53] but this was more common in books than on panels, where it usually appears shaded but not highlit. For the panel painter seeking to model vermilion with lights that could match its intensity, an alternative was to apply gold, as Cimabue did on the loincloth of Christ on the Crucifix at Arezzo (col.pl.I).

9. Coppo di Marcovaldo, *Madonna and Child*, 1261, 220 × 125 cm. Siena, Santa Maria dei Servi.

25

Habits of modelling in the thirteenth century varied according to the symbolism attached to colours. Ultramarine is the most obvious nonconformist. Ground from lapis lazuli brought from the mountains of Afghanistan, its expense and the depth of its blue, so like the sky by night, made it the most fitting pigment for the robe of the Queen of Heaven, the Virgin Mary, as well as for the mantle of her Son. Well nigh impossible to model by shading on account of its natural darkness, painters were reluctant to spoil its precious depth by heightening it with lead white.[54] Chrysography offered a solution. Ultramarine could be highlit with gold without being desaturated; indeed the chromatic contrast enriched the nocturnal, dreamlike, otherworldly resonance of blue. Far from imitating the mundane light of the noonday sun, the unnaturalness of such modelling suited its symbolic, celestial purpose.

While on the subject of nocturnal associations, we should remember how regularly mosaics and altarpieces were viewed by the flickering light of candles and lamps. Many services took place during the hours of darkness.[55] Whereas the diffused light of a bright day may produce joy, concentrated light in a dark interior induces admiration. In the Old Testament it was just such awesome brilliance that was termed 'glory', of which gold haloes are the direct descendant.[56] By 1300 candles were being placed upon the altar rather than simply near it.[57] The concentration of light on the lustrous surfaces of altarpieces decorated with gold leaf and chrysography produced in those who gazed upon them a state of admiration in which awe and wonder were mingled.

Chrysography is technically inflexible. Gold is either applied or not applied. It can offer no intermediate tone. When gold replaces white lead the separation between highlight and laying-in colour is absolute (see fig.10). The only mediation is achieved by applying fine offshoots or combs at right angles to the main lines of gold. Relief is expressed by the linear curvature of the fins of gold, rather than by gradation of tone. Thus the matrix of colour is free to be applied in full saturation, or, as Aquinas might say, in perfect *claritas*. Like the Heavenly Jerusalem described by St John in chapter 21 of *Revelation*, it was meet and right that the image of sacred things should be made of the most precious and most aetherial colours, the least sullied by dull matter, therefore the most akin to the Father of Lights. Chrysography and saturated colour were in keeping with this widely held cosmology and metaphysics of light.

Chrysography was powerless to render tonal gradation. Since its schemata could not be 'corrected' in the direction of greater naturalism, they became increasingly stylized. On the main panel of Duccio's *Maestà* (col.pl.XIX) a web of gold was applied here and there to the hem or shoulder of an angel to distinguish one layer of drapery from another. By the advent of the Trecento the stylistic isolation of chrysography, brought about by new techniques of modelling, notably in fresco, sharpened its significance as symbol of the celestial and divine. Such a separation of symbolic highlighting from tonal modelling will be explored in later chapters. Though tonal modelling is the technique we rightly associate with Giotto's innovations, it would be wrong to suppose that *matizatura* and chrysography were a dead end. Giottesque modelling should not blind us to the elementary challenge that faced earlier Italian painters: their problem was how to create the illusion of convexity on a flat surface. The manuals on colour imply that the highlight marks the forwardmost projection on an object or figure. On the figure of St Francis in the altarpiece of the Bardi Chapel, for example, the highlights

10. Attributed to Cimabue, *St John the Evangelist* (detail from *Crucifix*, col.pl.I).

running down from the waist of his habit mark the protrusion of the thighs beneath: a break accentuated by curves marks the height of the knees. Such highlights act as a diagram of the body's joints, descriptive less of the accidents of light incident upon the surface than of the essentials of skeletal structure. Modelling with *matizatura* carries through mediaeval art the Classical awareness of the body beneath the drapery. It differs from the Classical system in that the distinction between body and drapery is confounded. The highlights function simultaneously as a kind of X-ray reading through the drapery and a delineation of the folds themselves. Thus the highlights that loop around the sleeve of St Francis do more than mark joints and protrusions; they detach the sleeve from the mass of the habit behind, and they define the aperture at the wrists.

Here the painter had little use for gradation; the linear clarity of *matizatura* better suited his purpose.

In the late Byzantine style of the Paleologans, bright highlights, set off by dramatic shadows and by contrasts of colour, act as metaphor – almost seismograph – for the fervour of the saints. When Vasari dubbed this the 'maniera Greca' he recognized only stiffness and misproportion. He failed to note that Byzantine luminism bequeathed to the Italian tradition a sense of light as metaphor. In fact the expressive rather than the mimetic function of modelling dominated the habits of Italian painters in the Renaissance. To compare Botticelli's or Leonardo's light and shade with that of a Netherlandish master is to be made aware of a difference that flows from the Byzantine as well as the Classical heritage of the Italians. Ever conscious of the body, the Italians preserved in their modelling something of the Byzantine synthesis of drapery and the anatomy beneath. That veiled inwardness – body within garment, soul within body – tempers or deflects objective description of external light.

Yet seeds of change had been sown by the end of the thirteenth century. The antecedents of Vasari's admiration for *disegno* – the intellectual quality of design made manifest in drawing – are dimly discernible. The primitive mind that viewed the world in terms of magic was coming into conflict with the inquiring mentality that sought control through the understanding of natural causes. In the convenient shorthand, we may say that the Aristotelian spirit of empirical observation was making headway against Platonic idealism. The realm of the magical was being contained. The revival of Roman law furnished concepts of justice based upon reason rather than appeal to divine authority. Urban life and the civic sense were more fully developed than elsewhere in Europe.[58] Art in the service of the commune, whether fountains in public squares or Madonnas watching over council chambers, demanded a style more palpable than transcendent.[59] The commercial revolution spawned a numerate class who valued a mathematical education; the Church was losing its monopoly of learning. Such social transformations are not remote from our subject. If the mystic is transported by the light that dazzles, the merchant values the light that informs of measure and quantity. St Francis understood this craving of contemporary society for the tangible and realistic. Yet the growth of empiricism is far from the whole story. Consider how the development of banking and credit, as well as international trade recorded by double-entry accounting, affords a separation between the visual manifestation of wealth and its abstract calculation by means of figures: gold no longer has to be seen to be believed. It would be quite wrong to imply that gold went out of fashion, but when Enrico Scrovegni commissioned Giotto to fresco his chapel in Padua he was rewarded with a cycle more rigorous in design and more convincing in illusion than rich in materials. In Giotto's frescoes pictorial light as descriptive of forms in space takes precedence over the splendour of a glittering surface. The Arena Chapel will be studied in chapter three: first we must turn our attention to developments in Rome.

II. Cavallini and the mosaic tradition

Surface and film colour

In conceptual systems of modelling, such as that of Theophilus, lights and darks are superimposed over uniform areas of colour. The choice of laying-in colour may be governed by considerations of availability, of contrast and brilliance of hue, of clarity, and sometimes of iconography, but never – at least according to written evidence – of illumination. Such a system, in which all intimation of lighting depends upon the later phases of painting, fails to build upon the tonal value – *valeur* – of the laying-in colour. Light and shade are added to each figure or area of colour as isolated units by *matizando* and *incidendo* (*matizando* meaning the superimposition of the *matizatura* or highlight). There is no discussion in the treatises of relationships between one drapery and another, or between figure and ground. To these broader relationships of colour, which generate sensations of light-filled space, we must now turn.

The texts reviewed in the last chapter were composed primarily for manuscript painters, and only to a lesser extent for panel and mural painters. For mosaic there were different rules. As a monumental medium, prominent in mediaeval Rome, it offered lessons as to how colour and composition affect values of illumination. The characteristics of the late antique and mediaeval tradition in Rome, as exemplified in the fifth-century mosaics in Santa Maria Maggiore and the twelfth-century apsidal mosaics in San Clemente (col.pl.V) and Santa Maria in Trastevere (fig.11), may briefly be summarized.[1]

Mosaic as a decoration of the expansive surfaces of basilicas and churches is subservient to the shape of the building. Its borders are flat patterns, not mouldings; no threshold or front plane of pictorial space is defined. The nature of the individual units of colour, the tesserae of glass or marble, and the deliberate irregularities of their setting in the plaster bed, induce scattered sparkle or lustre upon the surface. Mosaic reflects and conditions the illumination in a sacred ambient. Light striking the mosaic surface becomes integral to the subject represented. Since monumental mosaic is architectural – the precious vestment of the building – pictorial illusion is kept within bounds. The mosaicist does not strive after definition of space *behind* an aperture in the wall, and thereby preserves the bond between actual and pictorial light.

Gold backgrounds, at San Clemente for example, are linked with the other colours by a chain running from yellow through gold to green and deepening to blue. This modulation of a tonal change through transitions of hue within a limited section of the spectrum is employed to describe the passage of a ground-plane from foreground to background. In the apse of Santa Maria in Trastevere the ground passes from green,

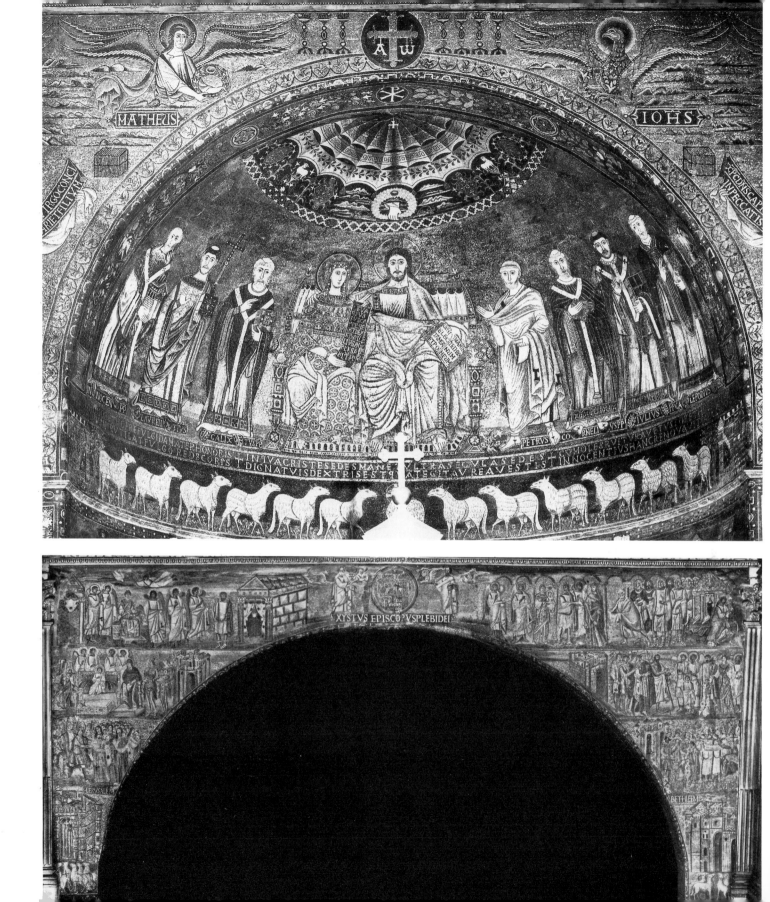

through pale green and yellow, to gold. Such a colouristic rendering of space leaves its depth as yielding and undefined as a seascape in a heat-haze, and offers no contradiction to reality of surface as architectural vestment.

Figure, in its broadest sense as any bounded form, is distinguished from the boundlessness of field. Earlier this century David Katz pointed out that colours have two principal modes of appearance, which he called surface colour and film colour.[2] Where colours have a visible texture and definite boundary or edge, they are perceived as belonging to a surface and lying in the orientation or slant of that surface. But where there is no texture, no boundary or contour, then colour will not be perceived as precisely located in space, and if it assumes any orientation it will be frontal. A surface colour appears illuminated by virtue of its unequivocal display of light and shade. A film colour by its very nature appears luminous rather than illuminated; it cannot inform of the direction of ambient light. Regardless of what terminology we may choose, the perceptual distinction between surface and film colour is the key to the late antique and early mediaeval mosaicists' reconciliation of surface and space, vestment of wall and pictorial illusion. Only the bounded forms display surface colours, are modelled in tones of light and shade, and therefore in any sense appear illuminated. These forms are set against broad expanses of unbounded field, where hues merge and blend, rather than meet in linear contours. This field – as for instance in the fifth-century narratives in the nave of Santa Maria Maggiore (fig.13) – appears filled with light, luminous rather than sharply illuminated.

Within this system cast shadows mediate between the definite shape of figure and the indefinite ambient. Typically, as in the triumphal arch mosaics in Santa Maria Maggiore (fig.12), shadows shoot out implausibly from the toes, beginning in a point and fanning outwards as they recede. Unlike the cast shadows in Pompeian painting which tend to fall parallel to the picture, those introduced in Early Christian and early mediaeval mosaics usually fall diagonally.[3] They define a strip of platform as base for the figures, counteracting for a small space the tendency for the unbounded colours of the field to orientate in the frontal plane parallel to the wall. Their stereotyped triangular shape, as well as the tenuousness of the connection between the shadows and the figures casting them, indicates that the rationale behind their projection has been lost. Rather than signifying the interruption of directed light, these cast shadows primarily act as recessional pointers that extend only so far as it is necessary to assure us of the levelness of the ground.

Santa Maria in Trastevere

In Pietro Cavallini's mosaics of the Life of the Virgin in Santa Maria in Trastevere, executed at the close of the thirteenth century, many of these characteristics of mediaeval mosaic are no longer to be found.[4] Consider the *Annunciation* (col.pl.VII). A rocky edge establishes a threshold between real and pictorial space. The lightening of the blue-green ground along this edge marks the change from vertical to horizontal surface and thereby establishes the level plane of the ground. The rear edge of the platform of ground is equally definite, cut off in a straight line by the gold background. Surrounded at the top and at either side by a green band fringed by ornamental brackets, the gold is separated from the red border that runs around the entire scene.

11. Twelfth-century apse mosaic, *Christ and the Virgin enthroned with Saints*, Rome, Santa Maria in Trastevere.

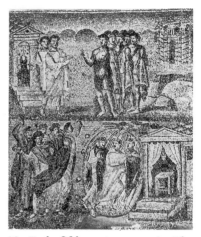

13. Early fifth-century mosaic, *The Sending Out of the Israelite Spies*, and the *Threatened Stoning of Moses, Joshua and Caleb*, Rome, nave of Santa Maria Maggiore.

12. Fifth-century mosaic, *Scenes from the infancy of Christ*, Rome, Santa Maria Maggiore.

14. Pietro Cavallini, *Adoration of the Magi*. Rome, Santa Maria in Trastevere.

The result is a paradoxical space. Since the gold background is clasped to the vertical surface of the wall by the ornamental brackets, it appears that the platform on which the narrative takes place is like a shelf projecting from the wall. But of course the lower margin of the *Annunciation*, which takes the form of an inscription, denies that this can be the case.

If the relationship between the narrative space and the wall that bears the mosaic is paradoxical, the organization of forms on the narrative stage is a model of clarity. Whereas in the *Annunciation* in Santa Maria Maggiore in Florence the posture and modelling of the figures are the primary agents of expression, in Cavallini's mosaic these do not bear the whole burden of the drama. Less vehement in their expressions, their state of mind communicates itself through their relation to the space they inhabit. The submission and strength of Cavallini's Virgin Annunciate are conveyed by the inclination of her head and the gentleness of its modelling in broadly lit planes, but the expressive message of her body is fulfilled by the niche behind the throne – an eloquent receptive womb, firmly bounded and strongly crowned by a projecting arch and gable.

The direction of the pictorial light is purposeful. In the *Annunciation* and the other five scenes, in accordance with the narrative flow around the apse, light falls from the left. Architectural structures in the *Annunciation*, *Adoration* (fig.14) and *Presentation* (fig.15) are positioned so that their most sharply receding face is in shadow. Though the identification of light tones with frontal surfaces and darker ones with receding surfaces was nothing new, Cavallini certainly planned orientation with special care: in the *Adoration of the Magi* the way the house behind the Madonna and Child faces towards the light underlines their turn towards the three kings.

Modelling is varied according to the orientation of a figure relative to the fall of light. In the *Nativity* (col.pl.VIII) Joseph is wrapped in a cloak of a single hue: never bleached to white, its highlights are a pale, brickish pink, whereas the shadows, a much darker pink, are restricted almost to contours for each limb. Sparing of his middle tones, Cavallini spread broad, illuminated planes between the concentrated shadows. The mosaic technique, being dependent upon just one layer of colour, no more, no less, ruled out modelling by superimposition. Drawing over a laying-in colour with lights and darks – *matizando* and *incidendo* – was out of the question. Colour and tone had to be chosen once and for all as each tessera was pressed into its bed of plaster. Cavallini applied his tesserae in long rows that follow the hang of the draperies; as each row passed from the shadowy pocket of fold into the broad light, such as where the protrusion of a thigh or shoulder pressed the drapery smooth, he had to determine the degree of contrast. Before he laid the tesserae for Joseph's cloak, no doubt he sorted his brick pinks into a series of tones and arranged them ready to hand in separate bowls.[5] Then as he filled each row he knew if he was using the same grade of tesserae as in the adjacent row. Each colour could be fixed without allowance having to be made for the changes that occur when paint is drying. If mosaic could not compete with painting in smooth gradation of tone, it compensated by precision of contrast. The irreducible, unblendable nature of the basic unit of mosaic, the tessera, lent itself to crisp tonal breaks. By controlled use of tonal jumps within bounded areas of colour Cavallini achieved an effect of illumination.

15. Pietro Cavallini, *Presentation in the Temple*. Rome, Santa Maria in Trastevere.

32

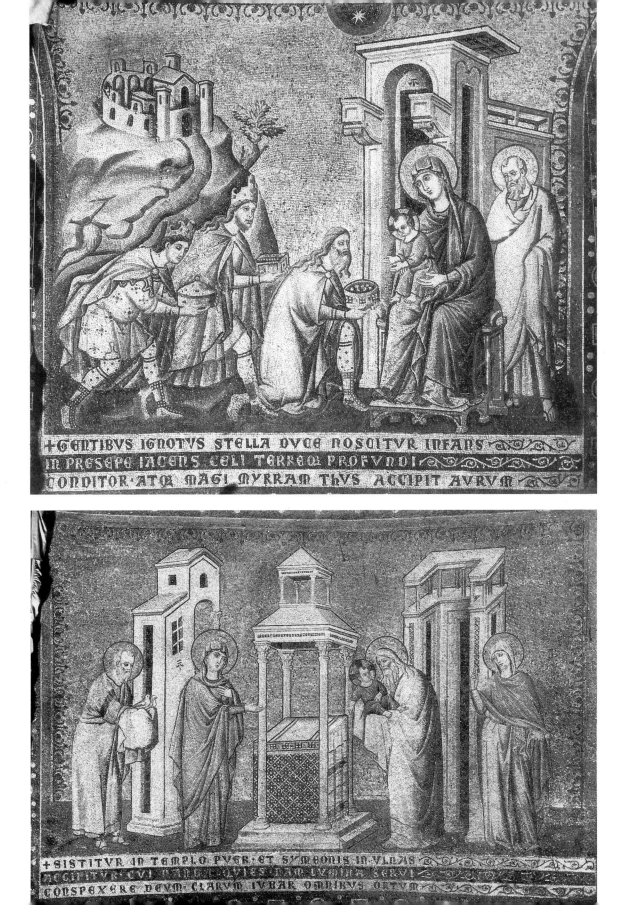

+GENTIBVS IGNOTVS STELLA DVCE NOSCITVR INFANS
IN PRESEPE IACENS CELI TERREQ: PROFVNDI
CONDITOR·ATQ· MAGI MYRRAM THVS ACCIPIT AVRVM

+SISTITVR IN TEMPLO PVER ET SYMEONIS IN VLNAS
ACCIPITVR·CVI DAT·LAVDES·IAM·LVMINA·SERVI
CONSPEXERE DEVM CLARVM IVBAR OMNIBVS ORTVM

When Cavallini discarded linear highlights and broadened the illuminated planes, he discovered our capacity to read the mass and structure of a figure of which only the essential guidelines are provided. There is a problem here about the precedence of a new technique of modelling or of fresh attention paid to light – chicken or egg? It is more probable that the change in the lighting of figures in art around 1300 was born from an understanding of how far modelling could be simplified and only subsequently led to renewed observation of light. The priority of stylistic change in the field of sculpture points to this conclusion. Antique art showed that selection was the key to powerful physical presence, and sculptors in the late thirteenth century, particularly those active in Rome, followed this lead. With an artistic Occam's razor they cut away the skein of lines and folds that had wrapped and ribbed figures in the Romanesque style. Sculptors like Arnolfo di Cambio smoothed the draperies over the rotundity of thigh or shoulder (fig.16); they contrasted tension and slackness, and spread broad expanses between the folds.[6]

The sculptors showed how the modelling of drapery could be simplified, but they would have had less to teach about a crucial aspect of Cavallini's art, the relation of figure to field. Where Cavallini carried his modelling to its most daring conclusion he eliminated contours on the lit side of the figure, and set the tone of the figure in relation to the tone of the adjacent background. This is very much in contrast with conventional technique such as can be seen in the mosaics of the Moses cupola in the atrium of San Marco in Venice – probably executed in the 1280s – where the mosaicist insulated the figures from the pale background by means of dark contour lines (fig.17).[7] Since 'a dark line drawn around (or even across) a shadow makes it look like a stain',[8] when outlines circumscribe modelling they diminish its luminary value.

By eliminating outlines and gauging the tone of a figure against its background Cavallini restored to modelling its value as light and shadow.[9] In the *Nativity* the tone of the rocky hillside varies according to whether it is adjacent the pale or dark contour of a figure. The lightening or darkening can appear arbitrary, as around the back of the piping shepherd, but, in the main, Cavallini only shades to give relief where the shading can appear to lie upon a surface: by sculpting the hillside with cliffs and ledges he accommodates his figures amongst the conveniently placed lights and attached shadows of the background. This flexible system, Byzantine in origin, does not call for cast shadows to assert the levelness of a platform of ground since this is achieved by the modelling of the stepped landscape.

In the absence of definite cast shadows is it justifiable to speak of a directional fall of light in Cavallini's work? Do the colour and modelling of individual surfaces add up to an experience of light in space? Or is Cavallini simply revamping earlier pictorial traditions without conscious reference to light? Before answering these questions we must pause to reconsider what is involved in the perception of a surface and its illumination.

Colour, slant and illumination are coordinated

The array of ambient light which reaches our eyes from an illuminated environment carries information regarding the structure of that environment. The array of light may be conditioned by four factors:

34

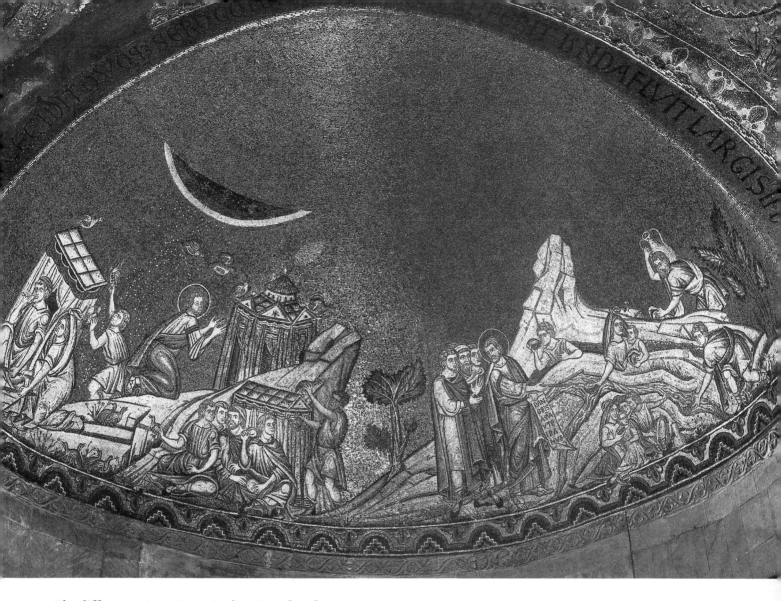

The different orientation or inclination of surfaces
The degree of whiteness of reflecting surfaces
The spectral or chromatic reflectiveness of a surface
The difference in illuminatedness of surfaces with shadows cast upon them[10]

Occasionally we misinterpret the information carried by light and confuse one factor with another. If a surface lacks discernible texture we may mistake a shadow on it for a stain. More rarely we may confuse a change in inclination with a change in colour or vice versa. The Cubists capitalized on such ambiguities, but on the whole we avoid these pitfalls in daily life.

Traditional theories attributed this success to the force of experience which we draw upon – largely unconsciously – to interpret the data of the senses. Such theories admit a discrepancy between *sensation* and *perception*. Sensations are unmonitored by the

17. Late thirteenth-century mosaic, *Moses strikes Water from the Rock*, and the *Fall of Manna*. Venice, north atrium of San Marco.

16. (left) Arnolfo di Cambio, Detail of tabernacle, 1283. Rome, Santa Cecilia in Trastevere.

intellect and may transmit ambiguous signals. Perceptions, on the other hand, involve the exercise of judgement.

This view has been challenged by James Gibson, who maintains that perception is not so much controlled by experience and judgement as guided by an innate imperative to hunt for useful information: the brain and the organs of the senses act in unison as 'perceptual systems'. Recent research on the firing of cells in the visual cortex indicates that nervous excitation at its most elementary stage is conditioned by the environment and experience of the individual organism.[11] If nurture modifies nature, if over time experience produces physiological correlates, then the belief that perceptual skills are learned may not conflict so radically with the belief that they are a consequence of the structure of the organism, but the notion of a split between sensation and perception must be abandoned.[12]

What we see and how we interpret what we see cannot be completely separated. Both are controlled by the intent of the perceptual system as it has developed during the evolution of the species and the life of the individual.[13] To discover meaning in the optic array is the intent of vision. Focusing is the most obvious spontaneous reflex of the eye, and there are many other ways in which our visual system seeks for meaning without our conscious control. How we see a combination of surfaces depends upon simultaneous estimation of their colours, illumination and orientation. How light or dark we see a surface may vary to a surprising degree, due in part to physiological patterns of excitation and inhibition and in part to our acute capacity to recognize familiar object-colours under mutable illumination. The phenomenon known as 'colour constancy' is explained largely by the ability of the visual system to take stock of the illumination that prevails at a particular moment and to discount it when noting the colours of objects. So, although lighting is registered, it is rarely attended to for its own sake; in terms of information crucial to survival, it is more helpful to be able to recognize the normal colours and textures of objects than the specific chromatic quality of light.[14] It is for this reason that the painter who seeks to see colours as they are in all their mutability, far from relying upon an innocent eye, must cultivate strategies to trump the utilitarian habits of vision.

The first step in such a painterly strategy is to watch for the relationships of colours one to another and particularly of figure to field. What would prompt such a habit of attention? The symbolic mode of iconic art presented things as it were in their permanent, most significant form and as separate entities, related not by the visual continuum of light and space but in a hierarchy of ordered and immutable design.[15] By contrast, the growth of narrative in the thirteenth century insinuated the notion that a picture is an analogue of a visual reality such as a religious play. The pictorial field became, by a gradual process of adaptation, like a stage, a scene. As space became essential to the portrayal of narrative progression, so artists grew more attuned to the interweaving of colour and light between figure and ambient. Painterly vision was nurtured by the special task of realizing an image of the three-dimensional world on a two-dimensional surface. Far from being a skill essential to every member of the human race, it can only develop within the context of a sophisticated artistic culture. Late thirteenth-century Rome, newly aware under the vigorous patronage of the papacy of its heritage of Classical and Early Christian art, had the makings of such a culture.

Since the perception of orientation, colour and light is interdependent, to render illumination a painter must conceive it at the same time as he places his solids in space. Cavallini scored over earlier painters and mosaicists not only by his eye for the spatial resonance of the colour of figure against field, but also by his explicit orientation of solids. This is crucial. 'If I cannot correctly orient a coloured surface, the basis for the normal constitution of illumination is also lacking'.[16]

Cavallini's coordination of light and space depends upon three principal features. First, architectural properties are presented at oblique angles which are informative of their depth and mass; the recession of the different faces is unambiguous, therefore we can correctly orient their surfaces. Figures likewise are posed in informative three-quarter views. Second, the pictorial architecture is in desaturated or neutral colours which readily display shading. The colours of the variously oriented faces of the same structure are distinguished by changes of tone rather than hue. Third, each architectural plane is uniform in tone. The only exceptions to this important and rather novel rule occur where Cavallini darkens part of a surface to set off another which projects in front of it: this relief shading darkens the niches of the *Annunciation* aedicula.

Taken together these features overturned the conventions that governed earlier Italian art, namely, uninformative, frontal disposition of architecture, distinction of parts by changes of hue, and the reinforcing of these distinctions by darkening or lightening of edges. Examples of these traditional devices can be found in mosaic in the baptistery of Florence and in panel painting in the St Francis altarpiece of the Bardi Chapel.[17]

Yet, although Cavallini's layout furnishes a better framework for displaying a consistent, directional fall of light than the flatter structures of earlier thirteenth-century painting, some of the means by which clarity is attained, such as relief shading and the eschewal of cast shadows, run counter to this consistency. This may serve as a timely reminder that the description of light was not attempted for its own sake but as an instrument in the service of narrative.

Cavallini's colour

In his mosaics Cavallini balances gold and green. Neither neighbours on the spectrum, nor complementaries, gold and green have a special affinity. Yellow and green do not share this harmony. Gold is not a pure hue: its impurity darkens it compared with yellow, bringing it closer to the tone of green, so that in certain lights the two colours seem interchangeable. Cavallini prefers balance to spectral sequence; there is no colour chain; unlike in the apse of San Clemente, no yellow mediates between gold and green. Like the mosaicist of San Vitale in Ravenna,[18] Cavallini prefers lavenders, pearly greys, browns and pinks to the primary hues. He avoids orange as well as yellow, and saturated red he uses sparingly. His purest colour is reserved for the shadows, while mid and light tones tend towards a range of neutrals.

Cavallini's handling of gold is masterly. He accepts that it does not belong among the lightest tones and does not let it compete with these. He ensures the separation from the gold of the broad areas of light by suffusing many of them with shades of pink or lavender. Nevertheless he values the sparkle of gold as fitting decoration for the royal and the divine. He weaves it into the vestments of the Madonna and the Christ-Child,

the cloak of the central king, and the robe of Christ in the *Dormition*. Its colour and gleam are enlivened by being mixed with neutrals and modelled with dark umbers. Dense, reflecting planes, which would compete with the near-white lights, are avoided: the distribution of gold tesserae kindles a scattered sparkle. Nowhere is gold applied like chrysography as linear drawing; it blends with the local colour of garments and these are moulded by the umber shading rather than the gold lights.[19]

In the first chapter it was suggested that traditional esteem for luminosity of surface came into conflict in the late thirteenth century with a growing ambition to describe pictorial space. Enamoured of lustre, painters found it difficult to isolate *lume*. By his handling of gold, Cavallini showed that he could exploit the tendency of glass tesserae to sparkle, but he did not allow this lustre to deflect his choice of tonal values. The breadth of his lit planes (mostly made with the less lustrous marble tesserae), as well as their positive orientation towards the light source and their colour relationship to the shadows, all witness to Cavallini's attentiveness towards the stable tonal highlight, *lume*.

So Cavallini's handling of gold is in keeping with a use of colour designed to reveal the illumination and slant of surfaces. Whereas earlier painters distinguished parts through changes of hue, Cavallini distinguishes through changes of tone, thereby preserving the plastic continuity of parts within the greater whole. Whereas for earlier painters colour was absolute, for Cavallini its value is relative – relative to an optical continuum that embraces figures and space. To summarize, this remarkable shift, fundamental to the history of Western art, is achieved by Cavallini by avoidance of two-dimensional, decorative patterns of strident local colour where these might confuse coherence of modelling; by increase in the proportion of the lights, so that they constitute a broader mass than linear highlights; by limitation of purest white and retention in the lights of a pale suffusion of the local colour; and, perhaps most importantly, by increase of near-neutral tones and desaturated colours, in which tonal nuance is telling.

When scientists measure the light radiated in a specific direction from a given surface they speak of its 'luminance factor'.[20] Whereas the 'reflection factor' measures the ratio of light reflected compared to the total incident light, the 'luminance factor' is more significant as far as a stationary observer is concerned because it takes into account only the light reflected in a single direction. Though he may use different terminology, the judgement of luminance is very much the concern of the painter who seeks to represent or create the illusion of the illuminated, polychrome world as seen from a single, fixed vantage point. The notion, real or theoretical, of fixity of vantage, such as is asserted by application of linear perspective, is a prerequisite for directing the painter's attention to luminance.

The mediaeval concept of *lume* was not nearly as precise as the modern concept of luminance – owing particularly to the confusion as to whether *lume* referred to the illuminated surface or to the radiation of light in space. But Cavallini is the first artist of the thirteenth century to combine successfully the form-defining and radiant qualities of *lume*. Whereas previous painters may have attempted to describe reflections on a surface (i.e. local colour with lustre or *splendor* superimposed), Cavallini comes

closer to describing luminance (the light radiated by the coloured surface). The coloured surface was no longer to be regarded simply in Grosseteste's terms as 'lux incorporata in perspicuo' but as a surface mutable in appearance according to its orientation relative to the fall of light and to the viewpoint of the observer.

The pattern of light and dark which the *Nativity* or the *Adoration* presents has a *claritas* and *splendor* that differ from the bulk of Duecento painting in the boldness of scale – a boldness necessary to quell the intrusive brightness of flanking windows. It is not the clarity of detail which impresses but the subordination of detail to the clarity of the whole. It is not the splendour of jewelled crowns which dazzles but the broader radiance of a cloak or bright facade. Furthermore, changes in the scale of lights are used to expressive effect. After the bold highlighting of the rocks which frame the Madonna of the *Nativity*, the gentler lights on the Jerusalem hill of the *Adoration* tell of greater distance. Whatever the formal value of light, it retains its power as sign. The splash of light cascading over the rocky apex of the Nativity cave represents the moment in the narrative when 'the glory of the Lord shone around', but this momentary

18. Pietro Cavallini, *Apostles* (detail from the *Last Judgement*). Rome, Santa Cecilia.

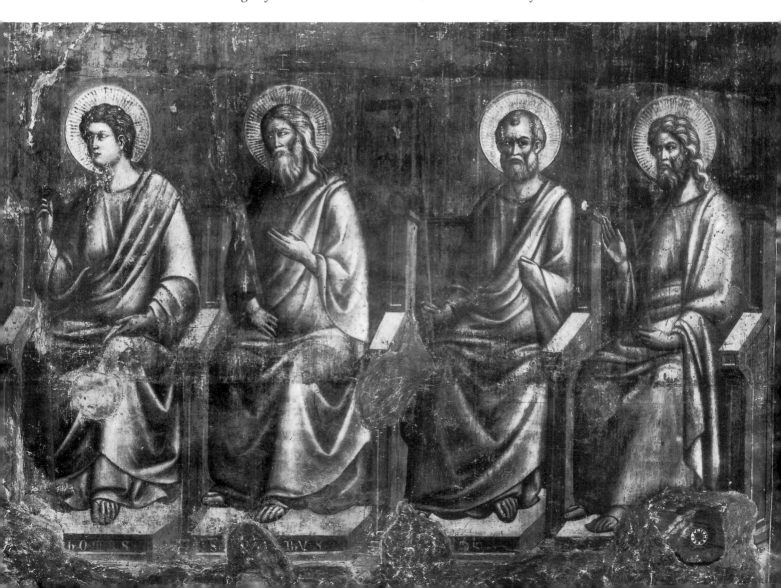

configuration of light and shade is transformed into a timeless ornament and sign of the mystery shown forth.

Faithful description of light, coherence of modelling and space, or the creation of compositions with emotive and symbolic power: the conflicting demands of these objectives were variously resolved by painters after Cavallini. Few, however, achieved compositions so effective in modelling, so dramatic in meaning and signs, as Cavallini in his mosaics in the apse of the Roman church of Santa Maria in Trastevere and no artist before Masaccio organized his designs with such an eye for the spatial connotations of tone. Little in thirteenth-century art prepares us for Cavallini's remarkable approximation to tonal unity.

Cavallini's frescoes in Santa Cecilia

Since working in mosaic undoubtedly affected Cavallini's attitude to colour and tone, it is worth enquiring whether his achievement was sustained in the medium of fresco.

In the *Last Judgement* (col.pl.VI & fig.18), frescoed on the inside of the facade wall of Santa Cecilia in Trastevere, the drapery colours of the Apostles belong to an ordered family.[21] Abrupt contrasts of tone – a pale drapery next to a dark – are generally avoided. Contrasts of hue are played down, the colours all being desaturated. Grey-browns, dull greens and reds predominate. Exact matching or pairing of colours is hard to find.

The lights and darks are so full of gradations that there is no single area of each drapery which can be said with certainty to represent the local colour of the stuff. Highlights are treated broadly, falling on the protrusion of the thick folds, but not sharply demarcated from the mid-tones of the penumbra. Though the technique is true fresco – the colours applied each day to a fresh patch of wet plaster – in places it appears that the paint is several layers thick, the lights vigorously hatched over the darks. These lights are not applied smoothly, but have a mealy, broken character that permits the darker undertone to show through at the edges. The rhythm of long, detached brushstrokes shapes the undulations of drapery. And, above all, the threads of the white lights, especially where they thin out in the penumbra, specify the rough texture of homespun. Material identity survives every transformation of tone: it is as if the texture of cloth can be seen 'beneath' the light and shade.

The simplicity of forms, the strength and breadth of modelling in Cavallini's frescoes, was calculated for viewing from the floor of the nave of Santa Cecilia. Looking up at the *Last Judgement* from that vantage we can see that Cavallini spurned such traditional means to combat distance as strident colour contrasts and strong linearity. Instead he gave monumentality to his forms. Rather than compensate for distance, he imitated the appearance of forms seen from a distance. It is tempting to conjecture that the unusual task of repainting the Early Christian cycle in San Paolo fuori le Mura taught him how appearances change as he moved from the floor of the huge basilica to the scaffold and back again.[22] The remote vantage subdues details and eases the transition from real to pictorial space: by imitating the effects of distance the artist redoubles this process. The correlation of distance, space and light will be more fully explored in relation to the art of Giotto.

III. LIGHT AND COLOUR
IN THE SCROVEGNI CHAPEL

Giotto's frescoes in their setting

Whereas the pictorial light in the illuminations of a manuscript is necessarily independent of the physical light in which they are viewed, the pictorial light of a fresco cycle is not. The fresco painter executes his wall paintings in their permanent resting place and, save for the obstructions caused by his scaffold, he will paint by the light by which his fresco will be seen. He can experience and, to some extent, foresee the viewing conditions, but he must allow for the awkward fact that he can no more exercise complete control over them by stopping the sun in its tracks than King Canute could turn back the tide. The light in a chapel will vary according to the season and time of day; parts of the plastered wall will be better lit than others; lamps and candles may shed a fitful gleam over the frescoes. The light of stained glass is immanent in the substance of its colour: in fresco the light of the setting and the pictorial light are distinct and yet they interact.

Accustomed as we are to viewing paintings as plates in books or as slides projected in a darkened room, or to seeing them hung by an 'ideal' unchanging light in museums, or – as is often the case now in Italian churches – floodlit for sixty seconds when we drop our coin in the slot-machine thoughtfully provided by the ecclesiastical authorities, we fail to register, let alone enjoy, the interplay between pictorial and actual light that was characteristic of Mediaeval and Renaissance viewing. We should make an effort to imagine this interplay because it is the key to understanding the norms that Giotto established with regard to modelling and pictorial light, norms that dominate the Italian tradition of monumental fresco right down to the period of the High Renaissance.

The brightness of any interior depends upon the quantity of light entering it and the absorption of that light by the surfaces it strikes. Since Giotto was responsible for choosing the colours of the entire walls and vault of the chapel of Enrico Scrovegni in the Arena at Padua, he was in a position to affect to a considerable degree the brightness of its interior (fig.19). This was a constraint. In colouring the walls of the chapel's interior he needed to maintain a reasonable level of brightness. Unlike the hierarchy and crescendo of the Byzantine iconography of the domed church,[1] Giotto's consecutive narrative, based on the Golden Legend of Jacobus de Voragine, was geared to an even tenor of emphasis. Throughout the cycle a norm is adhered to. The pictorial light in every scene functions within the wider economy of the total narrative, and the narrative

itself is ordered within a vigorously designed decorative and architectural frame.

Alterations made to the Scrovegni Chapel before it was frescoed indicate that Giotto was adapting a building he himself had not designed. A door in the south wall, and window in the north wall, and two small windows above the original high altar, all had to be filled in before painting could begin. Giotto opened the triumphal arch to add the choir and polygonal apse. He filled the window above the arch with a panel depicting God the Father.[2] Most likely it was the proximity of the Scrovegni palace that precluded provision of windows in the north wall of the chapel to match the row in the south. Giotto compensated for this asymmetry by ingenious planning.

The interior of the chapel is covered by fresco. Owing to the completeness of this vestment of painting and to the absence of light-obstructing membering – such as columns, pilasters, corbel-tables, string-courses, vault ribs and consoles – there is little opportunity for comparing the fictive against the real light and shade. This inconspicuousness of the chapel's actual light allowed Giotto to impose his own terms of reference as regards the direction, intensity, range and sharpness of his pictorial light. His division of the decorative vestment into three orders or degrees of reality – the dado with Virtues and Vices, the frames to the narratives, and the narratives themselves – establishes in the spectator's mind certain assumptions about illumination.[3] How these assumptions take root is worth examining.

The area of wall nearest to the eye, the dado, is painted with grisaille representations of the Virtues and Vices which alternate with imitations of marble panelling (fig.20). The overall tone is of greyish stone with coloured panels set within the framework. Compared with the frames beside the narratives, the contrasts in the dado are subdued. The basic stone colour is greyer than above, and instead of bright cosmatesque mosaic much vaguer, broader effects of marbling have been brushed in. As in all the frames, the mouldings are consistently foreshortened from a specific point of view and painstakingly modelled in light and shade. The direction of light is treated throughout as from the west, and falls at an angle of approximately 45 degrees. This direction does not conform with that of the actual light of the chapel. It is hard to imagine how Giotto could have done this without sacrificing the even tenor or pitch of the cycle. Yet he chose a direction that is ideal, taking his cue from the triple-light window in the west wall above Christ in the *Last Judgement* (fig.32). Interior light from such a window necessarily creates its own perspective. The angle and intensity of illumination will vary according to the position of a surface, whereas Giotto's frescoes imply a light from a consistent angle and with a regular intensity – such as occurs only when the source is very distant or very large. Yet if in the early afternoon you can persuade the custodian to turn off the floodlights you will be struck by how the illuminated surfaces in the frescoes orientate themselves towards the west window, creating a far more positive link with its light than is imaginable under artificial illumination. Floodlighting wrecks the harmony of colour and space. By natural light the blues appear less harsh; the figures stand out in greater relief and the pale tones appear more frankly to receive light as an external force.

The ideal consistency of Giotto's pictorial light is not quite uniform. The subdued quality of the dado sets it apart from the upper registers.[4] Virtues and Vices flank the chapel in the guise of monochrome statues, presumably to give the impression that they

19. The interior of the Scrovegni Chapel in Padua with frescoes by Giotto.

20. Giotto, *Justice*. Padua, Scrovegni Chapel.

43

exist within their marble surrounds as a tangible part of the fabric. But Giotto does not attempt to prove that this tangible order of the decoration is *precisely* illuminated by the light of the chapel. For the most part the angle of pictorial light is the same as in the upper registers, but in the pair of personifications next to the west wall, *Hope* and *Despair*, Giotto realized the illogicality of lighting them 'through' the west wall and shifted the lighting towards the east. In the narratives above, there is not such a clear eastward shift, though in the *Meeting at the Golden Gate* (fig.21) the tower closest to the west wall is not lit from the west like its partner – surely a deliberate departure from consistency of direction.

Modelling and the logic of context

'All that the eye can possess is light.'[5] Yet the light that reaches our eyes from an illuminated environment informs us of the shape of that environment. In the last chapter I considered how in reading a pattern of light we must distinguish between four sets of variables: the orientation of surfaces, their tone, their hue, and the shadows cast upon them. In the traditional system of modelling, such as Theophilus describes, a highlight down the exact centre of a tower indicates that it is round (see above, p.24). Giotto's attention to the direction of light undermined this useful convention. In the traditional system the position of the highlight refers to the shape of the object: in Giotto's frescoes the position of the highlight refers to the direction of light. A fundamental change in conceptual habits has taken place.

How does Giotto's modelling avoid confusion between the four variables or possible interpretations that may inhere in any pattern of light? In the Scrovegni Chapel fresco of the *Presentation of the Virgin in the Temple* (fig.22) the obliquely placed Temple presents illuminated and shaded planes at right angles to one another, thereby establishing unequivocally the orientation of surfaces relative to the light. The pale tones and desaturated colours of the architecture show off gradations of shading with clarity. The most far-reaching aspect of Giotto's consistency is that he abandons the convention of highlighting a wall towards one edge and darkening it towards the other. He recognizes that in the open air there is normally no gradation of tone upon a planar surface. Surprising as it may seem, this was a discovery that painters, perhaps because they were accustomed to making their observations in their workshops where the restricted source of light – window or lamp – *will* cause gradations on a plane surface, were slow to accept. A century after Giotto's death Alberti could write, as though congratulating himself on a personal discovery: 'Let me relate here some things I have learned from Nature. I observed that plane surfaces keep a uniform colour over their whole extent, while spherical and concave vary their colours.'[6]

The extensiveness of the Scrovegni cycle afforded Giotto scope to establish norms and expectations. Sadly, the observation of individual scenes in the isolation of a photograph obscures the cumulative logic of the cycle. Observing the frescoes *in situ*, the norm that plane surfaces are uniform in tone is obvious; hence lack of uniformity becomes meaningful. There is no difficulty in recognizing that the smudges on the walls of the Temple represent marbling, that is changes in the colour of the object, rather than patches of shadow.

But what of surfaces with shadows cast upon them? How does Giotto ensure that we

21. Giotto, *Meeting of Joachim and Anna at the Golden Gate*. Padua, Scrovegni Chapel.

22. Giotto, *Presentation of the Virgin in the Temple*. Padua, Scrovegni Chapel.

IX. Giotto, *Adoration of the Magi.* Padua, Scrovegni Chapel.

do not mistake shadows for a variation in relief or change in object-colour? We can realize the subtlety of the problem by comparing two passages. First, observe the wall beneath the portico of the Temple in the *Presentation of the Virgin*. Next, observe the area to the left of the High Priest's head in the *Presentation of the Rods* (fig.23). These passages show a comparable gradient of tone, yet there is no doubt that in the Virgin's Presentation we are looking at a flat wall, whereas in the Suitors' it is the concavity of an apse. In each case it is the logic of the total situation that leads us to read the scene correctly. In the Virgin's Presentation the projecting roof is patently the cause of the shadow cast upon the wall. In the Suitors' scene the string-course, rose coloured against the neutral of the wall, defines the curvature of the apse with the clarity of a sectional line. The orientation of the surface being unambiguous, we are able to differentiate between tonal, colouristic and luminary values.

Notice the economy with which Giotto differentiates. The insistence with which he defines orientation varies according to whether he wishes to draw attention to figure or field. The dark area beneath the arch to the left is allowed some ambiguity. Its orientation barely defined, its colour takes on the yielding quality of field, and attention is concentrated on the figure of the Suitor. Here in a shadowy area of field, colour is just beginning to lose its identity with surface. The planarity of classical art depends in part upon this unoriented, unassertive quality of field. Spatially suggestive, rather than definitive, it is a mode of which Giotto showed deepening appreciation as the cycle progressed.

Giotto's pictorial order is founded on constants rather than singularities of visual experience. One constant, stressed in recent studies of the evolution of the visual system, is that in the open air the strongest light generally falls from above because the sky as well as the sun acts as a light source.[7] This light from above acts as a visual counterpart to the pull of gravity, an unconscious means of orientation.[8] Whereas it is well known that Giotto took as his notional source of light in the Scrovegni Chapel the triple window in the façade, the care with which he observed the law that the strongest light falls from above is less often remarked. In the *Presentation of the Rods* it is the cause of the penumbra beneath the roof of the Temple. Throughout the cycle this generalized light from above, as though from the sky rather than from a point source, engenders areas of penumbra and darker shade. In the *Marriage at Cana* (fig.24) the projecting canopies hold their position in space thanks to the shadow they cast upon the walls. It is worth turning back to look at the antecedents of this remarkable feature.

The angle of vision and the direction of light

In discussing Cavallini's mosaics it was argued that an artist cannot describe directional light unless there is a certain explicitness about the orientation of surfaces. By the late Duecento the synthetic view from in front and above, favoured by Byzantine artists, was being abandoned in Italy. A median point of view, which introduced a novel difference between the upper and lower halves of the pictorial field, came into favour: in the lower half forms are viewed from above and in the upper half from below. In the upper reaches of their paintings artists found themselves with the unfamiliar task of rendering the undersides of things.

Antique illusionism offered some solutions to Duecento painters. Before the basis of

X. Giotto, *Christ's Entry into Jerusalem.* Padua, Scrovegni Chapel.

46

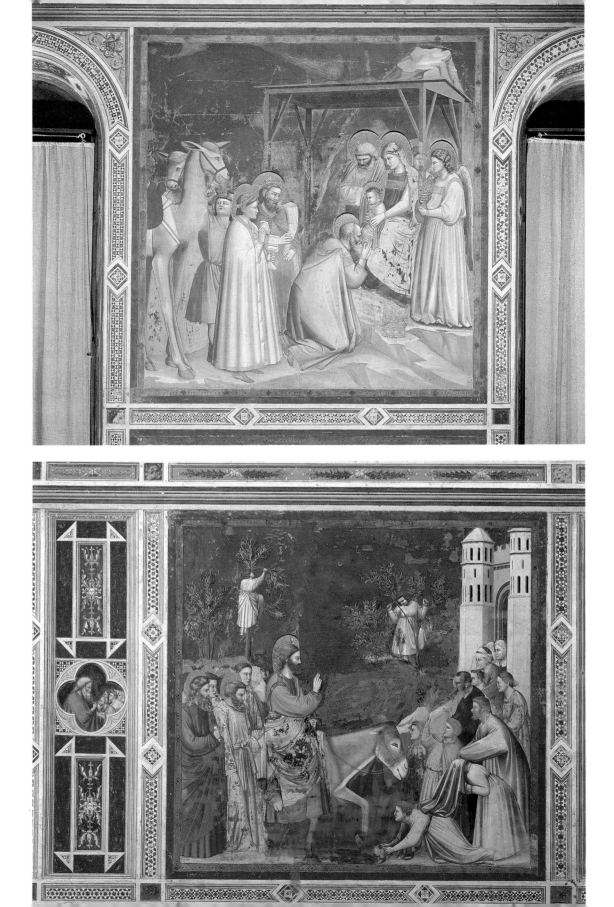

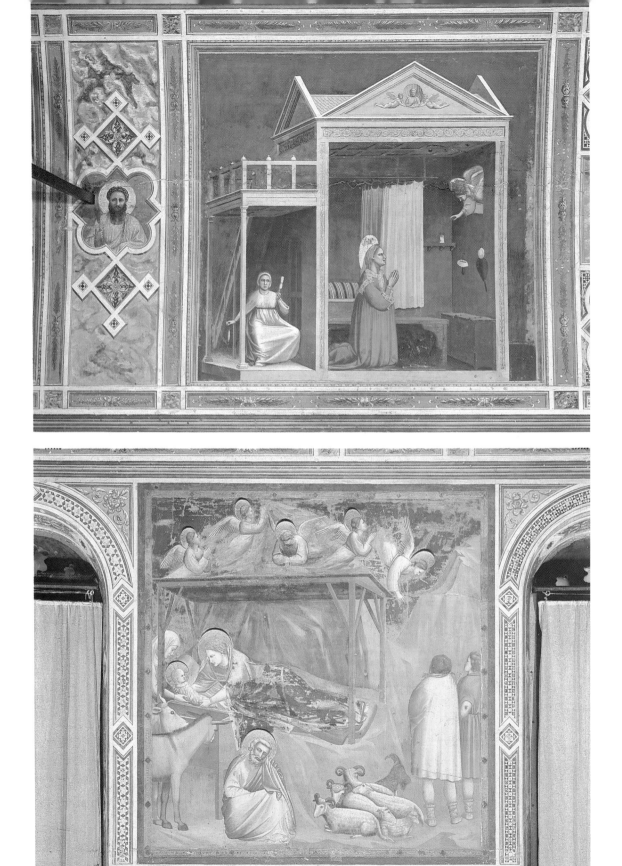

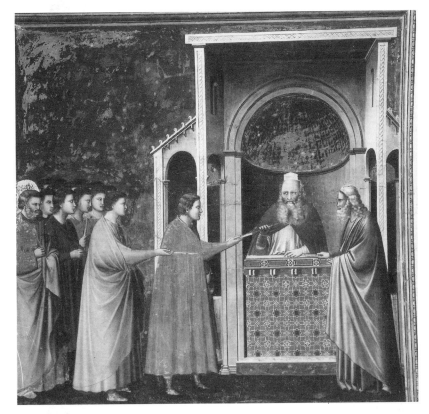

XI. (facing page) Giotto, *Annunciation to St Anne*. Padua, Scrovegni Chapel.

23. Giotto, *Presentation of the Rods by Mary's Suitors*. Padua, Scrovegni Chapel.

24. Giotto, *Marriage at Cana*. Padua, Scrovegni Chapel.

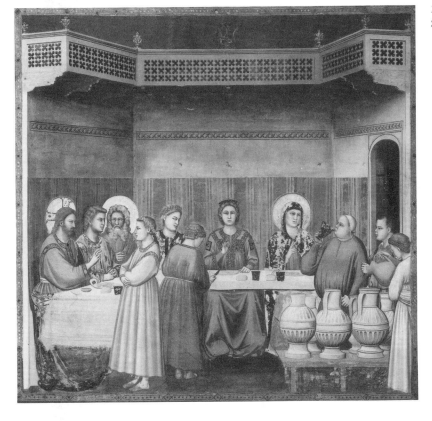

XII. (facing page) Giotto, *Nativity*. Padua, Scrovegni Chapel.

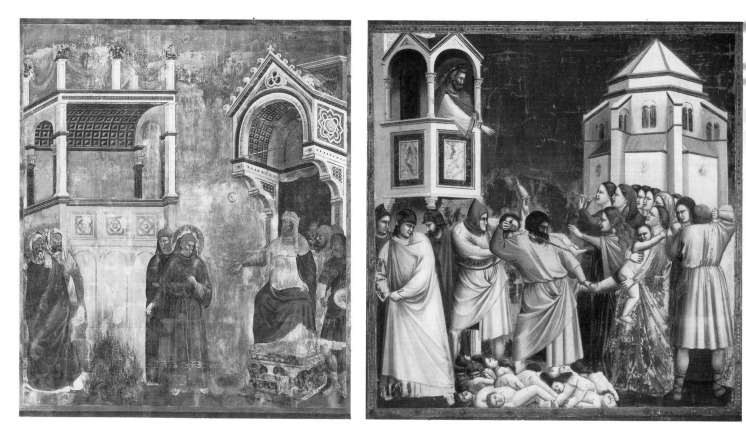

25. St Francis Master, *Trial by Fire*. Assisi, Upper Church of San Francesco.

26. Giotto, *Massacre of the Innocents*. Padua, Scrovegni Chapel.

perspective was grasped, details of undersides with strongly illusionistic pattern, notably coffering, made an impression and were readily copied line for line. Coffering is found in many of the ceilings in the St Francis cycle in the Upper Church at Assisi.[9] Usually rendered in two tones, the pattern reads as light and shade, but the clarity is unchanging and abstract. It does not accommodate directional light or the obscuring of its surface by shade. By its visual insistence it advertises the novelty of seeing beneath the roofs.

Whereas at Assisi such antique derivations are prominent, at Padua there is a general absence of eye-catching motifs such as coffering. The simple panelled ceilings are less forceful in pattern and more receptive of atmospheric values. They allow penumbra to veil them.

Another difference between Assisi and Padua is in the steepness of foreshortening, or, to put it another way, the implied distance of viewpoint.[10] In the St Francis cycle a close viewpoint has the effect of tilting the projecting roofs as if the undersides presented to view slope down towards the rear. In the *Trial by Fire* (fig.25) the soffits of the loggia vault and the arch projecting above the Sultan appear as open to the light as they are open to our view: the potential offered by the view from *below* in showing the obstruction of the fall of light from *above* is missed.

The two architectural properties in the Scrovegni Chapel *Massacre of the Innocents* (fig.26) are described from a more distant viewpoint than those in the Assisi *Trial by Fire*. This distance slows the rate of diminution within the picture – figures in the front

rank are not noticeably larger than those behind – and softens, but never eliminates, the contrast between viewing from above and from below. The more distant viewpoint, by softening steep foreshortening, sets vertical and horizontal surfaces in clearer contrast.

Though the depth of the canopies that project over the loggia in the *Marriage at Cana* is measurable at the sides, it is the shadow they cast down the wall that gives a special amplitude to the space. And notice with what force the view from below underlines the fall of light from above.

Direct or diffused light?

With regard to the clarity with which Cavallini displayed directional light he is the most significant predecessor to Giotto, but there is nothing predictable in the way that Giotto followed Cavallini's lead. It is quite conceivable, for instance, that a follower of Cavallini might have opted for sharper lighting with bolder contrasts between illuminated and shaded surfaces.[11] Giotto did not follow that path.

Cavallini's mosaics give us an inkling that here was an artist who responded to the radiance and order of directional light. There is a bigness of pattern in his narratives which is new. The illuminated surfaces mass together. In the Scrovegni Chapel Giotto did not develop the chromatism of Cavallini's mosaics – the pink tingeing of the lights. Giotto's light is less radiant. Rather, he grasped the constant that the strongest light falls from above. His illumination is a synthesis which blends directional light with the softer focus and firm modelling characteristic of light from the sky. Though it anticipates Leonardo's preference for observing the characteristic relief of forms beneath a sky when the sun is just below the horizon,[12] Giotto's synthesis does not reflect or reproduce a particular observation of nature. It is a pictorial ideal conditioned by innate sympathy for classical form. Nevertheless, anyone familiar with the streets of Florence with their jutting eaves will realize that Giotto's placing of shade beneath such projections was a response to the light and shadow of a familiar townscape.

One point must be added to avoid misunderstanding. Although Giotto modelled as if by light diffused by the sky, he made no attempt to represent the sky as a light source. To match the brightness of the sky with pigments cannot be done,[13] and Giotto did not attempt to find an equivalent for its brightness. His pictorial world is built of surfaces that receive light rather than emit their own. They appear illuminated rather than luminous. In keeping with their architectonic function they are dominated by surface, not film colour. The unmodulated blue of the backgrounds, repeating the symbolic, heavenly blue of the vault, reads as a backdrop that limits the narrative stage. There is no competition between the brightness of illuminated surfaces and the brightness of a non-surface, the sky. *Contre-jour*, that is light shining from behind objects so that they are thrown into silhouette, has yet to be conceived.

The pictorial windows, with the exception of those in the fictive chapels on either side of the chancel arch (fig.27), are not treated as sources of light. The torches in the *Kiss of Judas* (fig.28) hardly shine on the figures, unless you allow the hint of a warmer flesh tone than usual; even though it is a night scene its pitch is harmonized with the other narratives. In *Christ before the High Priests* a torch sheds its pinkish radiance over the walls and the beams of the roof, but the figures are not really lit by it, nor does the

27. Giotto, *Fictive chapel*. Padua, Scrovegni Chapel.

'perspective' of its diminution thicken the atmosphere. Only in the special case of the *Annunciation* (fig.29) (the chapel being dedicated to the Virgin Annunciate as well as the Virgin of Charity) did Giotto darken an interior to dramatize the presence of light. Here, as in the *Baptism*, the rays of symbolic light, once bright with siccative gilding, are, unlike physical light, powerless to reach beyond their visible limits. Except in cases of iconographic necessity, Giotto's wish was to fix attention on the object illuminated rather than the source of light itself. Whereas earlier traditions of modelling tended to conflate cause and effect, source and object illuminated, it was dawning on Giotto that their separation, allowing for that invisible traversing of a gap, was a key to the illusion of space.

The absence of light sources within the scenes, or of any effect approaching *contre-jour*, allows comparison with sculptural relief.[14] In most cases the space is too well defined to resemble the limited but real space of a metope type of high relief, or the more illusory space of pictorial low relief. But in so far as relief sculpture can by its very nature only be illuminated from the front, then there is a real similarity with the Scrovegni frescoes. Just how far Giotto was prepared to envisage a raking light remains within the limits of angle that a relief, or a figure in the round placed against a wall, might be satisfactorily illuminated. No doubt this was a norm adhered to quite unconsciously as Giotto and his assistants stood on the scaffold and brushed their colours on the wet *intonaco* plaster of the chapel wall. The proportion of light to shadow on Giotto's figures is generally two-thirds to one-third, and figures are only very rarely more than two-thirds shaded. If the grisailles of the dado were not evidence enough, the proportion of light to shadow in the modelling tells of Giotto's eye for the revelation of sculptural form by the stable *lume*.

Colour as design and as representation

Giotto dared to abandon the fixed tonal sequence by which shapes had been codified. Interpretation now depends upon the logic of context, and attention is widened beyond the individual patch of colour, whether it be a robe, a wall or a round tower, to include the entirety of the pictorial field. Within this emphatically framed field, the coupled rhythm of point of view and fall of light begins to shape a new pictorial order.

Like Cavallini, Giotto sensed that spatial and luminary values are mutually dependent. To realize them in the service of narrative demanded restraint in the handling of colour. In summarizing those aspects of Giotto's colour indicative of a move away from the norms of the *maniera greca* towards purposeful restraint, some points will be familiar from the discussion of Cavallini, others are particular to Giotto.

Like Cavallini, Giotto increased the proportion of the lights, particularly in the modelling of figures, so that they constitute a broader mass than the linear highlight. Aware of the technical inadvisability of using white lead on walls, where it will oxidize and turn black, he accepted the comparative dullness of lime white (Cennini's *bianco San Giovanni*). Rarely do his highlights reach pure white, instead he retained a pale suffusion of the local colour.

The number of near neutral and pale colours in which slight tonal gradients are as telling as shadows on an eggshell is increased. This is evident in the range of slate blues and ashen purples in the *Adoration of the Magi* (col.pl.IX), where one also notes distinc-

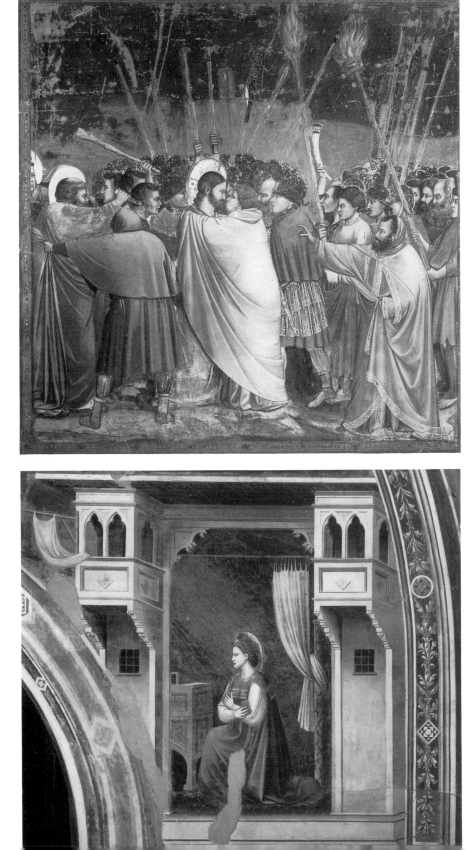

28. Giotto, *Kiss of Judas*. Padua, Scrovegni Chapel.

29. Giotto, *Virgin Annunciate*. Padua, Scrovegni Chapel.

tion between two whites: the cloak of the foreground king creamy white with brownish shading and the angel's vestment with shading of bluish-grey. Similar contrasts of a bluish-grey white and an oatmeal white are found throughout the cycle.

The units of colours are enlarged, mainly by eliminating subdivisions. Thus the majority of figures are clad in a single colour, either because only one garment is visible, or because robe and vestment are of the same colour. This colouristic unity, which must have streamlined the execution of the scenes in *buon fresco*, is a distinguishing mark of Giotto. A colour chord, struck by robe and vestment, accentuates the principals. Christ and his Mother are dressed in red vestments and blue robes, which are embellished with gold hems; apart from this there is hardly any patterning of drapery. In the *Crucifixion* (fig.30) the wings of the mourning angels are the same hues, rose or green, as their vestments. Strident patterns, rainbow wings, tartan gowns, chequerboard inlays, are virtually banished from the narratives. In contrast to earlier practice, the St Francis altarpiece in the Bardi Chapel for example, integrity of form is now matched by unity of hue.

While pattern is almost banished from the narratives, the borders are chequered with cosmatesque inlay, and there are strong contrasts between the panels of dark marbling and the surrounds of pale stone. The sharp contours produce the impression of a hard, well-defined surface. In the context of the borders our first variable, orientation, takes care of itself, since the situation allows the assumption that the major surfaces lie parallel to the plane of the wall. So why is there this discrepancy: pattern in the borders, renunciation of pattern in the narratives? Why is the gate of Jerusalem (col.pl.X) not adorned with precious stones? The answer is surely that in the narratives Giotto wanted to avoid any changes of tone that might confuse those that indicate orientation. And what goes for architecture is also true for draperies, though here other factors come into play. The blurred transitions of the modelling, indicative of the rough texture of cloth, are reinforced by comparison with the sharp demarcations of colour in the cosmatesque inlay in the borders. And it is a commonplace of studies of perception that fuzziness favours interpretation in terms of a change in illumination rather than in object-colour.[15] Thus on Giotto's draperies we may perceive constancy of colour underlying changes of tone. In short, we can discriminate between object-colours and luminary values.

Mention of the phenomenon of colour constancy is a reminder of the role that memory plays in helping us to discriminate between the illumination and the colour of surfaces. In the St Francis altarpiece in the Bardi Chapel the choice of many of the colours is so capricious that it hardly occurs to us to associate them with the specific colours of things seen and remembered. Now it is precisely the introduction of colours with fixed material associations that lends stability to our perceptions. Perhaps in reaction to the nineteenth-century view of art as imitation, recent studies of Renaissance colour have all but ignored the importance of material association.[16]

Few of Giotto's drapery colours convey the nature of the material by virtue of their colour alone since the colour is rarely that of the raw fabric; thus although the colour is descriptive it is not necessarily imitative. It may be changed according to aesthetic choice without detriment to its descriptive value. The greys of the donkey in the *Entry into Jerusalem*, on the other hand, cannot be changed. In the fresco of the *Last Supper*

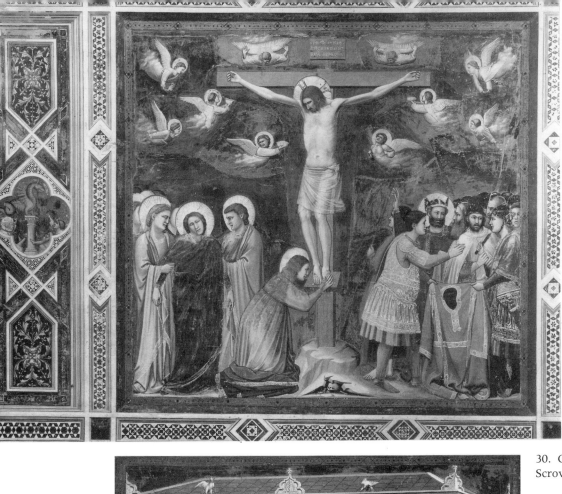

30. Giotto, *Crucifixion*. Padua, Scrovegni Chapel.

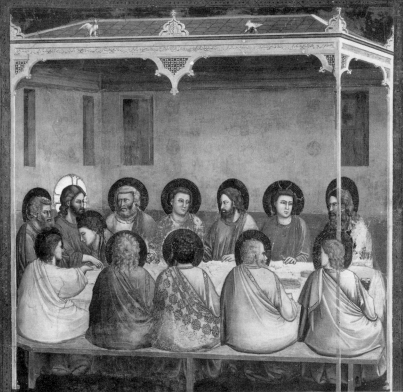

31. Giotto, *Last Supper*. Padua, Scrovegni Chapel.

(fig.31) we recognize that the roof of the building is covered with tiles more or less the natural colour of baked clay. We recognize also that the brown colour of the bench supporting the Apostles represents wood, and the expectation that the entire bench will be made of the same wood prompts us to read the changes of tone as caused by light and shadow rather than by differences in the material of the bench. Though such colours with material connotations may not be conspicuous, Giotto introduces them with care. When colours are chosen without much regard for material associations, as at times they are in the late Trecento, the painter may fail to convey either constancy of object-colour or consistency of illumination. The gravity of Giotto, the solidity of his forms, is due not only to superlative draughtsmanship and modelling but also to a certain density conveyed by the material associations of colour. Giotto's colour is by no means skin deep.

The features of Italian society touched upon in the closing paragraphs of chapter one have some bearing upon this new sense of colour as descriptive of the stuff of quotidian reality. We should not underestimate the sumptuousness of the Scrovegni Chapel; indeed, it provoked jealous complaint from the neighbouring Augustinians at the Eremitani. But it is a sumptuousness that is rigorously controlled. The extraordinary finesse and truth with which the fictive marbles of the dado are executed witness to the care of the painter, and, I think we may presume, the appreciation of the patron, for the colours of material things. If marbling leaves latitude for invention and fancy, the same cannot be said for the model of the chapel presented by Enrico Scrovegni in the *Last Judgement* (figs.32 & 33). Here we see not only accuracy of proportions, but fidelity to the colours of brick, marble and tile. Reality is accepted as sufficient in itself, without need of prettifying or embellishment.

32. Giotto, *Last Judgement*. Padua, Scrovegni Chapel.

The colour of flesh

Whatever the material connotations of colours, local colour is subservient to the demands of modelling. This is true of the faces of Giotto's figures. We have become so accustomed to Giotto's faces, to the softness of their modelling and the suggestiveness of their expressions, that we accept them as more naturalistic than is the case. In fact they follow a convention which only approximates to a limited area of experience of how faces appear.

If you stand in the Scrovegni Chapel and compare the faces of visitors with the faces in the frescoes, it is noticeable that the local colours of the real faces, especially the darks of the eyebrows, eyelashes and hair, the whites of the eyes, and the red of the lips, tell more strongly than gradations of tone due to light and shade. In the frescoed faces, Joseph's in the *Nativity* (fig.34) for instance, the colour of the features merges with the modelling: Joseph's eyebrows are not distinguished from the shadows beneath them and there is no red upon his lips. Only if the light in the chapel is dim do the faces of visitors appear at all like those in the frescoes.

In the *maniera greca* there existed an even closer identification of the shape and colour of facial features with the armature of modelling than in Giotto. Frequently the dark line of an eyebrow is continued unbroken as a relieving shadow to the nose (something like this can be seen on the St Francis in the Bardi Chapel altarpiece, though there is already some softening). In the late thirteenth century a number of artists – notably

Cavallini and the Isaac Master in the Upper Church at Assisi – started to naturalize Byzantine canons of proportion and to introduce softer, less linear modelling. The faces underwent three changes: their proportions and subdivisions became less stereotyped and less geometrically regular; the darks, whether indicative of a feature, such as an eyebrow, or of shading, became less heavy and insistent; and the lights and darks were blended more smoothly together.

Giotto developed these transformations, but if a head by Giotto (fig.35) is compared with one of the portraits in a wax medium from Roman Egypt, discussed in the first chapter, it is apparent that only the first of these changes represents an unequivocal gain in naturalism. On Giotto's faces the local colour of the features is never as pronounced as in the Egyptian portraits. The flesh is paler, less positive in hue, therefore less easily distinguished from the highlights. It is the shadows that must take on the role of relieving the broad lights. But the edge between light and shadow is neither so sharp in contrast nor so animated by jagged handling of paint as in the Egyptian portraits. On the Egyptian heads, cast shadows overlap attached shadows: nose and brow actually *cast* shadows onto cheek and eyelids. This is not the case on Giotto's heads. The colours of the features are softened or veiled by the modelling. And the lights on Giotto's faces do not express the slight moistness of skin that is apparent from a close vantage. By contrast, in the Egyptian portraits the play of lustre creates intimacy, and adds to every face a spark of individuality.

Why, in the case of Giotto's description of facial features, is local colour subservient to modelling? One answer seems to lie in the nature of the narratives which, typically, involve several figures interacting amongst themselves rather than directly with the spectator. Unlike when confronted by the Egyptian portraits, the spectator is invited to observe the story – and to *follow* it from one scene to the next – rather than to communicate with the figures. Even Christ in the *Last Judgement* looks down at the blessed (and perhaps at Enrico Scrovegni) rather than at us standing in the chapel. The modelling of the faces is, one might say, democratic; light falls on each and every one; as it softens features with its broad highlights and gentle shadows so it affirms the human community within the narrative. One further advantage of Giotto's soft-focus modelling should be underlined. It allows the visible parts of the body – usually head and hands – to appear at one with the draped figure: the same broad lights and blurred edges of shadow give shape to the rotundities of cloth and flesh. Thanks to this generalized modelling we apprehend the physical and spiritual integrity of each human being. Such modelling affects us as ontological metaphor.

I have dwelt upon Giotto's convention because it dominated central Italian painting into the fifteenth century and was revived in the High Renaissance. Integrity of form, visible sign of integrity of being and vitality of spirit, was crucial to the Italian tradition. Our familiarity with the conventions of Giotto's faces accounts for shock of Piero della Francesca's heads, where, for almost the first time in Italian painting, the darks of hair and eyebrows stand forth independent of the modelling in light and shade.

Interior and exterior

It should never be forgotten that Giotto *used* colour and tone rather than describing them. He employed colour and light: he did not copy specific instances of things seen.

35. Giotto, *Head of Christ in Judgement* (detail of fig.32).

58

It is true that I have argued that Giotto was attentive to the colours of material things as a clue to establishing their enduring identity, and certainly the referential function of colour within narrative imposed novel constraints, but it would be quite wrong to suppose that colour as reference monopolized the whole realm of colour as sense. What was important was that colour did not deny or undermine descriptive reference (i.e. colour as a reasonably stable characteristic of the thing described). Thus in Giotto's frescoes the materials of buildings – whether marble, brick or tile – are not contradicted by their colours, and the same goes for the flesh and hair of human beings. In the case of humans the fact that we are familiar with a wide gamut of pigmentation affords the painter an unusual latitude before plausibility is strained; so Giotto could subdue or even subsume the local colouring of his faces in his modelling while doing little damage to the referential value of colour.

The question of the referential status of colour and light may be pursued by examining how Giotto distinguished interior from exterior scenes. In the *Annunciation to St Anne* (col.pl.XI) the two spaces of Anne's house – porch and bedchamber – are visible according to different conventions: we see the spinner beneath the porch just as we would be able to see her if we stood outside such a building, while we see into Anne's bedroom only thanks to the convention of leaving a wall unrepresented. That Giotto was fully conscious of the 'wall lifted off' convention he was using is indicated by differentiations in the modelling, for whereas the pale threshold of the porch darkens to green shadows at the rear, there is no such transition on the dark brown floor of Anne's bedroom.[17] Evidently the porch is as open to the fall of light as it is open to our view. The bedroom is not.

Though Anne's room is evidently not illuminated through the aperture by which we view it, neither is it illuminated explicitly by the single window at which the angel makes his entry. The lighting of the room is generalized in conformity with the rest of the cycle, and yet it does convey an elementary impression of interior light. The top third of its walls are shaded in penumbra, the lower two-thirds illuminated, the hue of shadowy green softening the distinction. Giotto enlivens this green room with reds, oranges and ochres: plum for the chest on the right, deep ochre for Anne, brown-ochre for the bench and orange for the bed. Nowhere do highlights totally bleach colour. Whether in shadow or in light, it is colour that tells. Yet every colour is modulated by light. The lid of the *cassone* is orange-ochre, its sides plum: the colour of the lid denotes the material, wood, and at the same time indicates the stronger light falling upon it – for here, as everywhere, the strongest light falls from above. Contrasts of hue distinguish objects and materials; modulations of colour by chiaroscuro create associations. The ochre of Anne's robe deepens in the shadow towards the brown of the bench – just one of Giotto's colouristic affirmations that Anne belongs within this chamber. Contrasts of hue are accommodated within this scheme of modulations, and opposites are balanced in harmony. Red complements green; red and green mixed give brown. The reds and ochres stand firm upon the dark brown floor, existing within an ambient of green. In this setting, white and pale grey mark the diagonal of interest that leads from the hands and face of St Anne through the caesura of the hanging curtain to the out-stretched hand of the angel. The accents which guide our attention are not imposed by selective directing of the light, as they might be in the Baroque, but by the selective

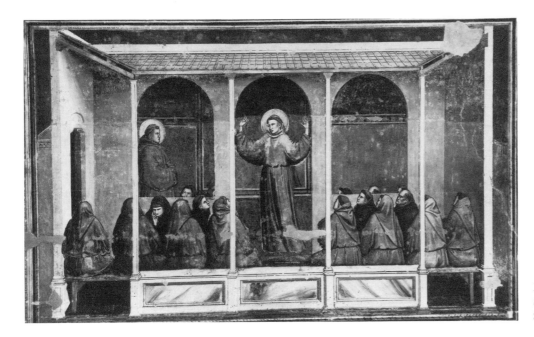

36. Giotto, *Apparition of St Francis to the Chapter at Arles*. Florence, Santa Croce, Bardi Chapel.

placing of pale object-colours. There are no dramatic light effects and the sacred story unfolds, as usual in Giotto, with minimal disturbance to natural appearances.

It may be added that the difference between the porch and Anne's room implies that Giotto was aware of the artificiality of the so-called foreshortened-frontal architectural perspective. Only four examples occur in the Scrovegni Chapel.[18] Later Giotto preferred an oblique view in which the 'invisible wall' is not aligned with the picture plane. In the *Apparition of St Francis to the Chapter at Arles* (fig.36), in the Bardi Chapel, Giotto placed the portico frontally, but indicated by the shadows cast by the roof on the left that the aperture through which we view the scene is integral to the architecture and not an 'invisible wall'. Thus the realism with which Giotto described light and, more especially, shadow in an interior depended upon the status of the pictorial architecture.

The fresco medium and the new techniques of modelling

For reasons discussed in the first chapter, it is unlikely that a change from highlights suggestive of lustre to a system of tonal modelling would have been initiated in panel painting. In Tuscany there is scant evidence of a flourishing early tradition of mural painting – although as an argument based on survival this must be treated with caution. In Rome Early Christian models existed and it is there that we find evidence of the development of *buon fresco*, that is painting directly on small patches of plaster while they are still wet. These patches, which can be mapped along the hairline joins, are known as *giornate*, from the Italian *giorno*, meaning 'day'. This *giornata* technique was probably brought to Assisi by Roman-trained artists in the last two decades of the thirteenth century.[19] While there is no evidence that Giotto played a formative role in the invention of *buon fresco*, his decoration of the Scrovegni Chapel, datable between 1303 and 1306, shows profound understanding of the inherent qualities of the medium.[20]

The first stage in the execution of a fresco consists in covering the masonry of the wall with a layer of coarse plaster known as *arriccio*. Onto this plaster the painter may

61

outline his composition, first with charcoal, and then with the auburn pigment sinoper. Cennini describes how elaborate chiaroscuro designs may be worked up on the *arriccio*,[21] but there is no sign that Giotto drew *sinopie* (as the sinoper drawings are called) with modelling. Before each day's work was begun a patch of fine plaster, known as *intonaco*, was laid over the *arriccio*. This *giornata* patch obviously covered the underdrawing in the relevant area, and although the painter probably repeated the outlines quickly on the fresh plaster before he forgot them, this was surely one reason why labouring over complex *sinopie* was a waste of time. Such a separation, by virtue of the structure of the frescoed wall, of the preliminary design in simple outline from the painterly execution of both modelling and colour surely encouraged that simple legibility of outline that is a hallmark of Giotto's style and one that tends to contain chiaroscuro, however strongly developed, within the boundaries of form. It was also one of the roots of Vasari's separation of *disegno* from *colore*.

True fresco demands forethought and decisive execution. Once the *intonaco* is dry the pigments are bonded with it and mistakes can only be rectified by chipping away and applying a fresh layer of plaster, which is time consuming, or by overlaying pigments on the dry plaster (*secco*) by means of a mordant, which is far less durable than true fresco. So, except where additions are made *a secco*, colour and tone are fixed once and for all during a single day's painting. The painter has to consider the gradations of his tones right from the start and also has to make allowance for the effect of drying. On lime plaster this generally produces a lightening of the colours.

In traditional wall painting, before the introduction of *buon fresco,* pigments which had been tempered with lime water or with size were usually applied in several coats. Theophilus instructs on varying the colour of the underpainting according to what will be the final colour, usually reserving the most expensive pigments for the final coat.[22] And in true fresco also, a certain density of pigment must be built up to give force to the colour: Cennini recommends laying two or three coats of each colour.[23]

The important point to notice is that this build up of layers is not the same as traditional modelling in manuscripts and panels by superimposing lights and darks over a laying-in colour. Cennini is referring to uniform coats over an entire area of colour. In true fresco these are all applied while the plaster is still wet, and the layers are never completely opaque. Lime white (*bianco San Giovanni*) certainly does not have the hiding power of lead white. In the area of the heads, Giotto, in common with all fresco painters, worked on smaller *giornate* so that the complex modelling of the face could be completed while the plaster was still wet. After casting aspersions on an easy method of laying in a face with a flesh colour and simply modelling it with *verdaccio* (a drab green earth) and highlights, Cennini describes a much more painstaking method – purporting to stem from Giotto – of blending one flesh colour into another.[24]

As far as draperies were concerned most pigments were modulated by the addition of lime white and graded into a sequence of up to seven dishes by a simple control of quantities. Any dish could be replenished by mixing the same proportion of colour to lime white as used before. By keeping a check on which dish was used for a given area of tone, the fresco painter could anticipate the effect of drying and ensure consistency between one *giornata* and the next. Such a system was most easily controlled where the mixtures of pigments were simple. Teamwork was essential in big fresco projects,

and it helped the master greatly that precise gradations of colours could be prepared to specification. What was lost in variety of nuance was gained in consistency of tone. The control of the dish system, as described by Cennini, would have allowed the master to delegate areas of painting confident that the same sequence of tones could be used as he might have already demonstrated in a completed scene of the cycle.

In the Scrovegni Chapel the final tone of a drapery must have been anticipated when the first layer of colour was brushed into the wet *intonaco*. Whatever modifications were achieved by subsequent overlaying, the colours retained a degree of luminosity owing to the influence of the pale ground of plaster. To avoid the loss of transparency and deadening of too many layers, Giotto must first have calculated in advance the position of lights and darks on the figure and, second, have exercised great control over the gradations of colours in the dishes. In the case of the expensive pigment lapis lazuli, used by Giotto for the robes of Christ and the Madonna, it was preferable to apply it *a secco*, probably with a size medium, rather than to allow contact with the wet lime plaster to dull its beautiful depth of blue. In the *Nativity* (col.pl.XIII) the Madonna's cloak was laid in with an underpainting in reddish brown with strong lights where the plaster is untouched. A uniform coat of lapis lazuli was brushed over this after the plaster had dried. The red of the underpaint lends the blue a much-prized violet tinge and the lights in the underpainting give a minimum of modelling to the final blue without detracting from the intensity of colour. This is modelling from below, exploiting differentiation in the underpaint, rather than modelling from above by superimposition of lights and darks.

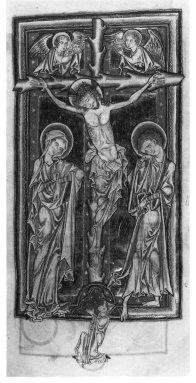

A parallel to this reversal of the techniques of *matizando* and *incidendo* can be found in manuscript illumination. During the thirteenth century in northern Europe changes took place in manuscript illumination that are not reflected in the treatises on colour. The painters of the full colour miniature adopted some of the techniques of the less highly worked form of illumination, the tinted drawing. In the *Crucifixion* (fig.37) from the Evesham Psalter, for example, the bare parchment provides a common light tone. From the mid-thirteenth century increasing use is made of the ground of the illumination. Gradation is achieved by diluting the pigments and by allowing the white of the page, or of a preliminary preparation, to tell in the lights. And a new range of neutral tints – greys, beige and dull rose – are employed in thin and subtle gradations. As is usual, artists striving to achieve smoother, more continuous modelling discovered the value of subdued or near-neutral colours.

The chains of influence are still largely mysterious, yet in their diverse media Giotto and the Gothic illuminators of the north were exploring a new conception of modelling. In the works of the Parisian illuminator Master Honoré and in those of Giotto the broad lights are not superimposed, but belong to the groundswell of the forms.[25] Surface is consolidated, not broken up, by modelling, and the breadth of the forms is reconciled with the extensiveness of space. In Master Honoré the luminosity of the ground is stronger than in Giotto, but in his attitude to colour, light and modelling Giotto has more in common with the northern illuminator than with the painter of the altarpiece of St Francis in the Bardi Chapel.

37. English mid-thirteenth-century, *Crucifixion* from the Evesham Psalter. London, British Library, Add. MS.44874,f.6.

IV. GIOTTO AND THE STUDENTS OF OPTICS: BACON, PECHAM AND WITELO

The purpose of this chapter is to offer a conspectus of the scientific opinions regarding vision, light and colour that were current during Giotto's lifetime. This may be a misleading undertaking, for it must be admitted that it is unlikely that Giotto, or any other painter, sat down to read the texts I shall be citing. However, if Giotto's descriptions of light discriminate in ways that earlier painters' did not, it does seem worth asking whether such discriminations had been made by intellects in other fields. Even if no causal relationship can be established between the texts and fourteenth-century paintings, they may help to delimit the boundary of theoretical knowledge within which even the most intellectual painter would be working. It should also be borne in mind that the writers cited retained their authority right down to the period of Leonardo. The following sections, then, broach subjects of wider reference than the painting of Giotto, and the collection of texts will furnish a corpus to be drawn on in later discussions.

Optics and the papal court

Between 1260 and 1280 three major textbooks on optics were written. The first was Part V, the *Perspectivae*, of Roger Bacon's *Opus maius*, to which may be added his short treatise *De multiplicatio specierum*. Next came the *Perspectiva* of Witelo; and finally John Pecham's *Perspectiva communis*.[1]

What is interesting to students of Early Italian painting is that all these treatises can be connected with the papal court at Viterbo. Bacon sent his *Opus maius* there to his acquaintance Pope Clement IV (1265–8). Witelo travelled to Viterbo in person, and probably arrived in 1270. He dedicated his *Pespectiva* to the then papal confessor, William of Moerbeke. It is most likely, according to David Lindberg, that he wrote his treatise between 1270 and 1273. Finally, in 1277 Pecham arrived at the papal court, which was then still resident in Viterbo, and spent the following two years partly in Viterbo and partly in Rome; and it was probably during this time that he composed his *Perspectiva communis*.

The confluence at the papal court of these treatises at the moment of the revival of monumental painting in Rome under the patronage of Nicholas III (1277–80) is striking. The new confidence with which the Roman artists tackled the projection of three-dimensional form on a flat surface reveals an understanding of the relationship be-

tween vision and geometry such as we find in the writings of Bacon, Pecham and Witelo. Quite apart from the likelihood of Giotto having spent an early period in Rome, it may not be fortuitous that he coped with the geometry of perspective with new sureness in Padua, a city which was showing a strongly Aristotelian bent in the studies of its university. Witelo almost certainly sojourned in Padua before travelling to Viterbo.[2] A chair of medicine existed in Padua from at least 1262, and Arab writers on the physiology of vision, such as Avicenna, were studied there in Latin translation.[3] In about 1305, when Giotto was at work in the Scrovegni Chapel, Pietro d'Abano began lecturing in Padua in subjects such as philosophy and medicine. Pietro's commentaries, though not strikingly original, contain discussion of colour, light and the geometry of vision.[4]

Direct and diffused light: 'lux primaria et lux secundaria'

In addition to discriminating between *lux, lumen, color* and *splendor*, the writers on optics distinguish between direct and diffused light:

> Solar light emanates in two ways: by radiating directly – this is called primary light – and also by radiating indirectly in every direction outside the rays. By means of the latter, when the sun is situated over the horizon, a house is full of light, even though no solar rays enter it; and this is called secondary or accidental light.[5]

Pecham goes on to observe:

> Although an opaque object impedes the direct and principal propagation of light, it does not impede the secondary propagation which proceeds circumferentially.[6]

Roger Bacon employs the same image of an interior illuminated by indirect light and stresses the utility of this 'accidental' multiplication of light. Then, more strangely, he comments:

> Moreover, the bodies of mortals would not be able to be exposed always to principal species (the image-bearing rays) without destruction, and for this reason God has tempered all things by means of accidental species of this kind.[7]

Physiological and metaphorical notions combine here. What must be emphasized is that the direct light of the sun or another powerful source and indirect or diffused light are distinguished in both their physical nature and their spiritual import. The art historian's eagerness to spot cast shadows, taking their presence or absence as sole criteria of a painter's attentiveness to light, hardly does justice to the reality of diffused light.

Giotto describes areas of shade with an indistinct penumbra, particularly beneath canopies and roofs where the light from above is obstructed, but he does not delineate precise cast shadows. I do not believe that the reason for the absence of cast shadows in Early Italian painting is to be explained by the treatises on optics, but a brief survey of what they observe on the subject suggests a degree of ambivalence.

Bacon and Pecham describe how the projection of a shadow varies according to the size of the illuminant relative to the size of the object.[8] Pecham also points out that a single object will cast several shadows when illuminated by several sources:

If a stylus is placed in the midst of several candles it will cast as many shadows as there are candles... The same thing is also evident in the case of secondary light for if secondary light should enter through openings near each other and oblique relative to one another in the two walls of a single corner, and if a stylus should be erected at the intersection of those lights, an observer would see several shadows.[9]

The explicitness of cast shadow is mitigated in Pecham's view by two factors. The first is the circumfusion or bending of diffused light around an object. The second is the metaphysical notion that, 'Every body is susceptible to celestial influence, it is certain that no body lacks transparency altogether... Therefore no density completely prohibits the propagation of powers and species.'[10] It was in line with this that the souls Dante encountered in Purgatory cast no shadow.

Brightness and transparency distinguished

Before the late thirteenth century there existed a long-standing confusion between transparency or perspicuity, on the one hand, and luminosity or brightness on the other. *Clarus* was used to mean bright, as of a fire, transparent or translucent, and clean, free of impurities, unblemished.[11] Such confounding of transparency and luminosity was to some extent deliberate, since, as we have seen, it was held that the more a body was penetrated by light, the more it was transfigured by the divine *claritas* and the less it shared in dull, opaque matter.

It was Roger Bacon who cut through the muddle and made the crucial distinction between transparent air and solid bodies which 'terminate vision'. In discussing whether the heavenly spheres of fire and of the seven planets are bright or whether they are transparent, he argues:

Since... rare and transparent bodies permit the passage of species, like the air, and since the species of the eye and of the stars pass through the sphere of fire, and through the medium of all the orbits of the seven planets, these media must of necessity be rare and transparent, and it is clear that they do not limit vision. Therefore they are not dense. Therefore they are invisible, because that only is visible... which can terminate vision, and this is a fact. But if they are not visible, they are non-luminous, because what is luminous is visible. I am speaking of a luminous body with a fixed light belonging to it and not one passing through it... I am not speaking of a body that receives light passing through it, as the air, which Aristotle calls luminous (*lucidum*): this is an equivocal use of the word. Therefore they make a mistake who judge that the sphere of fire is naturally luminous, especially since it is rarer than air, and therefore less visible, and on this account less fitted for light, because density is a cause of illumination.[12]

Without wishing to posit any direct causal relationship, I believe this text offers an intellectual precedent to formal aspects in Giotto. In Giotto's paintings the light and shade on the surface of objects are a fixed boundary in space; the light displayed on the surface is the only light that is visible; the air transmits light but is not luminous. The light revealed upon the surface differentiates solid from void. Compared with earlier painters–except Cavallini–Giotto accentuates the contrast of solid and void. He increases

the breadth of intervals between objects. These intervals are spanned and brought to life by the directional light displayed on the surfaces that terminate vision. From this modelling we intuit air traversed by light: dense bodies and transparent medium stand revealed.

The perception of colour

Thirteenth-century students of optics were ignorant of the rods and cones in the retina and how they mediate daytime and night-time vision, but they were naturally aware that the colours of bodies are not fixed and unchanging, and that, in Pecham's words, they 'appear varied according to the lights shining upon them'. He adds that 'this is clearly evident in certain colours that appear cloudy in a moderate light, but clear and brilliant in an intense light; in fact, their appearance in sunlight is wholly different from that in candlelight. Furthermore all coloured things are deprived of the customary beauty of their colour during a solar eclipse.'[13]

The reasoning faculty must sort out the mutable colours of objects. Witelo points out that to perceive the difference between two whites requires the use of reason to make comparisons.[14] Pecham distinguishes between the immediate perception of colour as colour and light as light and the discerning of the exact character or *quidditas* of an individual colour or light. If a coloured object is removed from light and placed in shadow it still appears coloured, Pecham observes, but for knowledge of its precise hue we depend upon experience, memory and reasoning. With experience we learn to discriminate between different kinds of light, such as sunlight, moonlight and firelight, and to recognize the same colours in different situations.[15] By this means stability is preserved.

Slightly aside from the mainstream of their argument, Bacon and Witelo record a rather painterly observation. If you look, Bacon writes, at a uniformly coloured body through a mesh of multicoloured cloth, when the holes in the cloth are big you will be able to distinguish the colour of the body behind as it really is, but if the mesh is fine the colour of the body behind will tint the colour of the cloth without being separately distinguishable.[16]

As for the nature of different hues, our treatises repeat Aristotle's misleading opinion that they arise out of mixtures of light and darkness. The failure to distinguish between hue (the place of a colour on the spectrum) and value (its tone in terms of light and dark) confounds their attempts to explain the rainbow.[17]

Mediaeval art used contrasting colour chords to brilliant effect, but the law of colour complementaries had yet to be defined. Although Aristotle had mentioned that contrasting colours enhance one another, there is little discussion of the topic in the thirteenth century. Actually it is strange that a scientific definition of complementaries was not hit upon, since both Bacon and Pecham studied after-images. 'If the eye after being directed with fixed gaze on a bright colour illuminated by an intense light is turned aside to a colour illuminated more weakly, it will find that the first and second colours appear intermixed because traces of the aforeseen have been left behind in the eye.'[18] Pecham, however, is inaccurate here since it would normally be the complementary of the first colour that would be seen. (This can be tested by staring at a tangerine, then looking at a white wall: a green circle will appear for a moment.)

Distance, colour and light

I pointed out in the first chapter that the writers on optics were anxious to establish the degrees of reliability of vision. The effect of distance on the certainty of vision was an important issue. Pecham writes:

> Only moderate distances are certifiable to sight, and those by means of continuous and intervening bodies.
>
> The distance to the visible object is not perceived by sight, but is determined by reasoning.
>
> The perception of the magnitude of a distance derives from the magnitude of the

38. Giotto, *Flight into Egypt*. Padua, Scrovegni Chapel.

intervening bodies. For example, clouds over flat land seem to be attached to the sky; over mountainous land they seem to be near the earth because they nowhere exceed the height of the mountains. Therefore certification of the distance from the observer to the clouds derives from the perception of the intervening bodies; if the intervening bodies are not well ordered but confused, the understanding will be incapable of certifying the magnitude.

And Pecham also notes that the measurements of objects must be familiar if they are to resolve the dimensions of space.[19]

The contents of space as the yardstick of its dimensions is comparable to the method of Giotto. The vagueness of immeasurable distance has little place in the ordered world of his frescoes. But one aspect of distance is peculiar.

In the *Flight into Egypt* (fig.38) the further objects, in this case the distant hills, are not so brightly lit as those in the foreground.[20] This conforms to a common pictorial convention, which originated no doubt as a means of giving relief. No connection between this and anything the writers on optics have to say is likely, yet at least it may be noted that there is nothing in the treatises to gainsay the convention, nothing that would have nudged a painter to describe *bright* distances or any effect of *contre-jour*. It could only be deduced from their proposition that the further a ray had to travel from the object to the eye the weaker it became; and weakening, in their view, could only lead to darkening. Therefore objects near to the eye – or in the foreground of pictorial space – should be more brightly lit.

Confusion may have been bred by the geometrical model applied to vision. The visual rays which link eye and object were identified, quite rightly, with rays of light. This network of rays was described as a pyramid, with its apex in the eye and its base spread over the surfaces that terminate vision. Such a figure is easily comprehended, yet its very simplicity and its subject-centredness – the eye as its apex – pre-empts any geometrical model for that other network of rays, namely between the source of light and the surfaces illuminated. When reading Bacon, Pecham and Witelo, we might be forgiven for supposing that the visual rays are the *only* rays of light traversing a particular ambient. In fact they state that this is not the case, but the conceptual purchase of the pyramid of vision (in contrast to Bacon's doctrine of species radiating in all directions, which demanded a mind as subtle as Leonardo's to be comprehended) led them to expostulate as though the position of the source of light were identical with the apex of the pyramid, in short, identical with the observer's eye. Plato's theory of the eye emitting its own light, although refuted by the great Islamic authority Alhazen, could not be scotched. It accorded so neatly with the pyramid of vision that even Alberti did not quite feel confident to deny it.[21]

Thus the pyramidal model of vision implied that shadows normally fall behind objects, moving away in the same direction as the lines of sight. In one passage, Roger Bacon describes the accumulation of shadows behind whatever is visible:

We should know that Ptolemy says that in the second book of the Perspective that we see the air or the celestial transparent body far off and within a considerable distance although not within a distance near at hand; for much of a transparent body

69

is accumulated in a great distance and has the same effect on vision as that which is perfectly dense within a small distance. Much, therefore, of a transparent object accumulated in a great distance becomes shaded, just as we see in the case of deep water, when we cannot see the ground through it as we can through shallow water. For the parts of deep water cast forward a shadow on those that succeed them, and a darkness is produced that absorbs the quality of rarity, so that in this way the whole body of water appears like some dense body, and the same is true of the air or celestial transparent medium at a distance, for which reason it is rendered visible, but not so at a close range.[22]

In reality light reflected by distant objects is scattered by the atmosphere between the object and the eye. Within a particular field of vision the intensities of individual areas may be reduced while the total quantity of light reaching the eye remains the same. The scattering of rays may not involve a loss of light so much as a spreading of light. Brilliant whites tend to occur close to the eye, but distance has a greater effect on the tone of dark colours than of pale ones.

The writers on *perspectiva* thought of this scattering in terms of the single rays between object and eye. Obstruction of these rays meant weakening. Weakening caused loss of vision, and loss of vision could only mean darkening. What they overlooked, and Alberti followed them in this, was that refraction by the atmosphere brings into the line of vision light that was not reflected by the surfaces of the objects seen. Extraneous light is refracted into the field of vision, while some light is refracted outside it. The profit and loss of individual areas changes the tonal patterns of the visual field in varying degrees according to the density of the atmosphere and the distance of the objects.

Thirteenth-century commentators could grasp the loss but not the profit: hence their belief that increasing distance led to darkening. The reason why aerial perspective was such a late arrival in the Italian Renaissance painter's armoury of techniques of illusion, turns out to be the other side of the coin to the early arrival of *perspectiva artificialis* or linear perspective. The geometrical model for vision, with its emphasis on the straight lines that link the eye and the surfaces that terminate vision, was singularly surface orientated. When Alberti writes of the visual rays as measuring quantity, and divides surfaces into planar, concave and convex, his conceptions derive from the geometrical model.[23] No Pompeian painter could have conjured up landscapes awash with coloured light if they had conceived of their picture as composed of surfaces that terminate vision. Taddeo Gaddi, as I hope to show in the next chapter, was more surface-bound in his pictorial imagination.

Apart from darkening, the treatises mention three other effects of distance. The first is obvious to the geometrically minded: when an object is so far away that it no longer subtends a perceptible angle to the eye then it ceases to be visible.[24]

The second is the apparent flattening of distant objects. Pecham reasons: 'Since convexity and concavity can be discerned only when the parts of the visible object are perceived to be unequally distant, sight must fail in the perception of sphericity when the distance is immoderately great. . . . If no part of the visible object appears farther away from any other, its entire surface must appear to be of the same disposition.'[25]

70

The third effect of distance is to change colours. Pecham notes, 'sense errs because of distance, for many small colours appear from a distance to be one colour', and Bacon reasons that this occurs because no single patch of colour subtends a large enough visual angle to be perceptible. (In an interesting coda Bacon mentions how colours are also unified by movement, as, for example, on a spinning hoop.)[26]

These remarks on distance are framed by epistemological concerns. Looking at distance 'sense errs'. Dante could use the tricks played by distance for moral allegory, but the painter of sacred images – the Bible of the illiterate as St Gregory the Great called them – was advised to stick to the unambiguous.[27] It is hardly a coincidence that aerial perspective was finally reborn when artists turned their attention to poetic and pagan subjects in the late fifteenth century. Once doctrine was not at stake, ambiguity might be enjoyed.

Perspective

Light, not perspective, is the primary subject of this study. But a brief comment on how far the writers on optics adumbrate the laws of linear perspective may be helpful.

The account in the treatises of how images are received by the eye is an obvious prototype for Alberti's account of how perspectival images can be projected by the artist. The figure of the pyramid with its central ray is common to both. Bacon, like Alberti, asserts that an intersection at any point in this pyramid contains within it all the rays that travel from the base to the apex in the eye. He explains vision in terms of an intersection in the eye itself.

But Bacon and Pecham are concerned with whether vision is reliable, not with how illusion might be created by perspective. Whereas Alberti emphasizes the necessary fixity of the pyramid, with its centric, or axial, ray equally fixed, they assert, in Pecham's words, that 'certification of a visible object is achieved only in a period of time by the passage of the axis of the pyramidal radiation over it'.[28] The necessity of the eye to rove may not in itself deny the possibility of a perspectival system, but it makes nonsense of Alberti's identification of the information derived from extrinsic, median and centric rays with the extremities and centres of objects.[29] There appears to be nothing in the thirteenth-century texts to justify the Albertian distinction between outlines and the coloured planes they contain.

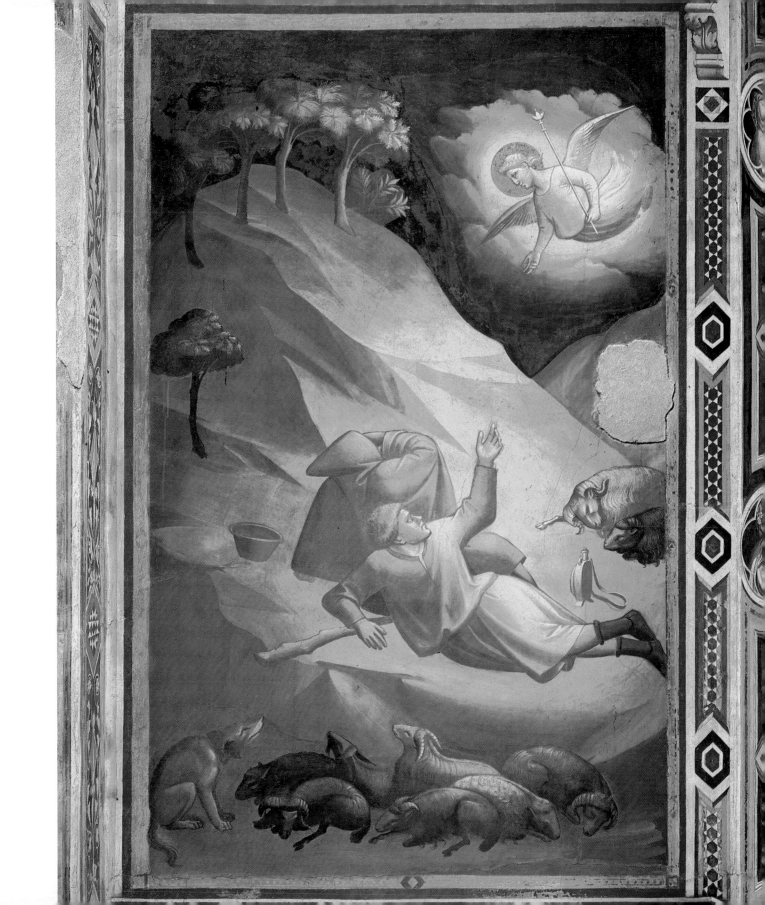

V. TADDEO GADDI:
THE BARONCELLI CHAPEL IN SANTA CROCE

Pictorial illumination and symbolic allusion

The clarity of Giotto's fresco cycle in the Scrovegni Chapel depends upon self-imposed limitations. Scale throughout the narratives is uniform. Pitch is homogeneous; no scene is dominated by very dark or light tones, and even night scenes are accommodated to this norm. The spectator accepts the conventions of pictorial illusion because of their consistency. While the scope of illusion, including the naturalistic rendering of light, is limited, no false notes strain credibility. A quarter of a century later the young Taddeo Gaddi, impatient with his master's classical restraint, slipped the leash, eager to impress. Breaking with the purposeful limitations of Giotto's Paduan cycle, he introduced potentially disruptive ambitions into Florentine painting of the mid-fourteenth century.

As a pupil of Giotto, Taddeo knew that the decoration of a chapel should follow a unified system of lighting. In the Bardi and Peruzzi Chapels, in Santa Croce, Giotto took the window in the altar wall as the cue for the direction of light for the modelling in his scenes on the side walls. In the Baroncelli Chapel, off the right transept of the same great Franciscan church, Taddeo was faced with painting vaults, a single lateral wall (fig.40) and an altar wall pierced by a two-light window (fig.39).[1] The spaces on either side of the window, wider than in the choir chapels, were the most visible from the body of the church, and therefore deserved to be utilized for narrative scenes.

But since the light source was on this south wall, what direction should be indicated in the frescoes?

Contre-jour (the light shining from behind) as a norm for pictorial illumination was inconceivable. If employed for ordinary modelling, *contre-jour* would have undermined the reassuring stability of the frescoed wall as a surface upon which light is incident: by grouping on the window wall subjects which justified abnormal or extraordinary illumination the painter reassures us that any instability is more illusory than real. That the grouping of subjects with abnormal light effects was deliberate is borne out by the inclusion of scenes associated with the birth of Christ, notably the *Annunciation to the Shepherds* (col.pl.XIII) and the *Appearance of the Child in the Star to the Three Magi*, which are not mandatory in a cycle dedicated to the Virgin. The incidents must have been selected because of the opportunity they offered for describing supernatural light; and far from being sub-plots, as was usually the case with the *Annunciation to the Shepherds*, they are enlarged into narratives in their own right.

39. (previous pages left) The Baroncelli Chapel in Santa Croce, Florence, with frescoes by Taddeo Gaddi.

XIII. (previous pages right) Taddeo Gaddi, *Annunciation to the Shepherds*. Florence, Santa Croce, Baroncelli Chapel.

XIV. (facing page top) Taddeo Gaddi, *Stigmatization of St Francis*. Florence, Santa Croce, window of the Baroncelli Chapel.

XV. (facing page) General view of the Baroncelli Chapel in Santa Croce, Florence, with altarpiece by Giotto, frescoes and stained glass by Taddeo Gaddi.

The theme of spiritual illumination by a light hardly to be borne by mortal eyes must have belonged to the earliest conceptions of the chapel's iconography, since the pinnacle (fig.41) of Giotto's altarpiece for the chapel, the *Coronation of the Virgin* (fig.42), shows angels shielding their eyes from the unapproachable brightness of the Godhead. Whether or not Giotto played a role in planning the entire pictorial decoration of the chapel, of which the altarpiece was chronologically the overture but thematically the finale, has been suggested and contested,[2] but it seems most likely that the choice of subjects for the altar wall was made in close consultation with the Franciscan friars of Santa Croce.

In the stained glass of the window, which is contemporary with the frescoes, Taddeo Gaddi represented the *Stigmatization of St Francis* (col.pl.XIV).[3] At first sight it appears irrelevant to the iconography of the chapel, but in 'The Third Consideration of the Most Holy Stigmas of St Francis', a text included in the *Fioretti* or 'Little Flowers of Saint Francis', it is related that on the eve of the feast of the Holy Cross (*Santa Croce*) St Francis was visited by an angel, and the brief exchange, in which the Saint declares he is ready to receive patiently everything that the Lord will do unto him, intentionally echoes the pliant Virgin's response to the Angel Gabriel. The Virgin's Annunciation (fig.43) is followed by the incarnation of Jesus Christ, Francis's by the imprinting of the wounds of Christ on his own body. Both receive the Lord physically in their bodies.

41. Giotto, *Angels shielding their Eyes from the Radiance of the Eternal Father*, 130 × 90cm. California, Fine Arts Gallery of San Diego.

40. (left) View of the left wall of the Baroncelli Chapel with scenes from the life of the Virgin by Taddeo Gaddi.

42. Giotto, *Coronation of the Virgin*, 185 × 323cm. Florence, Santa Croce, Baroncelli Chapel.

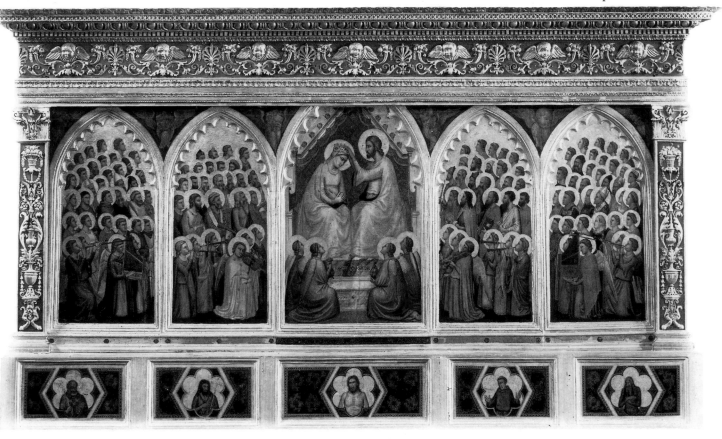

43. Taddeo Gaddi, *Annunciation* and *Visitation* (fresco) and *Stigmatization of St Francis* (stained glass). Florence, Santa Croce, Baroncelli Chapel.

And Francis's Stigmatization, like the Nativity of Christ, is accompanied by an appearance of wondrous light to the shepherds – as the Third Consideration relates.[4]

So the *Stigmatization* links the iconography of the church, dedicated to the Holy Cross, to the iconography of the chapel, dedicated to the Annunciation. Five Annunciations, or Theophanies, are represented: on the left wall, the Annunciation to Joachim (fig.44), and on the altar wall the Annunciation to the Virgin, to the Shepherds, to the Magi, and – since the Stigmatization immediately follows the appearance of the angel – to St Francis.

The Considerations on the Holy Stigmas did not form part of the *Actus beati Francisci et sociorum eius*, but they were likely to have circulated before the *Fioretti* were col-

78

lected and translated in the second half of the fourteenth century. Doubtless the Franciscans at Santa Croce knew the parallels that could be drawn between the Stigmatization and the Incarnation, and so it would seem probable that Taddeo Gaddi's seizing upon the luminary aspects of the Nativity scenes was prompted by emphasis upon supernatural light in Franciscan hagiography.

In Taddeo's narratives the reception of light is an outward sign of spiritual communion. Gabriel, airborne like the traditional seraph, approaches Mary from the right, which is contrary to tradition but congruent with the Stigmatization in the window. Although Gabriel, skied over the arch of the window, salutes Mary from a greater distance than usual, the dark void between them is not bridged by any visible ray. Mary's acceptance

44. Taddeo Gaddi, *Annunciation to Joachim*. Florence, Santa Croce, Baroncelli Chapel.

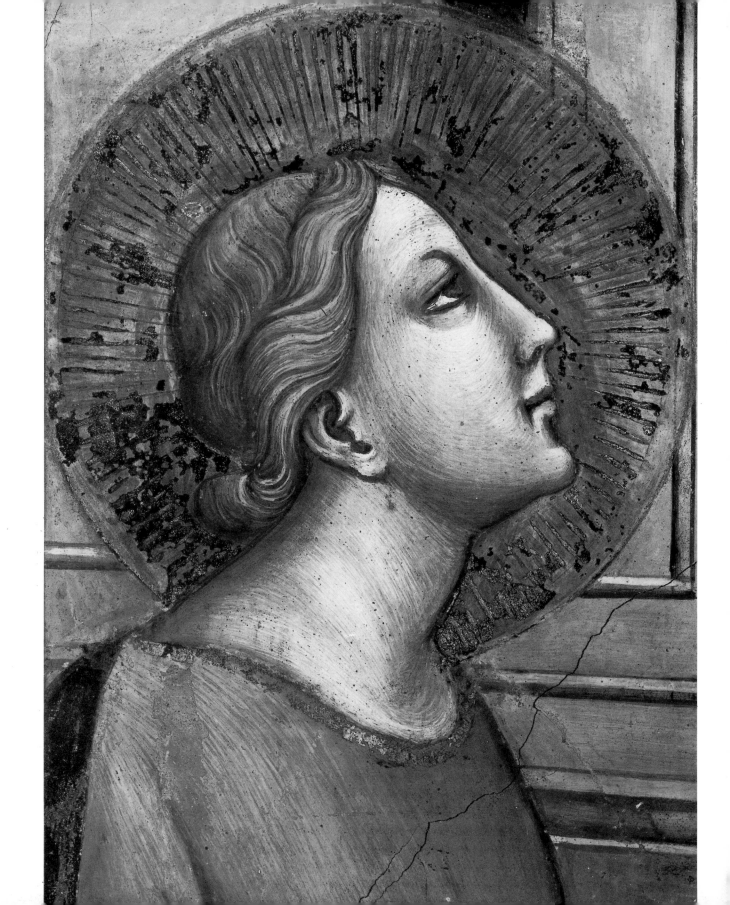

of Gabriel's message is expressed by the turning of her face to receive the full flood of light (fig.45). By proximity to the window the effect of the scenes of supernatural illumination is intensified, for as the worshipper turns to gaze at them he must also receive in full face the light of the window.

45. Taddeo Gaddi, *Head of Mary* (detail from the *Annunciation*, fig.43).

Luminary colour and colour modelling

In the *Annunciation to the Shepherds* the light of the angel and of the cloud awakens the shepherds and they are dazed by its brilliance (fig.46). Taddeo recreates the shepherds' own experience by capturing two aspects of sudden illumination, which, it seems to me, he is more likely to have noted by nocturnal observations than, as has been suggested, by the observation of a solar eclipse.[5] When a flash of lightning illuminates the night (a closer natural analogy to the shepherds' experience than an eclipse), the eye, not having time to adapt from scotopic or darkness vision to photopic or

46. Taddeo Gaddi, *Shepherds* (detail from the *Annunciation to the Shepherds*, col.pl.XIII).

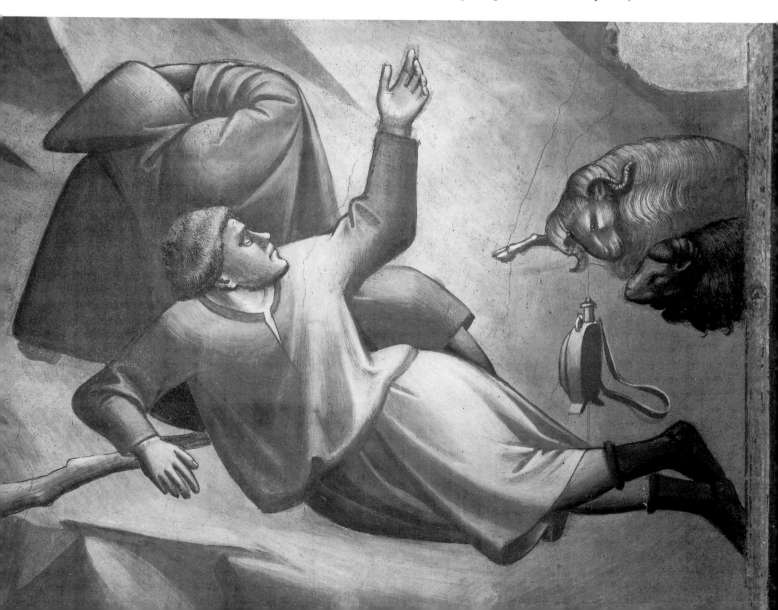

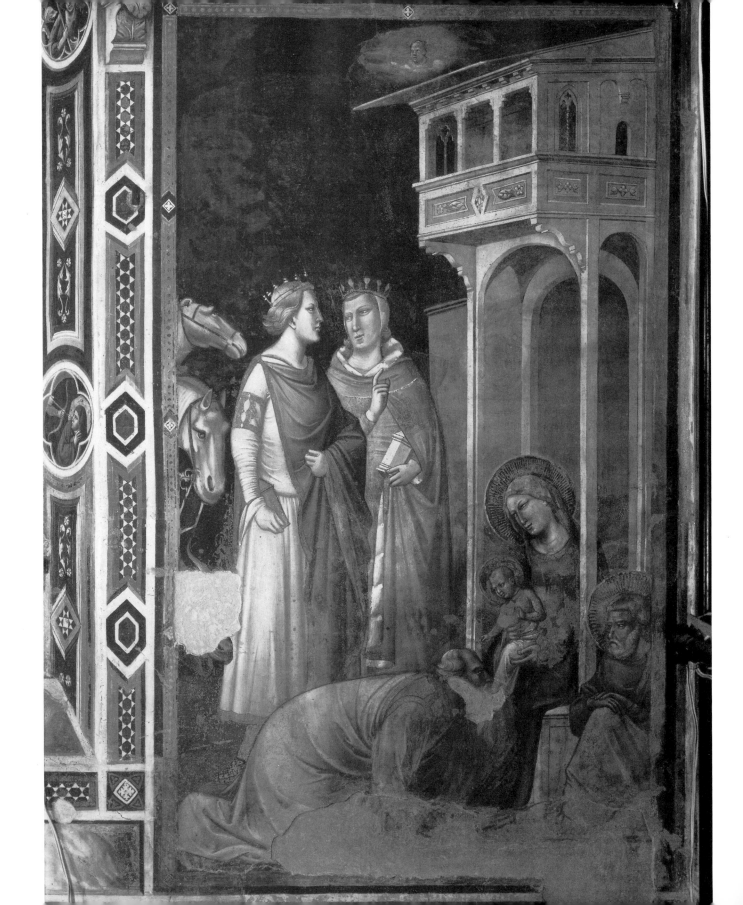

daylight vision, sees the scene in black, white and silvery greys, and fine details are indistinct. So Taddeo paints landscape and shepherds in greys and touches of umber, and is sparing of intricate detail. To the supernatural light he gives a yellowish cast, quite different from the monochrome, mundane light of other scenes. This yellow light heightens awareness of illumination by its common tinting of surfaces – though this effect is rather stronger on the rocks than on the figures.

Viewing the altar wall as a whole, the yellow cast of supernatural illumination is purposefully associated with yellow as a drapery colour, and the two are linked to the yellow glass in the window, where, although it does not bulk large, it admits more light than the other areas of coloured glass, and therefore appears to *be* the colour of light itself. In the frescoes the figures in yellow are generally closest to the window: they include a maid in the *Visitation*, the foremost Magus in the *Appearance of the Child in the Star*, and the left-hand angel in the *Nativity* (col.pl.XV). Even in the *Adoration* (fig.47), where it is the central Magus who is in yellow, the rose robe of the kneeling Magus is tinged in the lights with yellow. Here such colour change is not called for on grounds of luminary realism, but is a device that establishes continuity across the wall, from the apparition of the Child to the Magi, through the yellow glass, to the Magus prostrate at the goal of his journey.

Again, in the modelling of Joseph in the *Nativity*, the demarcation between local and luminary colour is ambiguous. He sits on the ground flanking the window in a red vestment and a mantle that is almost impossible to label – grey-lavender in the shadows on the right, straw in the lights and tending to pink on the left and in the pockets of the folds in the centre. So chameleon a figure is hardly to be found in the Scrovegni Chapel. Whereas the young Giotto established the material density and the constancy of object-colours, by the 1330s colours are used for a new kind of pictoralism that is more luminary and less stable. Joseph's yellow highlight advertises the reception of light while linking with the yellow glass near the figure and beyond that with the yellow light in the *Annunciation to the Shepherds*. The lavender-grey as near complementary of yellow is an effective foil as shadow. And, just as yellow as light is associated with yellow as drapery colour, so lavender as shadow is associated with lilac as drapery colour.

In Early Italian painting the green shadows of the flesh complement the warm carnation. Taddeo developed a new gamut centred around the poles of yellow and its complementary, violet. Yellow and violet were used as primary components of colour chords in mediaeval glass.[6] From the end of the thirteenth century the new lighter yellow, 'jaune à l'argent', was being used to admit more light into churches.[7] Pure yellow only becomes prominent in the palette of Italian panel painters after 1310: yellow, as distinct from ochre, is absent from Duccio's *Maestà* (1308–11), but prominent on its derivative in the Cathedral of Massa Marittima (c.1315–17).[8] Yellow in Taddeo Gaddi's frescoes is stronger, more shrill, than in Giotto's. As saturated violet is tonally much darker than yellow, Taddeo chose a greyer, paler violet as softer foil to the yellow tinting of his supernatural illumination. It spreads as an undertone – grey with just a hint of violet – in the rocky landscapes and even in the nuances of flesh shadows, but in the uncertain light of the chapel, dim and coloured by the glass, it is difficult to gauge the force of this tingeing.

47. Taddeo Gaddi, *Adoration of the Magi*. Florence, Santa Croce, Baroncelli Chapel.

Though Taddeo is not amongst nature's great colourists, since the system he evolved dominated Tuscan fresco painting for nearly a century it is worth analyzing with some care. Let us start by noting differences in the behaviour of pigments and coloured light.

If complementary lights are shone together they act additively to produce white light, whereas if two complementary pigments, say red and green, are mixed, they act subtractively to produce a tertiary or impure colour, in this case, brown. Colours, such as brown, beige and mauve, cannot be matched by spectral light.[9] Taddeo's palette consists of colourless greys combined in varying degrees with spectral colours; non-spectral colours, such as chocolate or maroon, are rare. Unlike brown, Taddeo's violet undertone and hint of violet in the shadows of flesh may be read as luminary – not light itself but its complement in shadow. It is as though we are seeing grisaille fresco overlaid with the spectral hues of stained glass – colours which retain their intensity in a few draperies but elsewhere are neutralized by grey.

This is no accident. The prestige of sculpture, antique and contemporary, opened painters' eyes to the importance of tone in modelling. Giotto, a keen student of the sculpture of the Pisani, demonstrated the tonal discipline of grisaille in the Virtues and Vices in the dado of the Scrovegni Chapel. By choosing grisaille for these personifications of abstract concepts, he distinguished them from the polychromy of the historical, human world of the narratives. In the Baroncelli Chapel this distinction is less clear cut. A greyish preparation for many of the draperies and much of the architecture, as well as for the flesh tones, invades the modelling of the narratives, while in the vault over the principal bay of the chapel the Cardinal Virtues (fig.50) are as colourful as any figure in the scenes from the life of the Virgin. Giotto could shift from monochrome to polychrome without loss of power. In the Baroncelli Chapel sensuous fulness of colour is no longer allowed free play. Through the introduction of a kind of neutral staining, the insistence of modelling obtrudes, shaping and defining. Might it be suggested that this invasion of grisaille, formerly reserved for didactic concepts, into the empathetic, human context of the narratives indicates a reassertion of the ideological primacy of meaning over the instinctual play of feeling? The Baroncelli Chapel is situated in a Franciscan church to which was attached one of the great Franciscan centres of theology, the Studium. Taddeo's fresco, now mutilated, of *Christ among the Doctors*, located between the Baroncelli Chapel and the door leading to the Studium, must obviously allude to the theological eminence of Santa Croce. In the refectory of the same church, the didacticism by which images are labelled and governed by texts is clear to see in Taddeo's great illustration of the *Lignum Vitae*, the Tree of Life, as described by the Franciscan 'Seraphic Doctor', Bonaventura. That Bonaventura's writings were permeated by imagery of light, reminds us that Taddeo's fondness for light effects is doctrinal in origin: the grey foundation that damps down the freedom of colour is an assertion of authority. Colour is literally overwhelmed by the dazzling light of supernatural appearances. As it approaches grisaille, Taddeo's modelling subdues colour; as it approaches the textureless hues of stained glass, Taddeo's colour is abstracted from attachment to material substance.

Taddeo's conflation of antithetical sources – the spectral hues of glass, the greys of grisaille – set the pattern for Tuscan painters of the later fourteenth century, particularly the fresco painters. It is less a synthesis than an enduring tension. In one place the

monochrome modelling may dominate, in another, glaring vermilion or flat azurite. Colour has an iconographic function but not a mimetic one. Art imitates art. Thus imitation of the glass painter's violet is all the rage. In late fourteenth-century texts, violet, or *biffo* as it is called, becomes a widely recommended colour for shading. Cennini instructs that it should be made by mixing lac and ultramarine, and recommends it as shading for ash, lac and blue draperies.[10] The Strasbourg manuscript on colour, dating from the fifteenth century, doubtless reflects earlier practice when it describes 'a violet colour or a blue which is much used for painting or shading'.[11] The Naples *De arte illuminandi*, a fourteenth-century manual for illuminators, recommends rose as 'a constant and universal shading for all colours, and the violet clothlet serves practically the same purpose'.[12] Whether rose or violet is to be used for shading – 'universal shading for all colours' – does not depend upon the substance of things seen.

Cennini declares in his handbook: 'You follow this method in everything which I shall teach you about painting: for Giotto the great master followed it. He had Taddeo Gaddi of Florence as his pupil for twenty-four years; and he was his godson. Taddeo had Agnolo, his son. Agnolo had me for twelve years: and so he started me on this method, by means of which Agnolo painted much more handsomely and freshly (*colorì molto più vago e fresco*) than Taddeo, his father, did'.[13] That lack of freshness that Cennini discerns in Taddeo's work stems from his reliance upon a greyish foundation to the modelling. In fact, the range of recipes for greyish colours in Cennini (*verdaccio* – dirty green, *cinerognolo* – ash, *berrettino* – a Venetian word for brownish grey) and the frequency with which they are mentioned imply that Taddeo's habits were far from expunged.[14]

Illumination and space

Taddeo realized that darkness might be described, not merely symbolized by torches, and the darkness of the nocturnal scenes – all the narratives on the altar wall approximate to nocturne – is the premise from which his modelling takes its departure. The basic tone of his backdrop, painted blue over maroon or dark grey, is darker than Giotto's in Padua. We lack a full technical report, but Ladis notes 'the unusual dark brown preparation, which makes the blue opaque and the yellow incandescent'.[15]

The new spatial qualities of darkness may be observed above the window. On the right-hand side the distance between the city on the hill and the *Visitation* below is vague. Diminishing scale, not continuous perspectival space, implies distance. The intervening rocks are so dimly modelled that standing in the chapel it is hard to see their shape, and the city appears separated by darkness from the measurable space of the Visitation. The separation in time as well as space – an image for Mary's journey 'into the hill country' to visit her cousin – is marked by a change in orientation of light. On the city it falls from the right, on the rocks and Elizabeth's house, from the left.

By admitting deeper space, more varied scale, fitful light, and gaps of darkness, Taddeo abandoned Giotto's self-imposed limitations. It would be wrong to regard this as the result of a purely naturalistic ambition. Taddeo employed light to draw attention to salient features of the story, and darkness is the diminishing of this light rather than a quality of atmosphere. Darkness coincides with absence of detail or an utter void: light illuminates as much as there is to be seen. Ashen softness speaks of the muting of

48. Giovanni Pisano, *Annunciation and Nativity*. Pistoia, S. Andrea.

local colour by light; bold and summary modelling captures that simplification of tone typical of sudden illumination by night; but there is no teasing indistinctness of Leonardesque chiaroscuro.

The character of Taddeo's modelling and spatial construction suggests that most of his observations were made indoors rather than under the light of the sky. An interior, whether lit by a window or a lamp, will present a gradient in the illumination according to the distance of surfaces from the source of light, and there will be a corresponding gradient in the definition of shadows. Out-of-doors differences in distance between the sun and the various features of a single prospect are so infinitesimal that there is no gradient but an even tenor of illumination. Taddeo's modelling of his out-of-doors scenes presents a diminishing of brightness with increasing depth that is only apposite for a close source, amongst which we may count the supernatural luminants. Conventions of space-darkening may have prejudiced Taddeo's observations, but, whereas Giotto noted the soft penumbra where light from the sky is obstructed by eaves, Taddeo's darker shading is much more like the shadows of a restricted light source observed within the workshop. Replacing the constancy of Giotto's light diffused from above by the sharper discriminations of angle and pitch characteristic of interior light, Taddeo threatens not only the unity of his cycle, but also the reposeful gravity of the Giottesque figure-syle.

With the exception of the strap of the water-bottle in the *Annunciation to the Shepherds*, Taddeo saw no use for cast shadows which reproduce the contour of the illuminated object. Attached shadow reveals relief; cast shadow elucidates position. Pietro Lorenzetti, excited by the poetry of space, its alleys, cells and interconnections, discovered how a banister or bench could be made to project in front of a wall by means of a cast shadow.[16] But fourteenth-century inhibitions about rendering cast shadows must have been at root epistemological. If vision is fallible, why add to the dangers of deception by rendering the shadow as well as the substance? The rising star of nominalist philosophy may have been asserting the reality of particulars, but the Platonic tradition, which for centuries had moulded the imagery of cognition, treated shadows as at the furthest remove from the truth of universals. Light escaped the mediaeval disregard for what is evanescent and fleeting thanks to the Johannine and Augustinian identification of it with the divine, but for shadow there was no such redemption.

It is not precise cast shadows that elucidate position in Taddeo's frescoes, but explictness of structure. How this aggressive explicitness, which will bedevil much Florentine painting in the later Trecento, undermines values of illumination, is worth pondering.

Perception of orientation, colour and illumination is correlated. In my second chapter it was suggested that the clarity of the orientation of objects, together with the simplicity of their colouring, was a pre-condition for Cavallini's intimation of light falling upon them from a consistent angle. But the proposition can be reversed: consistency of lighting underlines orientation and permits the correct reading of constancy of colour. To me it seems a general truth of painting that those artists who awaken most vividly our feelings for light — feelings which from the sun's diurnal round permeate our consciousness — handle orientation, colour and illumination in such a manner that each remains, in some elusive fashion, dependent upon the other. This

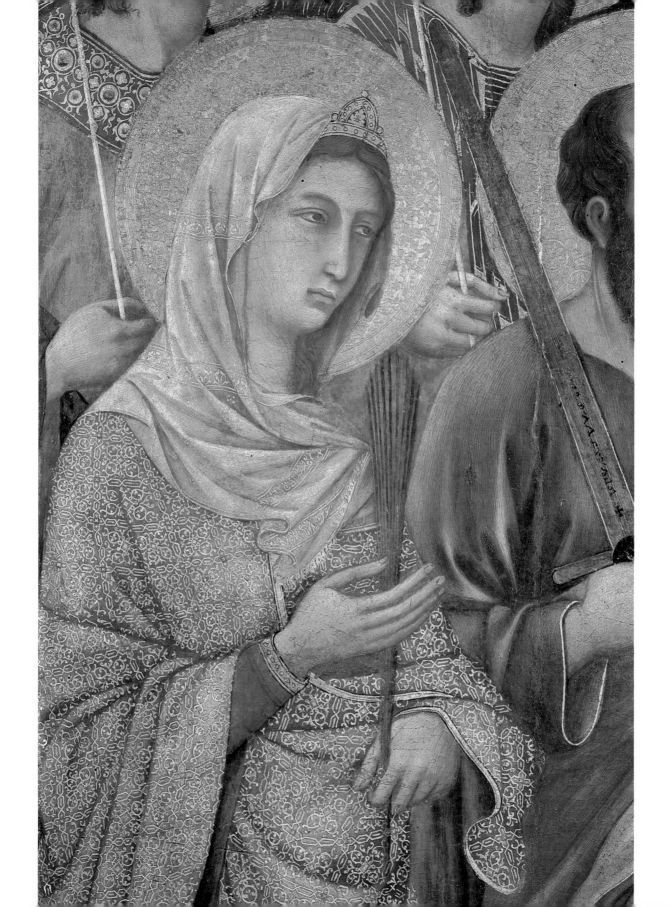

XIX. Duccio, *Maestà* (front), 1308–11, 214 × 412cm. Siena, Museo dell'Opera del Duomo.

XVIII. (left) Duccio, *St Catherine* (detail from the *Maestà*, col.pl.XIX).

XXI. Detail of the Campanile of Florence Cathedral.

XX. (left) Agnolo Gaddi, *Coronation of the Virgin*, 182 × 94cm. London, National Gallery.

interdependence, this lack of any redundant information, we have already admired in Pompeian landscapes (col.pl.IV).

In Taddeo's frescoes there is never any doubt as to the orientation of buildings: they jut and recede obliquely, their horizontal mouldings describing repeated orthogonals. Apertures, string-courses, corbels and consoles are clean-cut. Surfaces are divided into panels, often with changes of colour picking out individual mouldings and panels. Since this variety of colour pre-empts any massing of lights and darks, light cannot emerge as a prime revealer of pictorial order.

How is it that Cavallini's virtue has become Taddeo's vice? In part the answer lies in a predictable historical development: Cavallini's softly oblique settings for his architectural properties were a vast improvement on the uninformative 'foreshortened frontal' and flat elevations of his predecessors.[17] The assertiveness of Taddeo's more sharply oblique settings seems an obvious consequence – and the more oblique the view of architecture the less we need to rely upon the subtleties of luminary values to read its orientation. But there is another change.

When Cavallini described Joseph in the *Nativity* (col.pl.VIII), he drew with his shadows, and where there was no shadow eliminated outline. Taddeo, in the *Annunciation to the Shepherds*, encloses the shepherds in a dark outline which seals them from the brightly illuminated hillside. Lit by the same radiance, shepherd and hillside are sundered by the drawn outline, that same conceptual line with which the composition was

49. Taddeo Gaddi, *Allegorical head* (detail of window-embrasure). Florence, Santa Croce, Baroncelli Chapel.

50. Taddeo Gaddi, *Prudence*. Florence, Santa Croce, Baroncelli Chapel.

first sketched in sinoper on the rough *ariccio*. Again, in the architecture, drawing obtrudes. If we look closely, at the Virgin's aedicula in the *Annunciation* for example, we can see that some lines notionally are fine shadows, but their edges – unlike those of Giotto – are too clean-cut to distinguish them from the junction between two local colours.

To conclude, the decoration of the Baroncelli Chapel is startlingly original. The illusionism of the ambries with still life in the dado is daring and effective. The heads in the window splays (fig.49), modelled in dark shadow like a pictorial realization of the undercutting in Giovanni Pisano's reliefs (fig.48), are dramatically expressive. The exploration of the nocturne and the rendering of supernatural sources of light by relatively naturalistic means are inventive. When Taddeo concentrates upon a single figure and coordinates point of view and angle of light, as is the case with *Prudence* (fig.50) on the vault lit from the window below, he impresses. Elsewhere ambition overreaches understanding, and strain intrudes. The alliance between light falling here and now on the plastered wall of the church in which we stand, and light as a directed stream in pictorial space belonging to the time and ambient of the narrative, yet somehow open, free to traverse between a denoted world of signs and the actuality of the spectator's world, that alliance intuitively felt in the chapels frescoed by Giotto, is less secure in the Baroncelli Chapel.

51. Giovanni del Biondo, *Madonna of the Apocalypse*, 136 × 86cm. Florence, Santa Croce, Rinuccini Chapel.

In the third quarter of the Trecento the separation of the sensuous from the intellectual led to insidious distinctions between modelling on the one hand and symbolic or shorthand representations of light on the other. Like the hobby-horse put through its paces by Gombrich, the radiance around Christ on Orcagna's Strozzi altarpiece in Santa Maria Novella (col.pl.XVII) is a substitute rather than an imitation, a shorthand for bright light rather than a description.[18] Similarly, Giovanni del Biondo paints the Madonna of the Apocalypse 'clothed in the sun', without feeling any necessity to heed the appearance of sunlight (fig.51). Where the gap between the figurative language of a text and the naturalistic skills of a painter is too wide to be bridged, a symbol solves the painter's dilemma: by clothing his Madonna in a brooch which stands for the sun, Giovanni del Biondo is faithful to the letter of the Apocalyptic text, while betraying its true meaning, namely that the Queen of Heaven is resplendent with glorious light, the image of beauty and goodness. If, as Gombrich has argued in *Art and Illusion*, representational skills develop by a series of corrections applied to inherited schema, then symbolism of a literary rather than strictly visual character may sap the will to correct. The temptation for visual art in the great literary efflorescence of the mediaeval Christian metaphysics of light was that its figurative language, and its stress upon the otherworldly, unapproachable mystery of light, short-circuited representation of mundane light, thereby threatening to sever the technique of painting as modelling from its meaningful content, its theological symbolism. For Giotto and Cavallini, newly alert to the art of antiquity and thus to the spiritual value inherent in form and colour, pictorial light belonged equally to the domain of technique and content, or, to shift point of view, to sensibility and to signification. When, in the mid-fourteenth century, painters began to look back – as Millard Meiss discerned[19] – to the spiritual ideals of the thirteenth century, the old symbols of light flooded back to jostle strangely with

newer, more naturalistic techniques of modelling. In a period of dire famines and catastrophic plagues perhaps it is not surprising that painters undertook little fresh exploration of the natural world: when thousands, tens of thousands in Florence, were dying of the Black Death, even the light of the sun might seem pestilential. So Taddeo Gaddi's investigations were not followed up, and the hybrid art of the mid-fourteenth century in Florence did not produce any further major achievements in the rendering of light. By the last quarter of the century it was evident to Florentines that renewal could only be achieved by a return *ad fontes*, a return to the clear spring that was Giotto's art. Nowhere is this more obvious than in the paintings of Taddeo Gaddi's son, Agnolo.

Agnolo Gaddi and Florentine polychromy

'So one should do what the painters of our own age do, who though they may look with attention at famous paintings by other artists, yet follow the models of Giotto alone.'[20] These words, written in 1396 by the Paduan humanist Pier Paolo Vergerio, testify to the esteem in which Giotto's art was held at the end of the Trecento. Confirmation is to be found in Agnolo Gaddi's *Coronation of the Virgin*, now in the National Gallery, London (col.pl.XX).[21] The centre panel of an altarpiece the wings of which are lost, Agnolo's composition follows that of Giotto's *Coronation* in the Baroncelli Chapel of half a century earlier (fig.42).[22] Nothing appears to have occurred between 1330 and 1380 to render Giotto's prototype out of date: the later painting reveals no startling new approach to space, form, expression or light. Only the proportions have been elongated in accordance with a Gothic ideal of elegance; otherwise the design has been followed faithfully. Where the differences lie is in nuances of colour, and it is these nuances that reveal a Florentine tradition and its development.

As in the Baroncelli *Coronation*, compositional symmetry around a central axis is re-inforced by symmetry of matching colours, but Giotto's glowing hues are replaced by milky opalescence. Agnolo's are not mixed with neutrals but with white, which gives them the chalkiness we associate with pure tempera painting. Whereas in Byzantine and Venetian traditions differences of colour emerge from a matrix of darkness that holds all shades *in potentia*, in Agnolo's *Coronation* the common matrix of colour is white, both in a literal sense as the opaque whiteness of the gesso ground, and figuratively as the gentle pallor of feminine beauty.[23] In light, rather than in darkness, oppositions of colour – spectral fragmentations – are reconciled.

The kinship of colours revealed in degrees of whiteness is founded upon associations and soft contrasts. The pair of angels that kneel in the foreground are clad in green, with the lights modelled in long, rather thick strokes of whitish yellow. This luminary transition is re-presented in exaggerated key in the local colours of their wings, which pass from pale yellow through a narrow band of orange, and through green to blue at the nether tips. At the back of the picture space this darkening from pale yellow to blue-green is presented again, this time on the cloth that drapes the throne, though here a pattern applied in mordant gilding adds a flaxen haze over the darker ground.

Agnolo's modelling of the throne follows a system already established in the Baroncelli altarpiece: horizontal surfaces are lightest; frontally orientated vertical ones are intermediate in tone; vertical but receding ones are darker; and any undersides of

52. The Baptistery, Florence.

mouldings that are visible are painted darker still.[24] These surfaces are modulated in grey-blues which mediate between the dominant luminary chords of yellow and blue-green, and rose and green. Whereas Giotto's second rank of angels were dressed in blue, Agnolo's are in a slightly mauve rose. The rose and green of the two pairs of angels are repeated on the steps of the throne. On the bottom step, which is largely masked, green surrounds a panel of predominantly rose cosmatesque inlay, and this relationship is reversed in the central diamond. On the second step the pattern of rose and green is again reversed.

Agnolo instinctively reserved rose for positions that are more illuminated than shaded. It is absent from the receding faces of the throne. At all key points the mass of pale rose of the robes of Christ and the Virgin (now indubitably faded) is set off by the recessional grey-blues. A soft luminary contrast, tonal and chromatic, is established. Neither a brilliant clash of two saturated complementaries, nor of two tonal extremes, it is in harmony with the meditative treatment of Mary's Coronation, in which the eye is not distracted by glance, gesture, flashing highlight or strident colour, but quietly allowed to take in the whole.

Integrity preserved by the regular interweaving of chromatic pattern is an enduring characteristic of Florentine colour, as well as intrinsic to the Florentine apprehension of surface and space. Rooted in the geometrically ordered polychromy of Tuscan Romanesque buildings – notably the Baptistery (fig.52) and San Miniato – this Tuscan grammar was softened and enriched by Giotto when he added a delicate rose to the traditional green (*pratoverde*) and white marbles in his facing of the Cathedral campanile (col.pl.XXI). As in his paintings, the colour contrast of rose and green in his campanile is balanced by the tonal contrast of white, contrasts that are strong enough to shine through the light and shadow thrown over the building by the Florentine sun. Such architectural polychromy instills a sense of the planarity of colour and a conception of colour as limited within circumscribed outlines. This is evident in the monumental frescoes inside the churches of Florence, where the teams of painters, high on their scaffolds, balanced the illusionistic demands of narrative and the decorative demands of wall painting. For these painters, colour belonged to the surface of the wall – that reassuring, enclosing surface – and yet opened space beyond the wall. Even in the fifteenth century the tradition of architectural polychromy, so insistently present in the stones of the city's most prestigious buildings, was to temper acceptance of the more positive, directional light explored by Masaccio. The reassuring order of architectural polychromy sustained the Florentine sense of that otherness of colour that lies beyond the descriptive and material. The luminary value of softly contrasted hues within a symmetrical design, demonstrated by Agnolo Gaddi, would be affirmed as late as the 1440s in the altarpiece by Domenico Veneziano for the church of Santa Lucia dei Magnoli. But now we must turn away from Florence and back to the start of the fourteenth century to examine the rather different, equally vital, relationship between pattern, colour and light in Sienese painting.

VI. PATTERN, PLAID AND SPLENDOUR OF GOLD IN SIENESE PAINTING: DUCCIO, SIMONE MARTINI AND PIETRO LORENZETTI

Ornament and opulence – costume, fashion and aesthetics

In the first decades of the fourteenth century the wealthier citizens of the Italian communes were enjoying the fruits of expanding trade. Luxuries were more widely attainable and no doubt, in the self-conscious milieu of urban societies, more widely coveted. Writing shortly before 1318, Riccobaldo of Ferrara compared the vigorous days of Frederick II to the *douceur* and foppery of his own:

> In those times customs and habits in Italy were rude . . . By night the supper table was lighted by torches held by a boy or servant; it was not customary to have tallow or wax candles . . . Men and women wore little or no silver on their garments . . . Many dissolute habits have now stifled these early customs . . . One sees garments of rich material which are decorated with exquisite or excessive artifice, with marvelously fashioned silver, gold, and pearls, with wide embroidery and linings of silk, and trimmed with exotic and precious skins.[1]

Dante comments in similar vein on the virtuous austerity of the twelfth century before the murder of Buondelmonte, when

> Florence . . . abode in peace, sober and chaste.
> There was no chain or coronet, nor dames
> decked out, nor girdle that should set folk
> more a-gaze than she who wore it.[2]

The myth of the 'good old days' ought to be discounted, but remarks about the artifice of contemporary dress can be corroborated by the sumptuary laws promulgated in most Italian cities and by the records of the silk industry, as well as by pictorial evidence.[3] When St Bridget of Sweden arrived in Rome in 1349, she warned the people that if they wished to avoid a recurrence of the plague they must 'abolish earthly vanity in the shape of extravagant clothes'.[4]

Of course, sumptuous dress had long been justified in ecclesiastical and court circles. Earthly courts were, in theory, paradigms of the heavenly court, and the light that gleamed so bright on gorgeous attire offered some inkling of the glory of the eternal

95

and celestial light. This function of attracting the gaze and representing joy is plainly expressed in Thomas of Celano's account of the canonization of St Francis:

> The Supreme Pontiff is there, the Bridegroom of Christ's Church, . . . with a crown of glory on his head in manifest token of sanctity. He is there adorned with a pontifical chasuble, and clad with holy garments bound with gold and ornamented with the work of the carver in precious stones. The Lord's Anointed is there resplendent in glorious magnificence; covered with engraven jewels shining with the radiance of spring he invites the gaze of all. The Cardinals and bishops surround him; decked with splendid necklaces and flashing with garments white as snow they exhibit the image of super-celestial beauties and represent the joy of the glorified.[5]

In the eleventh and twelfth centuries cloth was embroidered, or it was embellished by brocading with gold thread – *aurum battutum*, gold beaters' skin – or by sewing on gold or silver strips, wires, stamped plaques, glass beads and pearls.[6] By these additions garments were spangled with points of light. Thomas of Celano was still most attracted by such ornaments as resplendent jewels, but towards 1300 attention shifted from these embellishments to the cloth itself. The magpie mentality gave way to an appreciation of the quality of a weave and how it reflects the light as it folds and turns.

I believe this new sensibility was fostered by the Chinese silks that were finding their way to Italy in increasing numbers. Following the conquests of Genghis Khan and his descendants, the Mongols' influence spread right across Asia from China into Europe. At first there were intermittent wars, and communications were circuitous. But for half a century following the return of Marco Polo in 1295 trade with Cathay flourished.[7] The turnabout was such that by 1340 one Italian merchant, Francesco Pegolotti, reported that the road from the Black Sea to Cathay was 'very safe'.[8]

The satin weave was pre-eminent amongst the textile novelties that arrived from the East.[9] Since, in satin, the warp threads cross the weft in long floats, it presents a smoother surface than a twill. It was diversified by damasking – that is the creation of a reversible fabric in which the design is mapped out by a contrast between a satin weave and a simple weave such as cloth, twill or weft satin.

Satin was further enriched by brocading. At intervals in the weaving, additional warp threads were introduced which did not necessarily run from selvage to selvage. By this means detached motifs could be woven and picked out with frequent changes of colour.

Chinese brocaded silks, notably in satin weave, were introduced into Europe in the late thirteenth century. Italy was well placed to garner the Eastern influences. Through Venice it picked up the Byzantine and Sassanid style; via Sicily and Spain it intercepted the Islamic stream.[10] By the fourteenth century the Italian silk industry was imitating oriental designs (fig.53). Apart from technical aspects of weaving, they learnt new modes of decorative and abstract design; from the Hispano-Moorish tradition they learnt new geometrical forms; from Islam they learnt arabesque.

In Tuscany the centre of silk weaving was Lucca. After its fall in 1314 Florence usurped its tradition. Perhaps it was because Siena never had a silk industry of its own that it was open to manifold influences. In its painting it showed, like Venice, a preference for motifs of Chinese or Sino-Persian origin throughout the fourteenth century.

53. Sicilian (?) fourteenth-century silk textile. London, Victoria and Albert Museum, no.832–1894.

My purpose in this chapter is to show how the impact of oriental textiles – in which modelling in light and shade counts for nothing, the interaction of colour and pattern and the sheen of surface for everything – modified and enriched the nascent, essentially occidental concern for three-dimensional illusion. It was a strange collision, almost a meeting of oil and water, and yet a fusion took place that was to last a century and more.

Duccio: density of pattern and mobility of light

As far as the response of painters to the new weaves and patterns is concerned Duccio is a transitional figure.[11] On the front panel of his great *Maestà* (col.pl.XIX), the high altarpiece of the Cathedral of Siena, the cloak of St Catherine on the left (col.pl.XVIII), and that of St Agnes on the right, and the cape of St Savimus, to the left of centre, all possess an extraordinary actuality.[12] The almost super-real quality of each drapery depends upon a fusion in the eye of a host of small, precisely controlled touches. Nothing in the painting of the Duecento matches the fineness and density of this patterning – not at least on this scale, and scale is important.

Let us look at how the cloak of St Catherine is built up. The laying-in colour in the lights is pale grey-green or grey-blue, shaded rather neutral but warmish in the folds; applied over it is a fine white pattern with a few twirls of gold and a little red cross; each white line is bordered by a hairline of red to detach it from the greenish-grey background. From more than two feet away these red lines are invisible *per se*; from ten feet the garment assumes a silvery sheen. The little red crosses, not clearly distinguishable, lend a blush of warmth; the linear pattern in white and gold, indistinct over the lights, takes on a broken shimmer over the dark folds. From a close vantage, we can see the pattern is tilted or interrupted as it follows the orientation of the surface. From afar, disjunctions in tone between uniform pattern and modelled ground create a shifting depth of surface, and the pattern itself appears strongly raised, almost like a flock.

The question whether Duccio planned the optical effect that his patterned draperies would have at a distance or simply copied, as painstakingly as he could, a specific fabric is beside the point. The desire to render textiles with a new degree of realism would have educated his eye in the relationship between a fine mesh of colours and the effects of distance. Dyed threads, whether in woven cloth or in embroidery, have always offered an instructive source of observations about colour. Chevreul's theories were the progeny of his work with the Gobelin tapestry dyers and weavers. Aristotle in his *Meteorologica* – a text well known in the Middle Ages – followed his discussion of the rainbow with an illustration of his concept of colour contrast which is drawn from textiles:

The same effect can be seen in dyes: for there is an indescribable difference in the appearance of colours in woven or embroidered materials when they are differently arranged; for instance, purple is quite different on a white or black background, and variations of light can make a singular difference. So embroiderers say that they often make mistakes when they work by lamplight, picking out one colour in mistake for another.[13]

97

The designing of textiles unites near-sighted concern for how something may be made with far-sighted concern for how it will appear when worn or hung on the wall. The basic unit of silks, the coloured thread, is of gossamer fineness in relation to an entire expanse of fabric. Many of the weaver's decisions would have been reached intuitively on the basis of traditional combinations, yet judgement must have been exercised in gauging the right scale for a pattern – too large and it would be disturbingly broken by folds, too small and it would be insignificant at a distance.

Unlike Duecento painters (e.g. see col.pl.II), Duccio realized that no justice was done to textile patterns by drastic simplification. In his predellas he is shy of patterned drapery, realizing that expansiveness is necessary to reproduce the interplay of motifs and colours. On the large figures on the front panel of the *Maestà* Duccio describes surfaces which reflect light with a novel fineness of grain, a quality between sheen and sparkle.

Traditional criticism, conditioned by its original reliance upon line engravings as *aide-mémoires*, paid scant regard to pattern in its concentration upon composition. Photographs, which cannot duplicate the reciprocal relations of scale and viewing distance, have not helped greatly, for pattern affects us according to the size of motifs relative to the visual field. It is characteristic of the grain of Duccio's patterns on the *Maestà* – on the cloth of honour, on the cosmatesque inlay of the throne (fig.54), on the collars of angels and on the copes – that at a distance of two to three times the width of the panel individual motifs are barely distinguishable yet not totally lost. The eye, as it traverses such patterns, cannot pin down the exact location of motif over field, of pale tone and adjacent or circumambient dark. Alternations in brightness of the surface due to the spatial distribution of colours are enmeshed with a flickering alternation experienced over time.

In nature, sparkle and glitter are experienced over time and produced by movement.[14] The light of Duccio's *Maestà* is of two kinds: the conventional light of modelling that moulds faces and distinguishes facets of the throne, and light which is more like a pulse, transmitted by the conjunctions of colours and rhythms of pattern.

This pulse of light transmitted by the surface is not overwhelmed by light and shadow in pictorial space. Scale holds the key. The grain of light and dark in the patterns sends a ripple through the bigger alternations of light and shade in the modelling. The throne, for example, is bulky, but the light and shadow – attached not cast – of its facets are counterpointed by dense chequers of inlay and delicate mouldings and crockets.

To anatomize a perception that is subliminal inevitably distorts. Perhaps a pulse of light is not consciously experienced. We are aware only of a radiance that is continuously renewed. The eye, pathway to the soul, roves long over these alternations of colour and the mind is held in prolonged contemplation. Whatever the realism of such patterns, the pulse of their radiance diverts from the representational and offers a refuge from the insistence of meaning.

Shimmer of satin

In the early Trecento the exploration of the pictorial effects of patterned costume transformed habits of modelling and hence, perhaps as much by accident as by design, the implications modelling has for light.

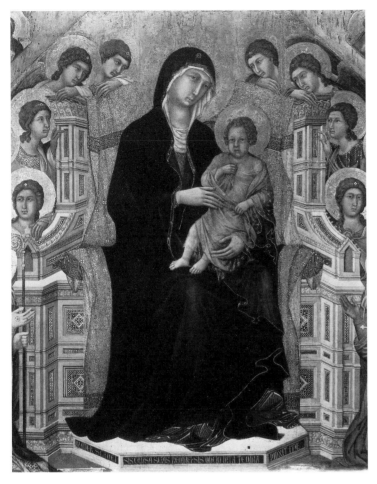

54. Duccio, *Madonna and Child enthroned* (detail from the *Maestà*, col.pl.XIX).

A silk fabric, particularly a satin, tends to shimmer regardless of whether it is in direct light or in shadow. It picks up whatever light is around and reflects it from its illuminated surfaces into the pockets of the folds, bathing them in a lucent half-light. And the sheen of the surface is unstable, as much dependent upon the angle of vision as the direction of incident light. Traditional techniques of modelling, *matizando* and *incidendo*, which break up draperies into bold 'furrows' of dark and 'ridges' of light, were quite at odds with the shimmer of satin that 'will flame out, like shining from shook foil'.

If a silk is damasked or brocaded a further difficulty presents itself. A painter absorbed in the task of rendering a pattern, instinctively extends it right across the expanse of drapery and applies it with the same colours and tones throughout. To vary the tone of a linear pattern is difficult. The solution is to vary the tone of the ground, or to glaze shadows over the pattern. Neither system totally obscures the pattern, and in both cases the superimposed white highlight, the *matizatura* of the mediaeval texts, is eliminated.

55. Duccio, *Rucellai Madonna*, 450 × 290cm. Florence, Uffizi.

56. (above middle) Detail of the cloth of honour in fig.55.

57. (above right) Giotto, *St Nicholas* (detail of the Badia Polyptych). Florence, Uffizi.

In the Duecento, patterns were generally applied flat. If the painter wished to indicate folds he glazed dark lines over the regularly spaced motifs. On Duccio's Rucellai altarpiece (fig.55) the glazes over the cloth of honour (now discoloured) read as folds, rather than changes in the colour of the cloth, because the continuity of pattern is not lost. The conflict between flatness, implied by the unforeshortened pattern, and the curvature of the cloth, implied by the shadows of the folds, is resolved by the sagging loops at the extremities, which reassure us of the pliability of cloth (fig.56). Duccio took care to specify the exact points of support from which the folds derive.

The legibility of Duccio's cloth of honour was desirable because its pattern repeats that of the fictive hangings painted in fresco on the lower walls of the Rucellai Chapel in Santa Maria Novella by Cimabue's workshop.[15] The altarpiece forms part of a greater whole. Unlike Vermeer, Duccio was not free to create a self-sufficient world in his paint-

59. Cosmati and Shop of Cavallini, *Tomb of Matteo di Acquasparta*, 1302. Rome, Santa Maria d'Aracoeli.

58. (above left) Detail of the bier in fig.59.

ing. The need to forge a stable relationship with the constancies of a fixed environment circumscribed his description of light. It is no accident that the rise of the easel painting, in the period of Leonardo and Giorgione, coincides with a diminishing of the force of pattern and local colour in favour of the evanescent quality of chiaroscuro.

The first pictorial attempts to break up the regularity of pattern to suggest the third dimension may have been prompted by the painstaking rendering of ornamented hems and orphreys in the sculpture of Nicola Pisano and his followers. On the pall that hangs over the bier in the tomb of Matteo di Acquasparta (figs.58 & 59) the masking of the motifs indicates the overlapping of folds.[16]

Giotto who, as has been noted in chapter three, used pattern sparingly in the narratives of the Scrovegni Chapel, demonstrated on the cope of St Nicholas (fig.57) in the Badia polyptych how a break and change in orientation of the geometrical motifs will detach the hang of the cope over the forearms from the expanse behind.[17]

Without losing sight of the rest and stability that a certain planarity and breadth give to a painting, it was Simone Martini and Pietro Lorenzetti who fully exploited the foreshortening of pattern. In his wall painting of the *Maestà* in the Palazzo Pubblico at Siena, Simone clad the Madonna (fig.60), most unusually, in robe and vestment of identical colour and pattern. The motifs in white and gold are intricate and they are foreshortened. But since there is considerable variation in the blue of the field which provides tonal modelling, the effect is still close to that of Duccio's patterns.

Again, vestment and robe of Pietro Lorenzetti's Madonna (col.pl.XXII) in the Pieve at Arezzo are identical. The motifs, as they are bigger and painted dark blue over a light ground, are more distinct. For the most part, the complete motif is visible and rendered flat. The small number of folds are marked by breaks in the pattern, and in some places – notably down the left side – by the foreshortening of the motifs. Pietro darkened drapery at the extremities and in the pockets of the folds, but pattern is not obliterated or the unity of the figure destroyed, for neither the white of the field nor the blue of the motifs is intrinsically varied in tone. Shadow is attenuated and highlights eliminated:

101

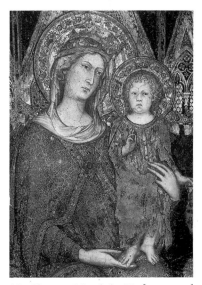

60. Simone Martini, *Madonna and Child* (detail from the *Maestà*), 1315–16. Siena, Palazzo Pubblico.

61. Simone Martini, *Dream of St Martin*. Assisi, Lower Church of San Francesco, Montefiore Chapel.

62. Pietro Lorenzetti, *Birth of the Virgin*, 1342, 187 × 182cm. Siena, Museo dell'Opera del Duomo.

XXII. (facing page) Pietro Lorenzetti, *Madonna and Child* (detail of polyptych), 1320. Arezzo, Pieve di Santa Maria.

the illuminated surface and the area of 'normal' local colour are commensurate with the broad mass of the figure.

We can see here how attention to pattern gives rise to a new feeling for the correlated qualities of three-dimensional shape, luminosity and illumination. Superimposed lights and darks, which fissure as much as they model, are banished; gentle shading, glazed towards the contours, curves the surface away from the line of vision.

Plaid

The efficacy of line, rather than modelling, as indicator of the turning of a surface in space is demonstrated by plaids and checks. In Simone's *Dream of St Martin* (fig.61) at Assisi and in Pietro's *Birth of the Virgin* (fig.62) at Siena, the perspective of plaid orientates the top and sides of the beds. Highlight and shadow are subordinate.

Whereas traditional modelling – *matizando* and *incidendo* – was conceived in terms of individual colours, the painter of plaid must establish a network amongst colours in shadow, darker in key yet analogous to the network amongst those same colours in light. Observation of a plaid or check passing from light to shadow educates the eye. If Italian society expected its painters to record, with some fidelity, such household items as tablecloths, towels and bedspreads – for thirteenth-century spirituality welcomed physical detail as an aid to the realization of scriptual events[18] – this must have led to

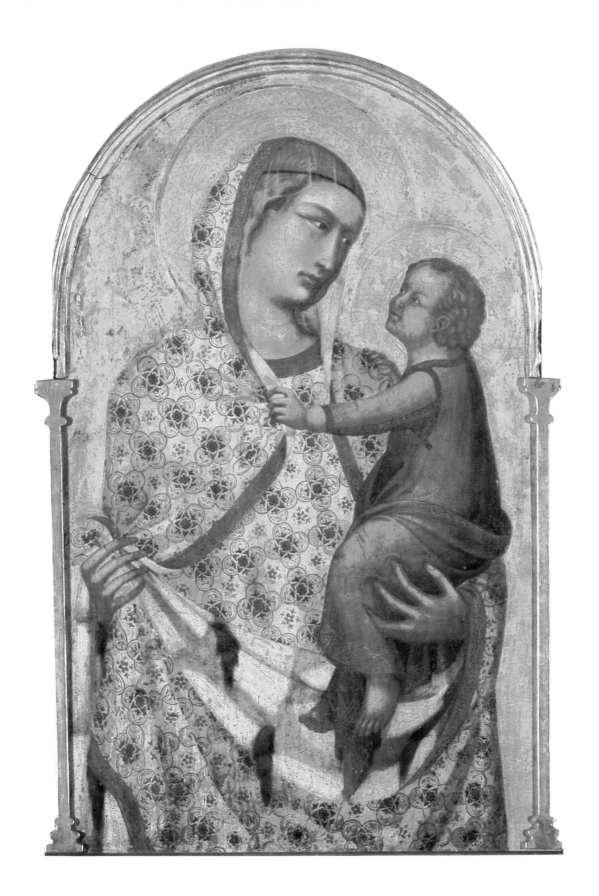

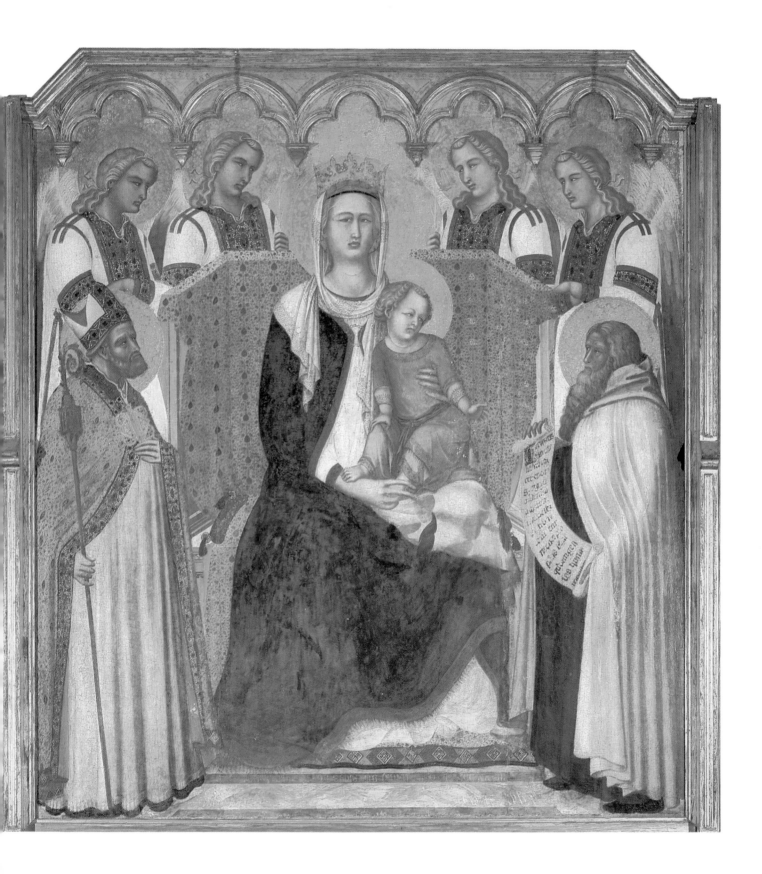

XXV. Simone Martini and Lippo Memmi, *Annunciation*, 1333, 265 × 305cm. Florence, Uffizi.

XXIII. (previous pages left) Simone Martini, *Investiture of St Martin*. Assisi, Lower Church of San Francesco, Montefiore Chapel.

XXIV. (previous pages right) Pietro Lorenzetti, *Madonna and Child with St Nicholas and Elijah* (The Carmelite altarpiece), 1329, 171 × 161cm. Siena, Pinacoteca.

correcting and even discarding of inherited techniques. If Pietro's *Birth of the Virgin* is compared with the St Francis altarpiece in the Bardi Chapel (col.pl.II), it may be noted that there is a certain uniformity of modelling in the thirteenth-century painting – towers, draperies, rocks are all striped light and dark – whereas in the fourteenth-century altarpiece, costume is modelled in one fashion, the bedspread in another, the water jugs in another and so on. The identity of things is now distinct, and the contrast between the patterned and the plain is not blurred by the imposition of strong modelling.

The lessons of plaid could only be absorbed slowly. In Simone Martini's fresco of the *Investiture of St Martin* (col.pl.XXIII), in the lower church of San Francesco at Assisi, the checks are basically white and green. How far the auburn is a fabric colour and how far a shadow is ambiguous. Simone associates local reds and auburns with the warm shadows of flesh, foiling them with apple greens and an occasional blue, which, instead of reading as shadow colours, glow as if illuminated. Such an inversion of traditional chromatic functions – warm lights, cool shadows – shows up on the rim of the hat of the recorder player (fig.63), where green is transformed to maroon in the shadow.

So the lessons of checks are twofold. Linear pattern offers an alternative to heavy modelling. (One may note how the tiled floor became popular at the same time as a handy means of providing a measure of the intervals between objects in pictorial space: it circumvented the necessity of observing cast shadows, which in Early Christian art had anchored figures and objects upon the ground and indicated its recession.) Second, the transformations of colour which a check presents shows how the shadow tone of one colour may associate with the local colour or mid-tone of another material or surface. It is this interweaving of luminary and local colour – blended in the coloured light of the wide arc of stained glass in the chapel of St Martin – which gives to the colours of Simone's frescoes a unity as natural and as strange as a tabby-cat's coat.

63. Simone Martini, *Musicians* (detail from the *Investiture of St Martin*, col.pl.XXIII).

Punchwork

Trecento patterns were not only painted, but also stamped, incised and scraped.[19] The staccato repetition of the punch answered the caressing fluency of the brush.

In his altarpiece of *St Louis of Toulouse* (fig.64) Simone extended punchwork on panel with dazzling skill.[20] The intricate punching of the ophreys of St Louis and King Robert illustrate a reversal of roles: highlights (or chrysography) have ceased to be the ornament of a panel, while ornaments have become points of light.

Punchwork on Trecento panels is rich in paradox. Around 1300 the richness of what is represented in a picture becomes an increasingly important aspect of the traditional sumptuousness of the panel as an object, but this descriptive richness supplements rather than ousts ornamental tooling. Punchwork and *pastiglio* (relief modelled in gesso) on Simone's figure of St Louis have a mimetic function, creating a pictorial equivalent to a real object. Yet these same punches are impressed in the border of the gold background to make a pattern which is not descriptive of any visual phenomenon. Yet neither is it meaningless. It incorporates the heraldic motif of the Angevin fleur-de-lis. No chasm separates descriptive from abstract use of punching, or illusionistic from decorative. Ambiguity endures (and luminary values are drawn into this ambiguity) because illusionistic description spells an order of significance which is richly confounded with the allusive significance of symbol and emblem.

If we say, then, that the ornaments of the panel have become points of light, we must recognize that the degree to which these points of light — these induced rather than described highlights — play a descriptive role is not constant; it depends upon context, the logic of situation, and upon the character and scale of the punches, whether motifs such as trefoils are recognizable, or whether the punchwork consists of representationally neutral marks such as rings or granulations.

Chrysography and linear highlights inhibited the suggestion of depth by the physical insistence with which they lay upon the surface of the panel. It is a conundrum that painters who had started to explore spatial values should have developed the indentation and punching of gold, for how could such a literal texturing of surface be reconciled with the notional variation of interval between the picture plane and the illusory forms lying 'behind' it?

Simone reconciled space and surface texture by the compelling modelling power of his line and by the fine scale of his surface markings. Just as the motifs in the patterns on the main panel of Duccio's *Maestà* hover between legibility and illegibility, so also does Simone's punchwork. No single highlight induced by the minute faceting of the gold that has been punched is large enough to disrupt the characteristic grain of the painting.

Cennini, in fact, recommends that stamping can be done either all over, or selectively as modelling: 'in the folds and in the shadows do not do any stamping; not much in the half tone; in the reliefs, a great deal; because stamping amounts to making the gold lighter; because by itself it is dark wherever it is burnished'.[21] Simone may have done this, but according to my observations he preferred to carry the punching or stamping throughout a gold cloth, as in the borders of Gabriel's stole in the *Annunciation* in the

64. Simone Martini, *St Louis of Toulouse crowning Robert of Anjou King of Naples,* main panel 200 × 138cm. Naples, Galleria Nazionale.

Uffizi (col.pl.XXV & frontispiece). Where this stole rests on the marble floor, perspective is achieved by the use of two sizes of punch with identical pattern, the larger stamped in the nearer border, the smaller in the one further away. This is highly unusual.[22] It is typical of Simone's inventiveness in seizing upon means, other than those of tonal modelling, of implying recession. Cennini is spokesman of a school and period which is less inventive in this respect; a more rigid notion of the necessary darkness of shadows underlies his descriptions of how to model.

'Sgraffiato'

Cennini devotes three chapters to describing how to paint damask of gold and silver.[23] Gold is laid over bole and burnished; the outlines of the drapery are scratched in; it is covered with the requisite colour; then a cartoon is pricked with the pattern; a contrasting pigment is pounced through the pinholes, leaving its dotted outline on the panel; and then either the paint covering the motif or the field ('o il campo o l'allaciato')[24] is scraped away to reveal the gold beneath. Cennini enumerates variations and refinements. For a blue damask a coat of white should be brushed over the gold prior to two coats of ultramarine. Vermilion and minium (orange lead) should be tempered with yolk of egg; ultramarine with size as well; lac and verdigris with oil. Colours tempered with oil

109

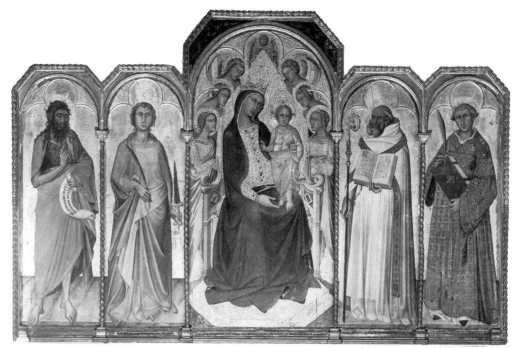

65. Niccolò di Ser Sozzo Tegliacci and Luca di Tommè, *Madonna and Child with SS. John the Baptist, Thomas, Benedict and Stephen*, 1362, 180 × 270cm. Siena, Pinacoteca.

66. Niccolò di Ser Sozzo Tegliacci, *Head of the Madonna with Angels* (detail of fig.65).

offer further refinements: an opaque egg-tempered pigment, such as vermilion (*cinabro*), can be applied, then the motif or the field scraped away and an oil-based glaze with lac spread over both the vermilion and the gold. This will create the depth of a damask, with the areas of red glaze glowing over gold. To achieve a 'velvety' blue drapery a pattern can first be applied with size, then the same blue tempered with size should be spread 'evenly all over the grounds and the patterns'.

Colour-change can be achieved by glazing over the gold. 'When you have worked with any colour you wish . . . and you want to get a shot effect (*cangiante*), work over the gold with any oil colour you please, provided it differs from the ground.'[25]

All these techniques diverge from traditional modelling. Cennini does not specify whether the pigment laid over the gold prior to scratching out is modelled. Where it was laid uniformly, modelling could be supplied by partial glazing, but if it was already modelled, contrasts could be toned down by a blanket glaze applied over motif and field, highlight and shading. In each case modelling is subdued in comparison to the local splendour of the textile.

The *sgraffiato* technique, as it came to be called, was applied brilliantly in Simone's *Annunciation*. On the vestment of Gabriel (frontispiece) he laid white over gold and scratched out a close-packed floral pattern, the motifs of which are so polymorphous that they read as neither disturbingly flat nor emphatically foreshortened. Whereas the distortions of the plaid on the cloak choreograph its dance, the vestment preserves a planar smoothness of broad expanse. The white is without intrinsic modulation; a dull blue, glazed over the gold pattern and white field, detaches the sleeve and marks the folds heaped over the archangel's feet. As description of shadow this glazing is daringly restricted. It allows the breadth of the vestment to affirm the stability and rest of arrival in contrast to the wind and movement of flight.

110

Punchwork and *sgraffiato* endow the garments in Trecento panels with great material opulence.[26] The contrast of the patterned beside the plain, the self-lit beside the modelled, is added to the traditional differentiation of draperies by colour. On Niccolò Tegliacci's *Madonna and Child* (fig.66), centrepiece of the polyptych in the Pinacoteca at Siena, the contrast between damask cloths and the plain ones which they surround is a source of compositional order. It is characteristic that the fall of light from the left, implied by the modelling of the throne, is overwhelmed by the local splendour of the damasks, and thus symmetry of colour and tone is preserved.

In Tuscany the *sgraffiato* technique buried the Byzantine sense of light as a dynamic external force striking the figures and manifested in the *splendor* of linear highlights. In the Veneto, painters such as Paolo and Lorenzo Veneziano decorated their draperies with mordant gilding rather than *sgraffiato* (col.pl.XVI). The gold nearly always constitutes the motif rather than the field, and in the main the Venetian painters preferred a dark background colour. In this they reveal their Byzantinism: the gold motifs shine against dark grounds and can be visually detached from them like the highlights of the *maniera greca*.

As far as I know *sgraffiato* was not practised on panels in the Duecento. Although related to the punching and incising of metalwork, it may be that the scraping through a layer of paint to reveal another colour beneath it was a technique borrowed from Islamic pottery. In Persian pottery of the twelfth and thirteenth centuries the design is often cut through a white slip to reveal the darker underlying clay, and the surface is then covered by a clear lead glaze. A dish in the Victoria and Albert Museum (fig.67) offers a typical example.[27] Historians of pottery have appropriated the Italian term *sgraffiato* to describe the technique of scraping through a slip.

The analogy between the Islamic potters' and the Italian painters' techniques might be regarded as coincidental if the Italians were not also adopting Islamic motifs at the same time as they took up *sgraffiato*. Pseudo-Cufic lettering is prominent as a decoration for borders in Trecento paintings.

Textiles were probably the major source of oriental motifs, but it is possible that some of the differences between Venetian and Tuscan reactions to Eastern art lay in the greater attention paid in Tuscany to Islamic pottery. The fondness for white, or near white, in Tuscan painting, not only in *sgraffiato* but also in cloths gilded with mordant, may owe something to the appeal of Eastern pots, with their gleaming white slips and lively patterns.[28]

In conclusion, the themes of this chapter may be tied together by taking a longer look at two master-works of Sienese painting, Simone Martini's *Annunciation* and Pietro Lorenzetti's Carmelite altarpiece.

67. Persian earthenware dish with *sgraffiato* decoration. London, Victoria and Albert Museum, C102–1927.

Simone Martini's Annunciation

In Simone's *Annunciation*, painted in 1333 as an altarpiece for Siena cathedral, the darkness of certain local colours, barely compromised by modelling and with contours as definite as the sutures between the blocks of white and green marble that stripe the cathedral walls, endows the other surfaces with a common radiance, as of reflected

112

light. Thus the black clasp of the Virgin's book, falling over the knob on the arm of her throne, brightens the pale wood.

Simone's command of pattern, transcending those features observed in the plaid, the punchwork and the *sgraffiato* of Gabriel's vestment and mantle, informs the ordering of his composition. In the liveliest oriental textiles and in Middle Eastern pottery, in the interplay between motif and field, attention can oscillate between positive and negative shapes. Similarly, in Simone's *Annunciation* the shape of the Madonna is eloquent in relation to the receptive hollow she leaves beside her in her movement of withdrawal. And as the gold field is drawn into the narrative, its hue, darker than the wood of the throne, the flowers of the lily, and the flesh of Gabriel, is integrated into the colour composition. The corals, auburns and reds (so reminiscent of the brick walls of Siena when they throw back the ruddy glow of the hilltop sunset) appear as metamorphoses of the gold; the greens and dark blues are its complement, and white stands apart, immaculate and virginal. The radiance of gold and of colour is fitting metaphor for the Virgin's Annunciation as described by Jacobus de Voragine: 'The power of the most high overshadowed her, while the incorporeal light of the godhead took a human body within her, and so she was able to bear God.'[29]

Haloes do not stand out as discs, but are surrounded by a radiance of fine rays, which describe a flare of light. Most cunning is the way this radiance is located in space. The rays of the Virgin's halo cross in front of the cloth draped over the left side of the throne, breaking its contour just as would a dazzling light. The depths between the gold background and the throne, and between the throne and the Virgin's head, are brought to life. The gold of nimbus and field, materially knit, are yet distinguished in space.

The forms in the altarpiece are lit from the left. It is not a raking light or a sharp one. It does not imply a point source; there are no cast shadows. It is a veiled light from a broad source. It is a soft light, the *luce temperata* that Cennini was to approve[30] and such as Simone himself had created with the arc of stained glass windows in the chapel of St Martin at Assisi. But this light from without accommodates the glow of colour achieved by simultaneous contrast and by fine judgement in the tempering and thickness of layers of pigment. More like a ripe persimmon than an orange, the glow from within transfuses the light and shadow upon the skin.

Pietro Lorenzetti's Carmelite altarpiece

On the central panel of Pietro's altarpiece (col.pl.XXIV), completed in 1329 for the Carmelite church in Siena, the accents of saturated colour – the Virgin's blue, the red lining of St Nicholas's cope – are surrounded by paler colours, whites, greys and soft blue-greens.[31] Modelled in a limited register of a light to mid-tone, these display no tone of shadow as dark as the Virgin's ultramarine. The grey vest and greyish yellow tunic of the Christ-Child are muted, his entire figure subdued, his garments blending with the flesh tones, and all a little darker than the white of the Madonna's vest. Within this setting the sap-green of the Child's sash is vivid; the lighting of its folds is picked out not in white or in yellow but in a pale whitish green. Pietro simplified tones into a light and a dark, both coloured, and between which there is a marked but not extreme jump. The light green floats over its darker partner, a mealy roughness at the edges,

never quite blended with the umber shadow that yields to and sets off the loop of sash.

Polarization towards two tones is the key to Pietro's colour, as it later would be of Masaccio's. Pairs of local colours are rhymed with the tonal polarities of modelling. The blue of the angel's wings plays against the white of their vestments, as the shaded facets of the sage-green throne play against the illuminated. Whether the interval between the pairs is due to modelling or to local colour, the effect is of a soft, lucid clarity.

On a large scale Pietro's illumination registers the orientation of forms in space: on a small scale he uses white lights to decorative and expressive effect. White, the colour of the Carmelite habit, breathes a new airiness through the scene.[32] The orphreys of the angels and Nicholas's mitre and cope are beaded with pearls. Painted in slight relief, with blobs of white of enamelled density, this pearling was a traditional technique popular in Siena. On the Carmelite altarpiece the ribbons of pearls pass without darkening from the light into the attached shadows.

As for the use of white highlights for expressive effect, notice the crisping up of hair and faces, particularly the whites of eyes, with tiny strokes. For beyond placing their figures in space and dressing them in realistic costumes, Pietro and his brother Ambrogio Lorenzetti were intent upon making their figures appear alive. To this end they directed the attention of their saints towards the Madonna and Holy Child. They turn towards them, they offer them ointment or flowers, they hold scrolls for them to read, and they look at them with rapt concentration. We are privileged to witness an event in the court of heaven, and the light on the faces, though not as fiery as in Byzantium, still flickers as metaphor for an inner state of awareness. It is the same light – an external ray, an inner power – that flashes from the eyes of the beloved in the poems of Dante, and of Petrarch:

> Gentil mia donna, i' veggio
> nel mover de' vostr'occhi un dolce lume,
> che mi mostra la via ch'al ciel conduce.[33]

Whatever the impersonality of pattern in Trecento painting, it is combined, to a degree unthinkable in a Persian miniature, with a personal sense of the human as incarnate image of the divine, seat of will and emotion. This marriage of oriental pattern with the classical conception of man's sovereign power, gives to the most fully realized art of fourteenth-century Italy its enduring fascination.

VII. Gentile da Fabriano

Stigmatization by light

After Taddeo Gaddi's contribution in the Baroncelli Chapel it was not until the 1420s that the treatment of light in Florentine painting received radical recasting. This was due largely to the influence of two painters, Tommaso di Giovanni, known as Masaccio, and Gentile da Fabriano. Born in about 1370 in a small town in the Marches, Gentile had been trained outside the Giottesque tradition of monumental fresco painting. In the course of a peripatetic career that took him from Fabriano to Venice, Brescia, Florence and finally Rome, he was drawn to the techniques and refinement of detail of illuminators — a self-contained world of illusion — rather than to the architectonic character of fresco where the painted wall is conceived as 'in dialogue' with the light and space of the ambient. The major altarpieces that Gentile executed in Florence must have seemed like a challenge to Tuscan habits of colouring, composition and modelling.

It may have been shortly after his arrival in Florence, in 1419 or 1420, that Gentile demonstrated his mastery of luminary phenomena in the *Stigmatization of St Francis* (col.pl.XXVI).[1] On this panel the stigmata of the Christ in the seraph are connected to those of Francis by gold rays edged with scarlet, but the spiritual influence — the flow of love divine — is expressed by light. Doubtless Gentile, like Taddeo Gaddi before him, was inspired to render the space-traversing power of light by the words of the *Fioretti*: 'The whole mountain of La Verna then appeared burning with resplendent flame, which shone forth and illuminated all the mountains and valleys round.'[2] And, again taking his cue from the text, Gentile draws a parallel between Francis and the Virgin Annunciate by the inclusion of an Annunciation around the door of the mountain oratory. Just as the Virgin bore Christ in her body, so Francis bore in his body the wounds of the Saviour.

A text may offer a motive, but it does not instruct as to how it may be realized in paint. Gentile describes the radiance of the seraph by rays and by modelling. Since the rays incised into the gold do not end where the gold background abuts the landscape, but continue a short span over the rocks, trees and chapel without quite reaching Francis and Brother Leo, the overlap locates the seraphic source between the mountainside and the figures. To reveal the further reach of the seraph's radiance — a radiance so strong that Brother Leo must shade his eyes from its painful brightness — Gentile introduces golden-hued modelling on the mountains. Light, as never before, leaps across space.

The modelling on the mountains and chapel implies a direction in accord with the

115

position of the seraph, whereas on the figures there is inconsistency. With unprecedented daring, Brother Leo is shown in *contre-jour*, his body casting a dark shadow towards the foreground, while St Francis casts no such shadow, for here Gentile is constrained to compromise the spatial logic in favour of the frontal presentation and lighting deemed fitting for the principal subject of a sacred painting. Turned towards us, the saint exposes his stigmata, his body as open to the light as it is open to our view.

Gentile builds around the contrast of light and dark, sacrificing multiplicity of local colour to luminary effect. Between the lights in gold, yellow, red and pale reddish brown, and the darks in a blackish green, a few browns mediate. Dark oaks foil the brightness of the saint. Instead of Cennini's graded sequences, mid-tones are restricted: golden lights pick out oak leaves from the forest darkness. But texture is not denied. Brushstrokes, as minute and as distinct as an illuminator's, suggest the characteristics of surfaces as well as the luminary effects. Rough transitions in the Franciscan habits describe the nap of coarse cloth. Rather than simply modelling the dun habits with golden highlights, Gentile lays in strokes of greenish umber, an undertone that links figures with ambient and strengthens chiaroscuro by contrast of gold against green. For the traditional terraverde in the flesh shadows Gentile had little use, preferring to endow his figures with a positive tawny complexion.

Bright light and dark shadows bring dangers of fragmentation. At first glance we might suppose that Brother Leo sits on the edge of a cleft like the one that separates him from Francis, but looking closer we discover that the grass and flowers continue across light into shadow. The whole area is laid-in with the same dark tone; then, by an illuminator's technique of hatching individual white strokes over this ground, Gentile achieves an effect like sunlight shining through grass; in the shadow he hatches the blades much more darkly. By never losing sight of the nature of this grass – describing how it is bent beneath Leo's hand and seat – Gentile establishes a continuity of texture underlying the potentially disruptive pattern of light and shade.

Textiles and texture

Gentile never quite succeeded in painting texture, colour and light in such harmony on a large scale. In the main panel of his great *Adoration of the Magi* (col.pl.XXVII), painted in Florence in 1424, descriptions of texture stand apart from luminary effects.[3] The light of the star above the cave is treated only half-heartedly as the source of light in the foreground scene because the artist's attention has been absorbed in the literal imitation of surface textures: the sumptuous brocaded costumes of the three kings have been fashioned by laborious punching, striating and partial glazing of burnished gold and silver leaf; crowns and caparisons have been built up on the surface in gilded pastiglio; in places the weave of cloth has been rendered thread for thread by striations in the surface. Such counterfeiting of material textures creates passages that appear independent of pictorial light, conditioned instead by the actual fall of light on the surface of the panel and by the angle of the spectator's view. The glitter of reflecting surfaces is by nature tonally unstable – as Alberti was to point out in *De pictura*, 'when done in gold on a flat panel, many surfaces which should have been presented as light and gleaming, appear dark to the viewer, while others that should be darker, probably look brighter.'[4] And there is a further pitfall. Literal texturing of surface denies

68. Gentile da Fabriano, *Midwives* (detail from the *Adoration of the Magi*, col.pl.XXVI).

116

atmospheric effects of distance, not only in terms of tone but in the degree to which details are visible. Thus the punched golden shoulder pieces of the figure in red towards the back of the crowd jump forward in contradiction to their implied position in space.

Yet there are passages in the *Adoration* which reconcile the reflective surface and pictorial light. The highlight on the flesh of the neck and shoulder of the midwife on the far left is continued over her red robe by gold dots applied with mordant (fig.68). Unvarying in its intensity, the vermilion is modelled solely by the selective placing of the gold reflectors, a device that allows Gentile to model while retaining stark contrasts of local colours. Where Agnolo Gaddi might have continued his light tone over the lining of the mantle, Gentile relishes a contrast and halts the highlight on shoulder and robe against the dark blue of the mantle's lining. Strong tonal contrasts in the pattern of object-colours are counterpointed by sharp luminary accents, as in the juxtaposing of the Turkish towel headdress beside the bright highlights on dark brambles. In this weaving of analogies between pattern and light in the fine fabric of his painting, Gentile reveals a sensibility towards the visual world of a high order and one rather apart from the more conceptual, more monumental outlook of the Tuscan tradition.

The three predella panels to the *Adoration* display remarkable descriptions of light. In the nocturnal *Nativity* (fig.69) the glory that shone around when the angel appeared to the shepherds, the radiance of the Holy Child, and the moonlight and starlight, are all differentiated. In the central scene of the predella (fig.70), which may represent the *Journey from Bethlehem to Jerusalem* rather than the *Flight into Egypt*,[5] he took up again the *contre-jour* he had tried out in the *Stigmatization of St Francis*, now treating it unequivocally as the effect of looking directly towards the rising sun, which gleams as a ball of gold embossed on the blue sky. To describe its morning rays streaming over the landscape, first Gentile laid gold leaf, burnished it, glazed over it the green of the fields, then scraped through the green to reveal streaks of shining gold – a device that must have originally charged the landscape with rhythm emanating from the sun but which is now blurred by further losses of pigment. In addition to the underlying gold, Gentile introduced warmly toned lights on the oatmeal of the hills to describe the reddish hue of the dawn sunlight, a positive luminary colour interpenetrating and

69. Gentile da Fabriano, *Nativity* (predella to the *Adoration of the Magi*), 25 × 62cm. Florence, Uffizi.

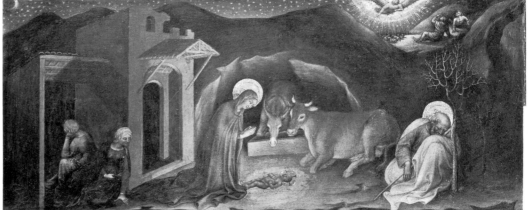

XXIX. Lorenzo Monaco, *Coronation of the Virgin*, dated February 1413, Florentine style, = 1414 modern style, 247 × 373cm. Florence, Uffizi.
XXVII. (facing page top) Gentile da Fabriano, *Adoration of the Magi*, 1423, 300 × 282cm. Florence, Uffizi.
XXVIII. (facing page bottom) Gentile da Fabriano, *Presentation of Christ in the Temple* (predella to the *Adoration of the Magi*), 25 × 62cm. Paris, Louvre.

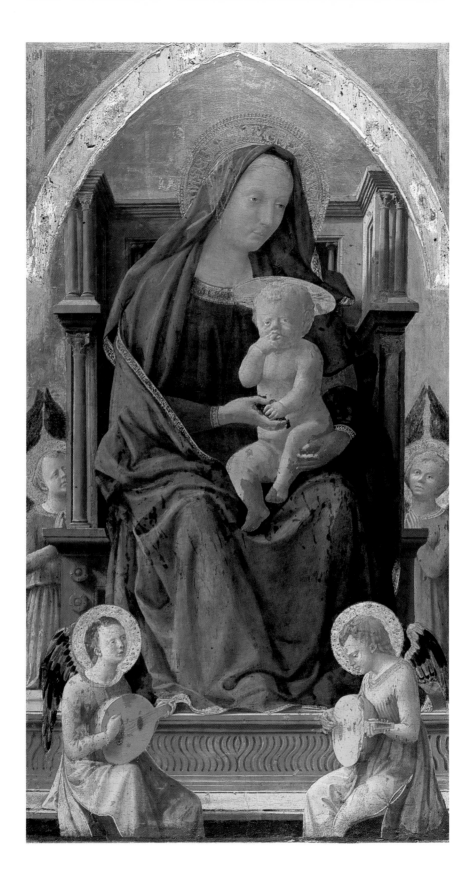

modifying local tints. Inanimate objects such as castles, hills, fields and trees are lit by this light, the trees on the left even throwing down shadows on the path in the foreground. And by means of this raking light Gentile offers a feast of surfaces, delighting to show how the low sweep of light picks out any corrugation or unevenness, as on a tiled roof, furrowed field or stony path. But the figures, bolstered by the central hill, are modelled according to the convention which uses shading to render the recession of the folds away from the line of sight; to have done otherwise would have left the most significant part of the subject in the undignified obscurity of *contre-jour*. As always in Early Italian painting, luminary realism is tempered by the conventions governing the representation of religious subjects.

In the *Presentation of Christ in the Temple* (col.pl.XXVIII) surfaces are, as usual in Gentile, distinguished by their characteristic textures. Whereas a Tuscan working in the tradition of Agnolo Gaddi – Niccolò di Pietro Gerini for example – distinguished buildings and their parts by changes of hue, such as alternating rose and green, Gentile pays more regard to the nuances of building stone, softens contrasts of hue, and distinguishes between surfaces by varying types of rustication and masonry pattern. Such attention to the textures of buildings as revealed by light may have been fostered during his early years in Venice: the house on the right has the type of window found on the canal façades of Venetian Gothic palaces.

In the most distinguished Tuscan fresco cycles all solids are modelled lightest on the same side according to the position of the largest window in the chapel. The convention was established by Giotto and described in a somewhat garbled fashion by Cennini:

> If, by chance, when you are drawing or copying in chapels, or painting in other adverse situations, you happen not to be able to get the light off your hand, or the way you want it, proceed to give the relief to your figures, or rather, drawing according to the arrangement of the windows which you find in these places, for they have to give you the lighting. And so, following the lighting, whichever side it comes from, apply your relief and shadow, according to this system. And if it happens that the light comes or shines through the centre straight ahead, or in full glory, apply your relief in the same way, light and dark, by this system. And if the light shines from one window larger than the others in these places, always follow the dominant lighting; and make it your careful duty to analyze it, and follow it through, because,

XXX. Masaccio, *Madonna and Child* (central panel of the Pisa altarpiece), 1426, 135 × 373cm. London, National Gallery.

70. Gentile da Fabriano, *Journey from Bethlehem to Jerusalem* (predella to the *Adoration of the Magi*), 25 × 88cm. Florence, Uffizi.

if it failed in this respect, your work would be lacking in relief, and would come out a shallow thing of little mastery.[6]

Cennini's priority is to teach mastery of relief rather than the spatial logic of pictorial light. He does not entertain the possibility that if an interior and an exterior are described within a single field some distinction should be made in the modelling of the figures. On the small scale of Gentile da Fabriano's *Presentation* predella just such a distinction is made: the cityscape is lit from the left, the interior of the temple is lit by the lamp hanging in the centre, and the arcade provides a transition between the two. Daylight is gently diffused into the dim recesses of the loggia on the right, casting shadows from the tie-bars onto the walls. The temple, by contrast, is open to our view only by convention, and daylight does not penetrate the sanctuary. Here Gentile renders lamplight by painting the wall and windowsill it illuminates a warm brown-gold and shading them into a dark umber-green very like the umber-green which modulates the shadowy area where the radiance of the Child begins to wane in the predella of the *Nativity*. In the *Presentation* the heads of figures almost hidden behind Mary and Simeon are just hinted at by subdued highlights, blurred and tawny, in an indistinct ambient of dull green – a most convincing rendering of the limited reach of artificial illumination.

Gentile's responsiveness towards the natural colours of materials is evident not only in the buildings but also in the secular figures, both rich and poor. In the linsey-woolsey of the beggars Gentile eschews all decorative colour. He models flesh and garments in buffs and neutrals, and within this narrow range creates drama in the exact yet mobile tonal values. Such a detail could well have borne a lesson for Masaccio.

From richness of colour to the colour of riches

As long as it is uppermost in a painter's mind that the blue of the Madonna's robe signifies her dignity as Queen of Heaven, and the whiteness of her veil her virginal purity, he will be inhibited from attending to such gross material qualities as texture. In the work of Lorenzo Monaco, a monk of the Camaldolese branch of the Benedictines, the most intense colours are concentrated in the draperies; their hues, largely determined by iconographic tradition, are enhanced by a system of alternation between robes, linings and inner vestments (col.pl.XXIX). Pigments tend to be used in a pure state rather than in mixtures: lapis lazuli and vermilion are usually applied saturated, with only minimal modelling, while other pigments are more often modelled by the addition of white rather than neutral darks. Lorenzo Monaco's modelling does not inform of texture: the iconographic colours, remote from visual referents, are allied to decorative alternation of hue.

In Gentile's paintings this alliance between iconographic codes and alternations of pure hue is breaking down. Boldly oversimplifying, it may be said that a religious, quasi-abstract code of colour symbolism is giving way to a descriptive mode rich in social as well as physical distinctions. Take Gentile's treatment of gold. While it seems unlikely that the gold backgrounds of fourteenth-century panels strictly speaking represent heavenly light, the gold of frame and background advertise the transcendent preciousness of the sacred image. In Gentile's *Adoration*, though gold may fulfill its

124

traditional function on the frame, in the narrative its sacred connotation is eclipsed by its use to denote such golden objects as stirrups, bridles and brocades. To the contemporary viewer such trappings in gold would have added more than decorative richness to the picture. The privilege of bearing accoutrements in gold – notably spurs, the hilt of the sword, the tip of the scabbard, and the bridle – was restricted to the special class of *cavalieri aurati*, 'the golden knights'. It is surely not accidental that the man who paid for the altarpiece, Palla Strozzi, belonged to this chivalric order.[7] By stressing the trappings of knighthood the patron is flattered and attention diverted from the sacredness of the image to the material value of the things represented. Gold, far from being set apart, appears as but one of a number of signs of social status and wealth.

If we compare Gentile's *Adoration of the Magi* with Simone Martini's *St Louis of Toulouse crowning Robert of Anjou King of Naples* (fig.64) we are aware that both altarpieces convey messages about high social status, but that in the *Adoration* the regal protocol is presented with remarkable informality and deliberate casualness. In the St Louis altarpiece the ritual significance of the act of coronation is sustained by the hieratic formality of design; meaning does not reside purely within the descriptive or mimetic elements of the painting but flows or eddies back and forth between the descriptive, the decorative, the structural and the emblematic. As noted in the previous chapter, the Angevin fleur-de-lis is prominent in the non-representational punchwork of the gold border and on the frame as well as in the descriptions of the garments of the figures. This enduring ambiguity, by which luminary values were – in no pejorative sense – compromised, is diminished. Even the decoration of the frame undergoes a naturalistic transformation to emerge as flowers peeping through apertures. Within the narratives the signs of status, such as spurs, crowns, bridles, are not set apart as sacral objects; a gift from the Magi has become an object of curiosity on the part of the midwives. The accommodation of gold within a descriptive colour scheme was integral to this process of naturalization.

From his earliest years Gentile succeeded in harmonizing gold with a personal palette of russets, maroons and auburns. The hue of gold was not isolated. In the *Adoration of the Magi* non-spectral colours, especially browns, link drapery and flesh colours, the colours of horses and of the earth. The gamut is darker than usual in Tuscan painting, and far removed from those simple, clean-edged and planar juxtapositions of colour and tone which took their cue from the ordered polychromy of Tuscan Romanesque architecture (e.g. fig.52 & col.pl.XXI). The methods of modelling are varied. Many draperies are modelled, not by an addition of white to the pigment mixture, but by a controlled looseness in the consistency and brushwork: by this means the whiteness of the gesso is allowed to show through – as a broken, shifting tone – where a highlight is required. Such modelling by control of density allows for the simulation of textures. Occasionally an optical tone (colours fusing in the eye) is created by an elementary pointillisme: this could consist of light dots on a darker ground, like the gold reflectors on the red robe of the midwife, or of dark dots on a lighter ground, like the dark flecks on Joseph's vestment of pale lavender-mauve. All these techniques introduce variety of colour and texture into the grain or microstructure of the painting, a fine weave of descriptive variety which pre-empts the massing of colours in bold decorative alternation. The increase in mixed and desaturated colours reduces the insistence of

chromatic contrast and shifts attention towards tone. Alberti's strictures against the application of gold leaf should not prejudice us against recognizing that Gentile seems to make an attempt – which is necessarily incomplete and partial – to treat gold as the summit or highlight of a tonal system.

To speak of system may imply too great a degree of self-conscious deliberation. The awareness of a range from darkness to light, into which colours must be fitted and to which at times they must be subdued, may stem from Gentile's esteem for the casual as token of the realistic. In the *Presentation of Christ in the Temple* the placement of the strongest colours is markedly asymmetrical. Iconographically determined colours are no longer overwhelmingly insistent: even the blue of the Virgin's mantle is desaturated. Gentile's alertness to those incidents, seemingly insignificant, which are the stuff of everyday life shows itself in a new informality. While her companion sleeps, a midwife peers around the corner of the stable in the *Nativity*, steadying herself with her hand as she cranes her neck. And we are reminded that events take place in time. One sleeps, another wakes. The night of the *Nativity* will be followed by the sunrise of the *Journey from Bethlehem to Jerusalem* – where the dawn mist has not yet been dispelled from the distant hills.

Whereas in the Giottesque tradition, which Masaccio was about to revitalize, light simplifies forms, orders and directs attention, Gentile's light is not always congruent with the human or religious focal points of the story. In the *Journey from Bethlehem to Jerusalem* the midwives and Holy Family are untouched by the dawn light. If, as we shall see in the next chapter, Masaccio's light underlines the moral force of the narrative, Gentile's describes the quotidian reality in which the story happens to be submerged.

Palla Strozzi's altarpiece

Gentile's *Adoration* was commissioned for an altar in a chapel attached to the sacristy of the church of Santa Trinita by a leading member of the Florentine oligarchy, Palla Strozzi.[8] What relationship can be discerned between patronal expectations and Gentile's performance? From the outset it should be borne in mind that Gentile arrived in Florence as a mature artist with a fully fledged style and a considerable reputation from his work for the government of Venice and for princely patrons in northern Italy. It is unlikely that any Florentine patron would have dreamt of changing Gentile's style, but rather would have wished to capitalize on its strengths. Palla Strozzi, the wealthiest man in Florence in the 1420s, may have believed that only the courtly style of Gentile da Fabriano could have provided the splendid display his wealth and rank merited. He may even, it has recently been suggested, have had in mind Aristotle's doctrine, put forward in the Nicomachean Ethics, a text owned by Palla, that spending on public ostentation should rightly be measured in proportion to the assets and rank of the patron.[9] Certainly, for his lavish expenditure Palla was rewarded with a sumptuous display; and the knightly accoutrements so prominent in this display would doubtless have reminded Florentines of Palla's dignity as a member of the *cavalieri aurati*. The sumptuous brocades and velvets, though in part derived from theatrical costume,[10] would also have found analogies in the conspicuous wealth of a Florentine magnate's wardrobe.[11]

But Palla was not only rich but a man of literary culture, an intimate of the humanist circle. Humanist ways of speaking about painting and sculpture, in particular their fondness for *ekphrases*, eulogistic descriptions, would have conditioned his expectations and taste. A painting that invited *ekphrasis* was one with copious variety of content, such as figures and animals, buildings and landscape.[12] The ekphrastic mode had been demonstrated by Manuel Chrysoloras, the influential teacher of Greek in Florence around 1400. He reasoned in a letter: 'We do not concern ourselves with whether the beak of a live bird or the hoof of a live horse is properly curved or not, but we do with whether the mane of a bronze lion spreads beautifully, whether the individual fibres or vessels are visible on the leaves of a stone tree or whether the sinews and veins are shown in the stone leg of a statue.'[13] With such attention to minutiae, typical of early humanist ekphrastic discourse, no optical principle controls how much detail is visible from a particular standpoint, or rather the notion of fixed viewpoint with the limitations that it implies is absent.

We may readily imagine how Gentile's paintings, with their descriptive variety and distinctions of texture, offered an abundance of material for this kind of free-ranging discourse. It is unlikely that he adapted his style under the influence of humanist ways of talking about painting: he did not need to, as his art was already suitable material for *ekphrasis*.

The rhetoric of *ekphrasis* thrives on antitheses, but not all antitheses are equally translatable from words into visual art or vice versa.[14] Colour contrasts – chromatic antitheses – are difficult to translate into words; thus Lorenzo Monaco's paintings do not invite literary paraphrase. In Gentile's art, on the other hand, Palla and the humanists could have seized upon antitheses that can easily be put into words. There is no difficulty in pointing out that the rich ladies on the left of the *Presentation in the Temple* stand as the social opposite of the beggars on the right, and that the upright carriage of the socially exalted contrasts with the lowly postures of the crippled and mendicant. Neither is there any verbal difficulty in describing Gentile's obvious antitheses between celestial and natural light, day and night. Within such a system of contrasts, Gentile's light, we may finally realize, far from being, as Masaccio's was to be, a pervasive, directed stream that renders all solids visible and orientates them in space, is yet another ornament that adds to the richness of content displayed in his paintings. In the fifteenth century Florentine painters were to be torn between the attraction of Gentile's particularity and their native instinct that pictorial light should share in a universality that transcends content.

VIII. MASACCIO

The Pisa altarpiece

Masaccio was born in 1401 in the small town of San Giovanni Valdarno, some thirty miles south-east of Florence. Unlike Gentile da Fabriano he arrived in Florence when still a young man, certainly by the age of twenty-one, and without – as far as we know – significant experience of art centres outside Tuscany. His art was grounded within the tradition of fresco painting. What distinguishes it fundamentally from that of Gentile is his extraordinary dramatic sense that whatever he describes exists in relation to a viewer. Not only perspective, but colour and light are governed by this subjectivity. Configurations of light and shadow, far from being ornaments or attributes of the things described, are an index of a point of view.

In 1426, three years after Gentile signed his *Adoration of the Magi*, Masaccio was commissioned to paint an altarpiece of the *Madonna and Child with Angels and Saints* (col.pl.XXX) for the church of the Carmine in Pisa.[1] The wooden panel and its supporting predella had already been furnished by a Sienese carpenter.[2] At the outset Masaccio must have noted that the eye-level of a spectator standing on the altar step would correspond to slightly more than one-third of the height of the central panel. He then constructed the Madonna's throne so that its seat coincided with this level – the level of the vanishing point of his perspective construction. What must be stressed is not only that the throne is described from a fixed point of view, but also that the point of view regulates the design of the throne itself.[3]

Next Masaccio must have chosen the angle of light. Like the height of the vanishing point, this, no doubt, would have been influenced by the prevailing light in the church, but the subsequent rebuilding of the Carmine precludes reconstructions of this with any certainty. Masaccio's pictorial light falls transversely from the left. Its angle, of approximately 40 degrees, is indicated by the shadows cast by the left wing of the throne and the projecting moulding of the seat.

Masaccio took into account that we look *down* on the lute-playing angels and *up* at the head of the Madonna. Single-point perspective introduces a ratio that governs appearance according to the position of objects relative to the vanishing point. In counterpoint to this instability of appearance relative to position, the light is constant in angle and intensity, as though it emanated from a distant, large source, such as the sun. Here we must recall our discussion of the art of Cavallini and Giotto. Take Giotto's use of the contrast between the view from *below* and the fall of light from *above*: Masaccio rediscovers this. Not only are we shown the undersides of hands, mouldings and draperies in the upper half of the picture, they are also shaded emphatically.

71. Masaccio, *Lute-playing Angel* (detail from the Pisa altarpiece, col.pl.XXX).

129

72. Masaccio, *Adoration of the Magi* (predella to the Pisa altarpiece). Berlin, Staatlich Museen Preussischer Kulturbesitz, Gemäldegalerie.

In the strength of his pictorial light, and in its raking, lateral direction, Masaccio goes far beyond Giottesque precedent. The strength of light is indicated by bold contrasts between highlight and shadow, and also by the reach of cast shadows across space – notably where the Madonna's shadow darkens the right wing of the throne. Its raking direction is emphasized by its strength; and its strength by its raking direction. Such illumination from the side divides solids into balanced masses of light and shadow, with the demarcation tending to fall centrally, in a prominent, eye-catching position. Not flinching from the abruptness of the transition, Masaccio presents his forms in terms of two dominant planes, one oriented towards the light, the other turned away.

In the predella panel of the *Adoration of the Magi* (fig.72) bars of light and shadow clarify the position of figures and horses upon the ground and indicate the depth of landscape. Unlike the diagonal cast shadows in the fifth-century mosaics of Santa Maria Maggiore in Rome, Masaccio's do not point or lead towards the distance.[4] They imply distance atmospherically through the alternation of light and dark, and by an increasing breadth and blurredness in the transitions. They do not distract from the frieze-like rhythm.

Lateral light, by illuminating the side more than the front of a solid, undermines the convention, still employed by Agnolo Gaddi, that shading indicates recession. Thus, even though Cennini had told the painter to take his cue from the dominant direction of real light when working in a chapel, his instructions for modelling faces or draperies are designed to create relief by identification of highlight with projection and shadow with recession.[5] In severing this link, Masaccio plays the subjectivity of point of view against the objectivity of directional illumination. And by letting highlight and shadow take their places according to the direction of light, rather than according to pre-conceived conventions of modelling, he opens the act of painting to visual discovery. Let us consider how this might come about.

The Madonna and Child and the angels on the central panel of the Pisa altarpiece share a solemn mood that is explained by Christ's act of eating the grapes symbolic of

his Passion. Masaccio must have started work with this iconography in mind – it may well have been suggested by the Carmelites or by the patron, the Pisan notary Ser Giuliano – and this may account for the basic attitudes of the figures. It may have determined whether they smile or frown. But the act of realizing the figures according to a strict point of view and under a consistent direction of lateral light introduces – paradoxically – an unpredictable element beyond the control of priest or patron. As Masaccio bent hand and mind to painting the pensive inclination of the Madonna's head, he noticed how placing a patch of light near the corner of the Madonna's lips expressed the thoughtfulness in their pursing. No patron could dictate that such an expressive nuance be included; nor did the artist necessarily foresee it. The painter does not seek, he finds. Masaccio's attention to light as an external force subtly changed the status of descriptive content. As he disciplined himself to observe the flow of light over form – no doubt with the aid of the living model as well as sculpture – he discovered a fullness of existence in a world objectively detached from himself. A parallel might be drawn with the classical sense of the independence and resilience, the innate *virtù*, of the individual, which the contemporary humanists publicized with such fervour.

The reading of pictorial light is tied to judgements about orientation. We have seen how Cavallini and Giotto made advances in this respect, whereas Taddeo Gaddi's explicitness divorced the perception of slant from that of lighting. Masaccio restores their mutual dependence. He describes the inclination of surfaces in terms of pairs at complementary angles. Observe the Pisa Madonna: mask from view the lute played by the angel on the left, and the shape of the lute on the right (fig.71) becomes slightly difficult to determine – and would much more so if you had no memory image of a lute. Seen in conjunction, the shapes of the two lutes are explained, their orientation and lighting more vividly apprehended.

The juxtaposed orientations revealed by directional light, so obvious on the lutes, give life to the figures. Light underlines the opposed directions in which Mother and Child face – or is it light that is underlined by their contrasting axes? What is certain is that the composition could not have been evolved without taking the lighting into account. Imagine the light reversed, falling from the right: the illuminated flesh of the Child, the hinge on which the composition turns, would have lurched to the right. The tonal asymmetry would have been disturbing. As it is, the radiance of Christ's flesh, its blondness echoed in the flaxen lutes, reconciles the illumination with the gold of the background.

In the paintings of a late Gothic artist such as Lorenzo Monaco (col.pl.XXIX), modelling expresses the graceful pliancy of form; the alternation of light and dark tones accommodates and yields to the unifying flow of line; any hardness, or obduracy, would disturb. By contrast, the throne of the Pisa Madonna is resolutely unyielding. Masaccio rejects the elasticity of the Gothic arch; he welcomes the firm opposition of verticals and horizontals offered by a classical style; and he abandons the interweaving of local colours so evident in Agnolo Gaddi's *Coronation* (col.pl.XX). Modelling no longer expresses the pliancy of form; it reveals its fixity in space, its density of surface.

Colour, relieved of its attachment to absolute symmetry and applied with a Giottesque preference for unity of hue to match unity of form, appears as a more specific attribute of material things, yet an attribute that is not absolute but subject to the effects of illumination. The monochrome intervals, established by the grey throne, show off the individuality of the drapery colours as well as their separation in space. Abandoning the repetition of identical hues traditional in Early Italian panels of an iconic nature, Masaccio links a family of colours in a chain.

The humanist Cristoforo Landino, writing in the late fifteenth century, characterized Masaccio's painting as 'puro sanza ornato'.[6] There can be little doubt that Masaccio's 'purity' and his purposeful restraint in the use of colour owed a great deal to classical precedent. In Pisa he saw antique sarcophagi (fig.73), from which he derived the wavy strigilation on the platform that supports the Madonna's throne.[7] Unlike cosmatesque inlay, which decorates by jigsaw alternations of coloured glass and stones, the strigilated pattern is made visible by the alternation of light and shade on the gouges in the surface of the stone. Cosmatesque inlay will not change its appearance markedly according to the direction of light incident upon it, whereas a strigilated pattern undergoes subtle variations. What holds for strigilation also applies to the more complex case of a figurative relief – such as the Phaedra and Hippolytus on a sarcophagus at Pisa (fig.74) – where form is revealed by light and shade (the modulations of tone) on the monochrome surface of the marble. In the process of carving, the classical sculptor was singularly aware of the angle or inclination of every projection in relation to the plane of the block. Masaccio's style, pure and without ornament, recreates the uncluttered conditions for this orientation of forms emergent, as it were, from the broad support of the relief plane. Landino recognized this when he described Masaccio as 'optimo imitatore di natura, di gran rilievo universale' – a very good imitator of nature, with great and comprehensive relief. Indulgence in textile patterns (*ornato*) of the kind in which Gentile excelled would have undermined the universal quality of this relief.

The 'Trinity' in Santa Maria Novella

As in the central panel of the Pisa altarpiece, Masaccio's fresco of the *Trinity* in Santa Maria Novella (col.pl.XXXI) presents figures within the geometry of architecture. Again, the centralized perspective corresponds to the eye-level of a spectator standing on the floor of the great Dominican church. Though not as monochrome as the Madonna's throne, the architecture of the *Trinity* serves as a symmetrical structure against which the asymmetry of lateral light may be registered. Unlike the elastic proportions of the Gothic style, the fixed proportions of the classical orders establish the invariant structure of the architecture as enduring through all distortions due to perspective and lighting.

The sizeable literature on Masaccio's *Trinity* has largely overlooked how its lighting as well as its perspective relates the pictorial to the real world.[8] By placing the donors on a step outside the chapel, Masaccio implies that they are on our side of the wall of the church, directly in the space and light of the aisle (fig.75).

The architecture is lit from the left, that is from the south-west, the predominant direction of light in the aisle. Since, in pictorial terms, the only aperture that could admit light into the Trinity Chapel is the arch through which we view it, it would seem

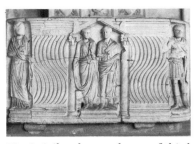

73. Strigilated sarcophagus of third century. Pisa, Camposanto.

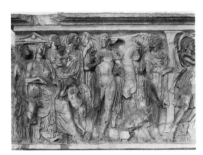

74. Sarcophagus of late second century depicting myth of *Phaedra and Hippolytus*. Pisa, Camposanto.

75. Interior of Santa Maria Novella, Florence, with the *Trinity* by Masaccio.

132

that the illumination of the interior must appear to flow in from the exterior. This was not simply a matter of taking a dominant direction of light from the real light of the setting and applying it throughout the pictorial space, which was standard in the Giottesque tradition and repeated in Cennini's instructions to painters: what is new is the concept of pictorial light as an extension of the light of the church, therefore no longer free to reach anywhere in pictorial space but conditioned by the distance from the fictive aperture.

This was the logic of Masaccio's scheme. Looking closer we come up against puzzling evidence. The male donor is not lit from the left with the same consistency as the architecture; the near side of Mary's nose and cheek are shaded as if lit from the right and even from the rear; down the left-hand side of St John a shadow is cast against the screen, which has been certified by the restorer, Tintori, as 'entirely authentic'.[9]

Do these discrepancies suggest that the figures are lit by some other source than the dominant direction of light in Santa Maria Novella? At least one supernatural source is indicated: the strong shadow on the cross to the left of Christ's head could not have been caused by the light falling from the left into the chapel, but appears to be caused by Christ's halo intercepting the gold rays that fan out from the head of the dove.[10] Whether one can claim that Mary is lit by light emanating from the Trinity is dubious, and certainly this would not explain the shadow to the left of St John. Symbol hunters too often overlook the exigencies of modelling: the shadow beside John sets off the rose of his mantle; the face of Mary if lit from the front would lose its dramatic force.

Masaccio knew that consistency in direction of light should be compromised for the sake of relief, or for balance, or for iconic propriety. Thus the frontal light that falls on Christ and God the Father is appropriate, and accords with their presentation in frontal perspective rather than as foreshortened from below. Whereas the passages from light to shadow in Jan van Eyck's *Arnolfini Marriage* (fig.76) prompt us to explore the space surrounding the figures, the anthropocentric bias of Italian art emerges not only as a factor in composition but also as a tendency to reserve the attraction of light for the figures. In the *Trinity* Masaccio achieves this with discreet tact by bathing the interior of the chapel in a broad penumbra which subdues the architectural perspective – the virtuosity of which might otherwise have stolen the show – and directs attention to the figures, whose pale flesh picks up the light. Amongst much that has been written about how Renaissance painters softened the insistence of linear perspective, too little has been said of subduing by shadow.[11] It was to be a crucial ingredient of High Renaissance style, and already in Masaccio's *Trinity* a generalizing veil of shadow liberates colour from too close an attachment to particulars and returns it to the domain of the bodily and instinctual.

When Masaccio took his cue for the pictorial light in the *Trinity* fresco from the prevailing light in the aisle of Santa Maria Novella, he realized that its direction was not constant, and therefore to describe a precise pictorial light would be self-defeating. By generalizing breadth he could make his pictorial light appear more satisfactorily congruent with the changeful light of the setting. Polychromy, banished from the throne of the Pisa Madonna, is introduced in the terracotta membering and in the rose and blue coffering of the vault. By linking these colours to the rose, red and deep blue of the draperies, Masaccio established a balance that is abstract in its order, universal in its

76. Jan van Eyck, *Giovanni Arnolfini and Giovanna Cenami* (*Arnolfini Marriage*), 1434. London, National Gallery.

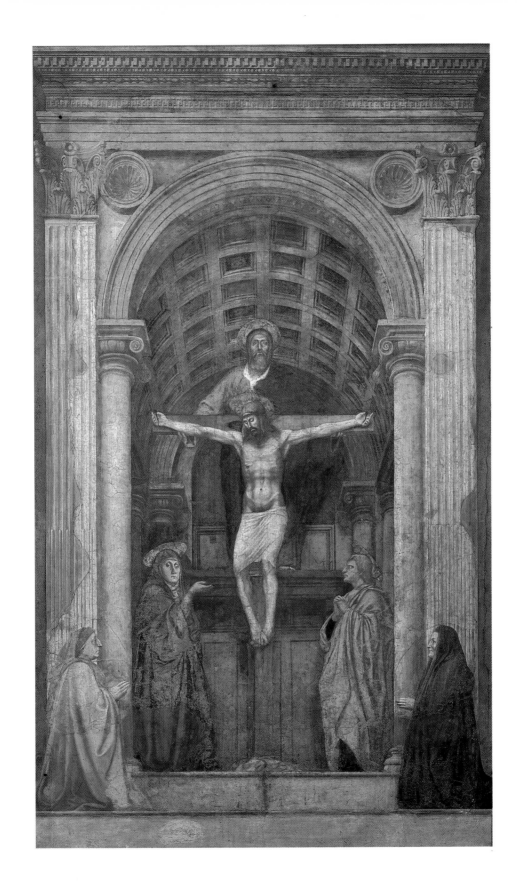

resonance, yet more rooted in material things – cloth, stone, terracotta – than the decorative interweaving of colour that we found in Agnolo Gaddi.

77. Masaccio, *Tribute Money*. Florence, Santa Maria del Carmine, Brancacci Chapel.

The frescoes in the Brancacci Chapel

To take the measure of Masaccio as a colourist we must turn to the scenes of the life of St Peter in the Brancacci Chapel in the church of the Carmine in Florence. These frescoes survive in a sadly damaged state. They narrowly escaped the fire that destroyed the Carmine in the eighteenth century, and they may well have been irreparably darkened and damaged by subsequent restorations. We are fortunate, however, in being able to compare the frescoes generally accepted as being by Masolino with those given to Masaccio. If both have suffered equally, as is likely, then discrepancies are revealing. For example, in Masaccio's *Tribute Money* (fig.77) Peter's cloak – in all three instances – is an earthy, almost orange ochre, whereas in Masolino's scene of *Peter preaching* he has a yellower cloak. From this we may deduce that Masaccio deliberately subdued his yellow (the iconographically appropriate colour for St Peter), particularly in the last scenes he frescoed, so that it would not disturb the luminary values.

In the settings for his narratives Masaccio prefers browns and umbers to neutral greys. Thus the slightly muted reds and ochres of the garments appear as a concentration of the richness of the brown earth, and this same gamut is picked up in the flesh tones. More like the portraitists of Roman Egypt or the Isaac Master at Assisi than Trecento painters, Masaccio chooses a ruddy or tanned complexion for his faces.[12] As this colour can be positively distinguished from the highlights, the light that falls on the skin is more obvious than on Taddeo Gaddi's figures, where the tint of the complexion is subsumed in the modelling.

XXXII. (facing page) Masaccio, *Christ, a tax-collector and his Apostles* (detail from the *Tribute Money*, fig.77). Florence, Santa Maria del Carmine, Brancacci Chapel.

137

However strong his modelling, Masaccio conveys an underlying constancy of colour. His rare gift was to apprehend colour as appearance and as essence, as mutable under light and yet as an enduring characteristic of material things. Stability in the recognition of local colours is necessary if variations due to lighting are to be understood. Colour change between highlight and shadow, on a drapery for example, undermines this stability. So do the manifold hues without strict descriptive value in Lorenzo Monaco's *Coronation of the Virgin*.

Cultural pressures would have determined what Masaccio constructed as reality. In preferring common colours to precious ones, he opened up the field of relationships between colours in a manner undreamed of by painters operating with heraldic oppositions of colour. In the Brancacci frescoes forms are not circumscribed by dark lines, and where one colour ends and another begins is no longer necessarily a decisive break. The deep ochre of Peter's mantle in the central scene of the *Tribute Money* is little differentiated from the rose of John's, a near continuity of tone which Masaccio exploited by running the hems of the two draperies into one another (col.pl.XXXII). In the *Enthroning of St Peter* (fig.78), one of the last scenes to be frescoed, Masaccio modified conventional *giornata* procedures. By placing the extremities of the *giornata* on which the central kneeler and the Carmelite to the left are painted a couple of inches outside the contours of the figures, he prevented the suture in the plaster from outlining the figures.[13] This technical innovation permitted him to paint the figure and its adjacent background in a single session. Nothing could be more revealing of his care in gauging the tone of the contour in relation to the field.

The elimination of outline liberated colour. Any patch of colour circumscribed by an outline tends to appear as a stain or local colour, whereas a patch unbounded by any line is more likely to assume a value indicative of illumination.[14] What led Masaccio to risk abandoning that conceptual safety-rope, the dark outline?

In the *Tribute Money* it is possible to make out the original guidelines of the building, especially in the step around its base. In the *Raising of Tabitha* a more complex grid of lines marks out the buildings on the piazza. In places these faint lines coincide with string-courses or lintels; elsewhere they traverse space or lie 'unattached' upon a surface. Could it be that it was this extension of orthogonals beyond the limits of form that brought it home to Masaccio that a line is itself a mathematical abstraction, a diagrammatic convenience. Once it was understood that the perspectival line marking the edge of a plane in architecture is a mathematical abstraction, it may have dawned that circumscribing with dark contours is contrary to nature.

Since there are plenty of Trecento examples of guidelines – either in sinoper or incised – running beyond the boundaries of architectural structures in painting, we may ask why this was not hit upon earlier.[15] As far as there can be an answer to this kind of question, it may lie in the *ad hoc* nature of studio practices. Nowhere does Cennini give an account of how to draw buildings according to the geometry of perspective.[16] It was only Brunelleschi's demonstration of single-point perspective that would have given to the invisible lines of projection an existence in geometry – and hence a rationale – independent of physical structures that might coincide with them. From the realization that lines in perspective are an abstraction, it was a short leap, performed by Masaccio, to notice that the edges or contours of objects are not necessarily

marked by a dark line, or rather that such a line was not essential to their representation.

The snag in this conjecture is that the same mathematical culture that may have been Masaccio's stimulus became through the writings of Alberti the very reason for a reassertion of line and contour. At the start of *De pictura* Alberti distinguishes between the fringes or edges of objects and the areas contained within them – 'like a skin stretched over the whole extent of surface'.[17] In describing how we see outlines and the colours within them he follows the division of the visual pyramid found in thirteenth-century treatises on optics. According to Alberti, outlines are conveyed by extrinsic rays and the surface within the outlines by median rays. Whereas the median rays act like a chameleon, changing their colour according to the colour of the surface they radiate from,[18] by implication the outline-bearing rays, since they are extrinsic, are unchanging in colour and presumably neutral. This peculiar description of the process of vision could well have obscured Masaccio's painterly achievement.

Brunelleschi and Masaccio are likely to have anticipated Alberti's formulation of the laws of linear perspective without trammelling them with his notions of centric, median and extrinsic rays.[19] This could explain how the same theory of linear perspective led Masaccio to realize the illusory nature of line as contour, whereas it led Alberti to distinguish between the immutable outline and the chameleon in-fill.

By abandoning dark outlines, Masaccio restored to the tones of colours a precise descriptive relevance. But pigments vary in their natural register. Yellow is obviously lighter than ultramarine. The shading on a yellow drapery is not as dark as that on an ultramarine, and there is a discrepancy in the lights. In Trecento painting colour areas vary in tone according to the pigment employed, and any effect of consistent illumination is weakened by local differences in modelling. The tonal jumps between colours give the junctions a linear sharpness, like seams in patchwork.[20]

In the late fifteenth century Leonardo sought to overcome the discrepancies between colours and to impose a degree of tonal unity. Leonardo's solution has no absolute claim to truth – after all, tonal discrepancies between colours are commonplace in this polychrome world – but should be regarded as having been generated by the artistic problem of how to rival the three-dimensional realism of sculptural relief. To see earlier Italian painting, particularly Masaccio's, in terms of steps towards tonal unity may be a mistake. Recent studies of perception indicate that vision in man is not attuned to measure differences of tone so exactly as to be bothered by small discrepancies in the modelling of adjacent colours.[21] Indeed, equality of tone is of no interest, rather it is the sudden changes that alert us to the key visual discontinuities in the three-dimensional world in which we move.[22] By playing down changes of tone that are due to a change in local colour, Masaccio, like Cavallini and Giotto before him, concentrates attention on changes indicative of relief and space. Thus in the narrative of the *Tribute Money* a strong contrast between the earthy ochre of Peter's mantle and the rose of John's serves no purpose. Masaccio simply deepens the shadow on the outstretched arm of Peter to throw this gesture into relief against the green of Andrew behind. A lesser painter would have contrasted the hues. Not so Masaccio; the deep rose of Christ's outstretched sleeve cuts across the paler rose of John's mantle, just as the deep green of Peter's sleeve cuts across the paler green of Andrew's.

What Masaccio's fast-moving brush searches for and finds is the smallest possible

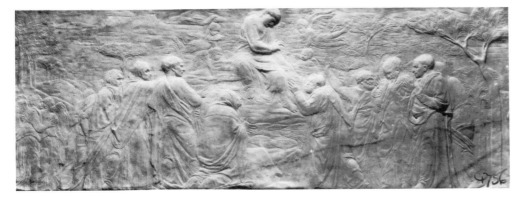

78. (facing page) Masaccio, *En-throning of St Peter at Antioch*. Florence, Santa Maria del Carmine, Brancacci Chapel.

79. (left) Donatello, *Ascension with Christ giving the Keys to St Peter*, about 41 × 115cm. London, Victoria and Albert Museum.

80. Donatello, *Christ* (detail of fig. 79).

difference that will modulate form within the luminous field of colour. In this his instinct is close to that of his friend Donatello. When Donatello coaxed figures, trees and clouds from the slightest undulations of low relief – more scratched than carved – he created spaces where figures and ambient are joined by light (figs. 79 & 80). Though Masaccio certainly was influenced by Donatello's sculpture, it would be a mistake to describe his technique as modelling by tone rather than hue. The modulations between related hues prompt alliances that guide our reading of the narratives. These subtle distinctions of intensity or saturation, hand in hand with variables of tone or value, register the proximity of the rose of the sleeve against the distance of the rose of the mantle. Like a swimmer striking out for the deep, Masaccio realizes that he can let go of conceptual distinctions and rely upon optical. Far from being suppressed, colour is activated by close similarity of hue; it is allowed to float, to find its level. In this trans-lation of the luminous integrity of Donatellian relief, colour assumes – as had already been hinted – a new freedom from the dictates of subject. Within the new-found optical continuum, colour builds kinship, cutting across traditional demarcations between entities, whether descriptive or symbolic.

In the Brancacci frescoes, as in the Pisa altarpiece, the blurred edge between high-light and shadow, falling centrally upon forms in a lateral light, gives to each surface a tactile presence. The force of the rough edge between light and attached shadow depends upon simplification of values towards two dominant tones. Pietro Lorenzetti had done this (col.pl.XXIV). Masaccio's modelling is more differentiated, yet looking at the *Adam and Eve expelled from Paradise* (fig.81) the bold simplification is evident: the massing of their limbs reads as two planes, a right-facing plane of light, and a left-facing plane of shadow. The lights mass together and, to a lesser degree, the shadows; as our eyes pass from the broad lights on Eve to those on Adam, we apprehend the common orientation and directional thrust. Forward movement in Gothic painting is dependent upon the actions of the figures. In Masaccio's *Expulsion* the rhythm of the lit planes establishes an impersonal order that points towards the source of light and the direction of their steps. In Masaccio's frescoes the lights massed upon one object or figure beckon to those upon another and gain power from this repetition.

141

81. Masaccio, *Adam and Eve expelled from Paradise*. Florence, Santa Maria del Carmine, Brancacci Chapel.

A consistent direction of light underscores differences of orientation. This was evident on the lutes in the Pisa Madonna. In the *Tribute Money* slight differences in the direction the Apostles are facing are vividly conveyed by contrasts in their lighting. Heightened awareness of the facing of the head towards or away from the light helps us to realize the ability of each head to turn upon its axis; thus it is the lighting as much as the poses which gives to Masaccio's figures that classical sense of potential for self-controlled movement.

It is well said that Masaccio is Giotto reborn.[23] They are alike in that their paintings demand wide-embracing vision rather than close scrutiny, because it is from a distance that we perceive the ordering rhythm of directional light. In the discussion of lustre in chapter one, it was remarked that, since points of light attract the eye, a painter can utilize lustre to draw attention to the salient points of form. In Duccio and Simone Martini, linear highlights ceased to ornament the panels; instead, ornaments in pattern and punchwork became points of light. In Masaccio the broad highlights attract attention, but what we discover is not a pearl, or a pattern on a cuff, or ivory inlaid on a throne, but a patch higher in tone than its surroundings, which when seen in isolation may not render a meaningful shape. Forced to explore more widely, we apprehend the community of things.

It has often been remarked upon that in the fresco of *St Peter healing with his Shadow* (fig.82) the fall of light enters the very subject of the narrative. It has not been sufficiently noted that the same may be true of the *St Peter baptising the Neophytes* (fig.83). The Greek word for baptism is *photismos* (φωτισμος), meaning 'enlightenment'; in Early Christian and mediaeval baptisteries the Baptism of Christ might be represented at the apex of the dome, or, as in the case of Florence, a lantern might crown the structure.[24] The pictorial image bears the same message of enlightenment through Christ as the physical light admitted by the lantern. In Masaccio's fresco the light that strikes the faces and then the bodies of the Neophytes as they undress expresses their new openness to the Spirit. By the metaphor of pictorial light the conversion that precedes baptism is made plain.

In the *Enthroning of St Peter* the saint's gaze is directed outside the scene, probably towards the Madonna and Child in the thirteenth-century altarpiece.[25] Masaccio has modelled Peter's uplifted face as though it were lit from the two-light window above the altarpiece. (The jambs on the exterior of the window indicate that it originally extended lower.) Peter's face (fig.84) is irradiated by a strong, rough-edged highlight that refers compellingly to the external source. The highlight even appears slightly raised above the surface of his skin. This external quality of the light reads as perfect metaphor for St Peter's own transcendence of the physical and the rising of his Spirit towards the Source of all Light.

In these examples Masaccio unites the symbolic and formal aspects of light: the split between symbol and modelling, noted in Giovanni del Biondo's *Madonna of the Apocalypse* (fig.51) (see chapter five), is healed by the discovery that the divine can be rendered in human terms. In the Pisa Madonna the significance of the grapes as symbolic of the Passion is revealed by the expressions on the faces.

Paradoxically, the power of light as an agent of facial expression lies in its independence of the cast of the features. Cennini's instructions, if followed to the letter, result

142

in modelling of the face dependent upon a preconception of its relief; shape cannot be disentangled from light in this stock configuration of highlights and shading.[26] In Masaccio's *Tribute Money* it is precisely the external quality of light striking each head that evokes the inner life of the Apostles. As we are each conditioned by the diurnal cycle from night to day, darkness to light, sleep to waking, so it may dawn upon us that

82. Masaccio, *St Peter healing with his Shadow*. Florence, Santa Maria del Carmine, Brancacci Chapel.

83. Masaccio, *St Peter baptizing the Neophytes*. Florence, Santa Maria del Carmine, Brancacci Chapel.

143

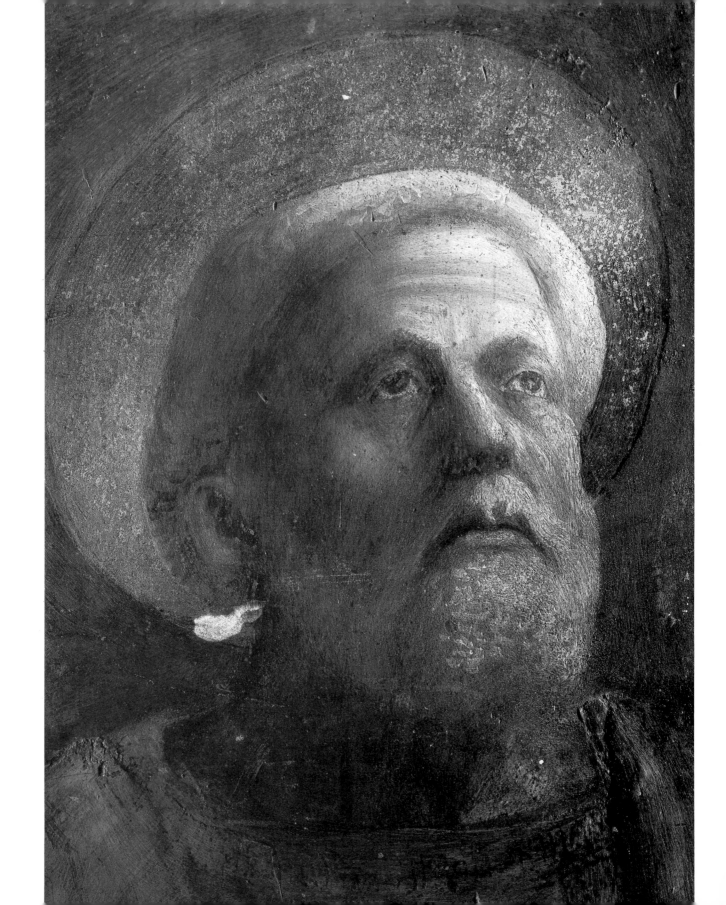

Masaccio's light is as much an expression of the fundamental sense of being alive as a representation of a visible reality. The strong contrasts of light and dark, introduced by lateral lighting, differentiate and link as highlight beckons to highlight. They create an internal order, as clear as Giotto's but with a hint of Byzantine fire, which is itself – to use Wollheim's phrase from Wittgenstein – 'a form of life'.[27] Masaccio's pictorial light transcends representational purpose, satisfying our search for internal order.

84. Masaccio, *Head of St Peter* (detail from the *Enthroning of St Peter at Antioch*, fig.78).

The theme that quickens the scenes from the life of St Peter in the Brancacci Chapel is the community of man. Many scenes show the responsibilities of political society – paying taxes, sharing wealth, caring for the maimed.[28] The ordered spaces reflect the urban ideology of early fifteenth-century Florence. Masaccio's Apostles are self-reliant and independent; they waste no words, yet by their appearance in a common space under a common light we are made aware of the social bond that unites them. By the 1420s Florentines were prepared for the pictorial realization of this bond. Masaccio's art is classical in its austerity and in the moral values it endorses: he spurns florid colours and adornments of gold, and treats his subjects with gravity.[29]

Though there is little evidence that the early humanists liked Masaccio's paintings, his image of the high seriousness and dignity of man is in tune with the ideals of civic humanism. From the 1390s the wars with the despots of Milan, first Giangaleazzo and then his son Filippo Maria Visconti, had sharpened Florentine awareness of themselves as defenders of republican liberty.[30] Oratorical skills and knowledge of classical history had been a growing desideratum for those involved in Florentine political life, at least since 1406.[31] Stoic philosophy and Roman history taught the distinctly secular virtue of self-reliance. Thus, although the humanists 'still referred to divine grace as essential to Florence's prosperity, they placed increasing emphasis upon themselves as the makers of their destiny'.[32] In their eyes, a citizen's worth in a republic was not measured by lineage or wealth but by his capacity to develop his talents and to deploy them in the service of the community.[33] In addition to his search for eternal salvation, man, in humanist eyes, has a goal that can be attained in this life in the society of his fellow citizens. So in Masaccio's paintings, light, that had once been considered the special instrument of the divine grace that enlightens the faithful, now reveals the equal dignity of man, whether Apostle or tax-collector, cripple or neophyte. Beauty of hue and richness of ornament, once tokens of social or religious status, are now subdued in favour of the more egalitarian nuances of tone. But the humanists' identification with a ruling oligarchy made them wary of accepting the consequences of the classicism which Masaccio had realized so instinctively. In the mid-fifteenth century, a period when the Florentine oligarchy was contracting,[34] the seemingly aristocratic style of Gentile da Fabriano was to find favour with patrons in search of luxury. But for subsequent generations of painters it was Masaccio's paintings that showed how the light that shines through colour creates both form and space. Building on the achievement of Giotto, it was Masaccio who apprehended the universality of light in the order and fabric of painting.

145

APPENDIX. A LIST OF TREATISES ON COLOUR AND FRAGMENTS OF ARTISTS' HANDBOOKS

The list is in approximate chronological order; some treatises, notably Eraclius, are compilations of widely varying origin; others, such as nos.10 and 12, are essentially derivative. Few of the treatises can be dated with any certainty. The editions cited in the text are marked with an asterisk.

1. Isidore of Seville (7th century)
 Patrologia Latina, vol.82, 675 ff.
2. The Lucca MS (8th century)
 L.A. Muratori, ed., *Antiquitates Italicae*, vol.II, 1739, diss.24, col.365–88.
 J.M. Burnham, *A Classical Technology, edited from Lucensis 490*, Boston 1920.
 H. Hedfors, *Compositiones ad tingenda musiva*, Uppsala 1932.
 R.P. Johnson, 'Compositiones variae from Codex 490, Biblioteca Capitalare, Lucca, Italy', *Illinois Studies in Language and Literature* (Urbana), 23, no.3 (1939) pp.23–116.
3. *Mappae clavicula* (8th or 9th century)
 *Prefaced by a letter from Sir Thomas Phillipps, *Archaeologia*, 32 (London 1847) pp.187–244.
 C.S. Stanley and J.G. Hawthorne, eds., in *Transactions of the American Philosophical Society* (Philadelphia), n.s., 64 (1974) pt 4.
4. *Liber sacerdotium* (10th century)
 P.E.M. Berthelot, *Chimie du moyen-âge*, Paris 1893, I, pp.179–228.
5. *Eraclius, 'De coloribus et artibus Romanorum'* Books I & II (10th century); Book III (13th century)
 *M.P. Merrifield, *Original Treatises on the Arts of Painting*, London 1849, I, pp.182–257.
 J.C. Richards, 'A New MS. of Heraclius', *Speculum*, 15 (1940) pp.255–71.
6. *De clarea* or *Anonymus Bernensis*
 *D.V. Thompson, ed. and trans., in *Technical Studies in the Field of the Fine Arts*, 1 (1932–3) pp.8–19, 70–1.

7. Theophilus, *De diversis artibus* (ca.1110–40)
 *C.R. Dodwell, ed. and trans., London 1961.
 See also R.P. Johnson, 'The MSS. of the Schedula of Theophilus Presbyter', *Speculum*, 13 (1938) pp.86–103.
8. *Recipes from Codex Matritensis A 1* (ahora 19)* (12th century)
 See J.M. Burnham, *University of Cincinnati Studies*, ser.2, vol.8:1 (1913).
9. *De coloribus et mixtionibus* (probably 12th century)
 Addendum to *Mappae clavicula* in Phillipps MS, see 3. above, pp.187–9.
10. *Compendium artis picturae* (12th or 13th century)
 *H. Silvestre, 'Le MS. Bruxellensis 10147–58 et son compendium Artis picturae', *Bulletin de la Commission Royale d'Histoire* (Brussels), 119 (1954) pp.95–140.
11. *Livro de como se fazen as côres* from Bibliothèque palatine de Parme, MS. De Rossi 945 (13th century)
 D.S. Blondheim, 'An Old Portuguese Work on Manuscript Illumination', *Jewish Quarterly Review*, 19 (1928) pp.97–136.
12. *De coloribus, naturalia exscripta et collecta* from Erfurt, Stadtbücherei, MS Amplonius Quarto 189 (13th or 14th century)
 *Technical Studies . . . , 3 (1935) pp.133–45.
13. Master Peter of St Audemar (St Omer), *De coloribus faciendis* (French, 14th century, with earlier sources)
 *Merrifield, I, pp.112–65. Merrifield's text is

corrected by D.V. Thompson in *Technical Studies . . .* , 4 (1935) pp.28–33.

14. *Liber de coloribus illuminatorum sive pictorum* from Sloane MS no.1754 (14th century)
 D.V. Thompson, *Speculum*, 1 (1926) pp.280–307 (addenda and corrigenda: pp.448–50).

15. *De arte illuminandi*
 *D.V. Thompson and G.H. Hamilton, *An Anonymous Fourteenth Century Treatise, 'De arte illuminandi'. The Technique of Manuscript Illumination*, New Haven 1933.

16. *Liber diversarium arcium* from Bibliothèque de l'École de Médecine de Montpellier, MS. 277 (*c.*1400, but incorporating Theophilus)
 Libri & Ravaisson, *Catalogue générale des MSS des Bibliothèques publiques des départements*, Paris 1849, I, pp.739–811.

17. Cennino Cennini, *Il libro dell'arte*
 D.V. Thompson, Jr., ed., New Haven 1932.
 *F. Brunello, ed., Vicenza 1971.
 *D.V. Thompson, *The Craftsman's Handbook*, New Haven 1933.

18. Johannes Archerius, *De diversis coloribus* (1398–1411)
 *Merrifield, I, pp.259–91.

19. Antonio da Pisa: Treatise on glass painting
 R. Bruck, 'Der Tractat des Meisters Antonio von Pisa über die Glasmalerei', *Repertorium für Kunstwissenschaft*, XXV, 1902, pp.244–69.

20. *Dell'arte del vetro per musaico*, Tre Trattatelli dei secoli XIV & XV

G. Romagnoli, ed., Bologna 1864. Reprinted, Bologna 1968.

21. *Tractatus qualiter quilibet artificialis color fieri possit* from Paris, B.N., MS Lat.6749 b (15th century)
 D.V. Thompson, 'Mediaeval Colour-Making', *Isis*, 22 (1935) pp.456–68.

22. *Tractatus de coloribus* from Munich, Staatsbibliothek, MS Lat.444 (15th century)
 D.V. Thompson, 'More Mediaeval Colour-Making', *Isis*, 24 (1936) pp.382–96.
 M.F. Edgerton, Jr., 'A Mediaeval Tractatus de Coloribus', *Mediaeval Studies* (Toronto), 25 (1963) pp.173–208.

23. The Strasburg MS (15th century)
 *trans. from old German by V. and R. Borradaile, London 1966.

24. *Segreti per colori* from Biblioteca dell'Università di Bologna, no.2861 (15th century)
 *Merrifield, II, pp.325–599.
 O. Guerrini and C. Rici, *Il libro dei colori, Segreti del sec. XV*. Bologna 1887.

25. The *Ricepte daffare più colore* of Ambrogio di Ser Pietro da Siena (15th century)
 D.V. Thompson, ed., *Archeion*, 15 (1933) pp.339–47.

26. Recipes by Jehan le Begue (15th century)
 Merrifield, I, pp.291–321.

27. 'Un Trattato inedito sulla tecnica dell'arte'
 F. Malaguzzi Valeri, ed., *Bolletino dell'Istituto Storico Lombardo* (1896) pp.117–50.

Notes to the text

Books referred to in abbreviated form

Bridges 1900 J.H. Bridges, ed., *The 'Opus Maius' of Roger Bacon*, 3 vols, London 1900

Fremantle 1975 R. Fremantle, *Florentine Gothic Painters*, London 1975

Gibson 1968 J.J. Gibson, *The Senses Considered as Perceptual Systems*, London 1968

Grayson 1972 C. Grayson, ed., *Leon Battista Alberti: On Painting and On Sculpture*, Latin texts and translations, London 1972

Katz 1935 D. Katz, *The World of Colour*, London 1935

Lindberg 1970 D.C. Lindberg, ed., *John Pecham and the Science of Optics: Perspectiva communis*, Madison 1970

Lindberg 1976 D.C. Lindberg, *Theories of Vision from Alkindi to Kepler*, Chicago 1976

Thompson 1932 D.V. Thompson, ed., *Cennino Cennini, 'Il libro dell'arte'*, New Haven 1932

Vescovini 1965 G.F. Vescovini, *Studi sulla prospettiva medievale* (Università di Torino, Pubblicazioni della Facoltà di Lettere e Filosofia, vol.XVI, Fascicolo 1), Turin 1965

Periodicals referred to by their initials

JWCI *Journal of the Warburg and Courtauld Institutes*

MKIF *Mitteilungen des Kunsthistorisches Instituts in Florenz*

Notes to the Preface

1. See ch.III, n.16.
2. Berlin 1954.
3. E.H. Gombrich, *The Heritage of Apelles*, Oxford 1976, pp.19–35.
4. *Zeitschrift für Kunstgeschichte*, 25 (1962) pp.13–47, and Proceedings of the conference on Color in the Renaissance held at Temple University, ed. M.B. Hall (forthcoming).
5. New York 1978.
6. In *Studies in Italian Art and Architecture: 15th through 18th Centuries* (Memoirs of the British Academy in Rome, XXV) ed. H.A. Millon, Rome 1980, pp.11–44.
7. Lindberg 1970 and Lindberg 1976.
8. Katz 1935.
9. Berkeley 1954.
10. Gibson 1968.
11. *Materials for a History of Oil Painting*, 2 vols., London 1847–69.
12. *The Materials and Techniques of Medieval Painting*, London 1936; also Thompson 1932 and items 6, 13, 14 and 15 in Appendix.
13. Oxford 1980.

Notes to Chapter I

1. E. Panofsky, *Abbot Suger, on the Abbey Church of St Denis*, Princeton 1946. On the importance of light in mediaeval aesthetics, see E. de Bruyne, *Etudes d'esthétique mediévale*, Bruges 1946, III, ch.I, 'L'Esthétique del la lumiere', pp.3–29; also R. Assunto, *La critica d'arte nel pensiero medioevale*, Milan 1961.
2. R. Arnheim, *Art and Visual Perception*, Berkeley 1954, pp.249ff., for a discussion of illumination; see also Gibson 1968, pp.12–13, for distinction between ambient and radiant light, and ch.X, 'Environmental Information', pp.186–223.

3. P.H. von Blanckenhagen and C. Alexander, 'The Paintings from Boscotrecase', *Rome: Mitteilungen des Deutschen Archäologisches Institut*, Suppl. vol.VI, 1962.

4. For an account of these portraits, see the booklet published by the British Museum: A.F. Shore, *Portrait Painting from Roman Egypt*, London 1972.

5. See Cennino Cennini, *The Craftsman's Handbook*, trans. D.V. Thompson, New Haven 1933, ch.LXVII, p.47: 'And go on blending one flesh colour into another in this way many times, until it is well laid in, as nature promises.'

6. For the *cauterium*, see Shore, *Portrait Painting*, pp.23–5.

7. On the work of art as object and as representation – something we see as other than itself – the most philosophically penetrating account is in R. Wollheim, *Art and its Objects*, Harmondsworth 1970.

8. For colour and modelling, see V.J. Bruno, *Form and Colour in Greek Painting*, London 1977. The question why the Greeks turned from the conceptual art of the Egyptians towards an art of appearances is discussed by E.H. Gombrich, *Art and Illusion*, London 1959, ch.IV, 'Reflections on the Greek Revolution', pp.99–125.

9. F. Haeberlein, 'Grundzüge einer nachantiken Farbenikonographie', *Römisches Jahrbuch für Kunstgeschichte*, 3 (1939) pp.75–126, makes the distinction between presentational colour (*Vorstellungsfarbe*) and observational colour (*Beobachtungsfarbe*).

10. Bonaventura I. sent., d.17, p.1.

11. See the authoritative work by Lindberg 1976, and the introduction in D.C. Lindberg, *Roger Bacon's Philosophy of Nature: A Critical Edition of 'De multiplicatione specierum' and 'De speculis comburentis'*, Oxford 1983. V. Ronchi, *The Nature of Light*, London 1970, is less reliable but has a useful first chapter on the Graeco-Roman age; see p.32 for distinctions between *lux*, *lumen* and *splendor*. The most detailed treatment of mediaeval optics is Vescovini 1965.

12. Lindberg 1970, p.86 (Pt I, prop.11a).

13. This was the position of Grosseteste: A.C. Crombie, *Robert Crosseteste and the Origins of Experimental Science*, Oxford 1953, p.104 and passim; for a concise summary of Grosseteste's position, see Lindberg 1976, p.95. Whereas Thomas Aquinas questioned Grosseteste's view that light was the first corporeal form, it is restated by Pecham, '. . . lux sit nobilissima formarum corporalium', *Perspectiva communis*,

Pt I, prop.7a (Lindberg 1970, p.72).

14. Vulgate Psalm 35:10; Psalm 36:9.

15. *Natural History*, XXXV, 29–34.

16. I. Squadrani, 'Tractatus de luce fr. Bartholomaei de Bononia', *Antonianum*, 7 (1932) pp.201–38, 337–76, 465–94; quotation from pp.230–1. Bartolomeo was working with the pontifical curia by 1259; by about 1265 he was teaching at the Franciscan school in Paris.

17. The Institution of the Crib is described in Thomas of Celano, *Vita prima*, 84–7.

18. *ibid.*, 83, trans. A.G. Ferrers Howell, London 1908, p.81.

19. R. Greene and I. Ragusa, *Meditations of the Life of Christ*, Princeton 1961. The same eye for graphic narrative detail is found in the influential collection of lives of Christ, the Virgin and saints, Jacobus de Voragine, *The Golden Legend*, ed. G. Ryan and H. Ripperger, New York 1941.

20. For the importance of mathematics, see Crombie, *Grosseteste*, pp.59–105.

21. For summaries of the debate, see Lindberg 1976, and G. Ten Doesschate, 'Oxford and the Revival of Optics in the Thirteenth Century', *Vision Research*, 1, Nos.5/6 (1962) pp.313–42. Also Vescovini 1965, pp.111–12, for the theory of emission, and ch.IV, pp.53–76, for Roger Bacon's notion of species. Alberti in *De pictura*, para.5 (Grayson 1972, p.40), leaves the question undecided. Emission and immission in relation to the glance or *sguardo* of love are discussed by A. Parronchi in 'La perspettiva Dantesca', *Studi Danteschi*, 36 (1960), republished in his *Studi sulla dolce prospettiva*, Milan 1964, pp.3–90, esp. pp.22–4.

22. A conspectus of the key tenets of optics established by the end of the thirteenth century is found two centuries later in Antonio Pollaiuolo's tomb of Sixtus IV. The personification of *Perspectiva* carries a book inscribed with the following principles from Pecham's *Perspectiva communis*:
 - Sine luce nihil videtur
 - Visio fit per lineas radiosas recte super occulum mittentes
 - Radius lucis in rectum semper porrigitur nisi curvetur diversitate medii
 - Incidentiae et reflectionis angulae sunt aequales

 See L.D. Ettlinger, 'Pollaiuolo's Tomb of Sixtus IV', *JWCI*, 16 (1953) pp.258–9. Refraction within the eye was first discussed by Alhazen; see Vescovini 1965, pp.98, 113–18. Thirteenth-century writers were confused as to the point

at which refraction occurred; see Lindberg 1970, p.38.

23. The two modes of *comprehensio* are distinguished by Alhazen: *Opticae thesaurus*, ed. F. Risner, Basel 1572, Bk II, para.64, p.67,

 Comprehensio ergo visibilium erit secundum duos modos: et est comprehensio superficialis, quae est in primo aspectu, et comprehensio, quae est per intuitionem. Comprehensio autem per primum aspectum, est comprehensio non certificata; et comprehensio per intuitionem est comprehensio per quam certificantur formae visibilium.

24. *De praem*, 45, 46 (L. Cohn, *Philonis Alexandrini Opera*, Berlin 1906, V, p.346); cited in translation in E. Bevan, *Symbolism and Belief*, London 1962, p.119. Compare Bartolomeo di Bologna, *Tractatus* (see n.16), p.470. Bevan's chapter on light, pp.111–33, offers a useful summary of symbolical attitudes to light in Hellenic, Judaic, Zoroastrian and Christian religions.

25. c.f. Dante, *Paradiso*, XIII, 52–7.

26. I. Cor.13:12, 'Videmus nunc per speculum in aenigmate' is distorted in the English translation '. . . *through* a glass darkly', as Paul was using the imagery of reflection. That images seen in mirrors are dimmer than those seen directly is maintained by Pecham, *Perspectiva communis*, Pt II, prop.11 (Lindberg 1970, p.165).

27. Symbolized in some Coronations of the Virgin where a moon is placed beneath Mary and a sun beneath Christ: e.g. Paolo Veneziano in the Accademia, Venice; see M. Muraro, *Paolo da Venezia*, Milan 1969, pls.113–15. Source is Rev.12:1.

28. *The Opus Majus of Roger Bacon*, trans. R.B. Burke, Philadelphia 1928, Pt IV, pp.238–9:

 Since the infusion of grace is very clearly illustrated through the multiplication of light, it is in every way expedient that through the corporeal multiplication of light there should be manifested to us the properties of grace in the good, and the rejection of it in the wicked. For in the perfectly good the infusion of grace is compared to light incident directly and perpendicularly, since they do not reflect from them grace nor do they refract it from the straight course which extends along the road of perfection in life. But the infusion of grace in imperfect, though good men is compared to refracted light . . . But sinners, who are in mortal sin, reflect and repel from them the Grace of God . . . But as of bodies from which light is reflected, some

are rough . . . and others are polished, . . . so sinners living in mortal sin are of two kinds. For Latin text, see Bridges 1900, I, pp.216–17.

29. Dante's use of optics is discussed by Parronchi, 'la perspettiva Dantesca'; for cases of *deceptio visus*, see pp.37–47.

30. Aquinas, *Summa theol.* I. quaest.39, art.8, 'Nam ad pulchritudinem tria requiruntur. Primo quidem integritas sive perfectio: quae enim diminuta sunt, hoc ipso turpia sunt. Et debita proportio sive consonantia. Et iterum claritas. Unde quae habent colorem nitidum, pulchra esse dicuntur. c.f. Dionysius, *De divinis nominibus*, cap.IV, lect.5.

31. See Assunto, *Critica d'arte*, p.168. In *Purgatorio* III, 16–18, Dante is revealed as living by the shadow he casts.

32. For the silver *paliotto*, see H. Hager, *Die Anfänge des italienischen Altarbildes*, Munich 1962, pl.185.

33. See L. Beccherucci and G. Brunetti, *Il Museo dell'Opera del Duomo a Firenze*, II, Florence n.d., cat.35, pp.276–8.

34. E.B. Garrison, *Italian Romanesque Panel Painting: An Illustrated Index*, Florence 1949, no.219. The original location of the panel is uncertain: E. and W. Paatz, *Die Kirchen von Florenz*, Frankfurt 1940–54, III, note 71, p.645.

35. For early panel types, see Garrison, *Italian Romanesque*. The transformation of the frame into a forward boundary *behind* which figures are presented is one of the changes that ensued when panels ceased to be placed on the front of the altar as antependia and were raised up on top and at the rear of the altar-table. By its position the retable, or altarpiece, was better suited to bear the illusion of depth than was the antependium, or *paliotto*, which was seen as the front side of a four-square block. For the later development of frames, see M. Cammerer-Georg, *Die Rahmung der toskanischer Altarbilder im Trecento*, Strasbourg 1966.

36. Note the force of *claritatis* in the Latin: 'Quia per incarnati Verbi mysterium, nova mentis nostrae oculis lux tuae claritatis infulsit: ut dum visibiliter Deum cognoscimus, per hunc in invisibilium amorem rapiamur.'

37. *De pictura*, Bk I, para.12 (Grayson 1972, p.48).

38. Panofsky, *Abbot Suger*, p.86.

39. *Perspectiva communis*, Pt II, prop.3a (Lindberg 1970, pp.166, 158).

40. Treatises and fragments on the preparation of colours are listed in the Appendix.

41. For the Lucca MS, see Appendix, no.2; for

Mappae claviculae, see Appendix, no.3; and for the Bolognese MS, see Appendix, no.24.

42. Appendix, no.9.

43. Appendix, no.10.

44. Appendix, no.5.

45. Ch.IV (Thompson 1932, p.4). Although Alberti does not speak of incisions, he implies such a line might be useful to mark the half-way transition from light to dark modelling, *De pictura*, Bk II, para.32 (Grayson 1972, pp.68–70).

46. E.W. Bulatkin, 'The Spanish Word *Matiz*: Its Origin and Semantic Evolution in the Technical Vocabulary of Mediaeval Painters', *Traditio*, 10 (1954) pp.459–527.

47. *Theophilus*, 'De diversis artibus', ed. C.R. Dodwell, London 1961, Bk I, ch.XXXII; M.P. Merrifield, *Original Treatises on the Arts of Painting*, London 1949, I, p.159.

48. *Theophilus*, Bk I, ch.XVI.

49. *ibid.*

50. For what follows, see the important article by E.H. Gombrich, 'Light, Form and Texture in XVth Century Painting', *Journal of the Royal Society of Arts*, No.5099, 112 (1964) pp.826–49; reprinted in W. Eugene Kleinbauer, ed., *Modern Perspectives in Western Art History*, New York 1971, pp.271–84, and in E.H. Gombrich, *The Heritage of Apelles: Studies in the Art of the Renaissance*, Oxford 1976, in which is added a companion piece, 'The Heritage of Apelles', pp.3–18, and 'Light, Form and Texture . . .' is revised, pp.19–35.

51. c.f. Grosseteste, 'But it should be understood that the visual species (issuing from the eye) is a substance, shining and radiating like the sun, the radiation of which, when coupled with the radiation from the exterior shining body, entirely completes vision' (translated from *De iride* in Lindberg 1976, p.100).

52. c.f. O. Demus, *Byzantine Art and the West*, New York 1970, p.236.

53. Eraclius, Bk III, and *De coloribus et mixtionibus*.

54. c.f. Cennino Cennini ch.LXXXIII (Thompson 1932, p.55), 'ultramarine wants little association with any other mixture'; to get round this, 'If you want to get a little light on the tops of the knees or other reliefs, scratch the pure blue with the point of the brush handle.'

55. The importance of this in relation to Byzantine art is discussed by S. Runciman, *Byzantine Style and Civilization*, Harmondsworth 1975, p.59. For a survey of light-fittings, see S. Wechssler-Kümmel, *Schöne Lampen, Leuchter und Laternen*, Munich 1962; also J. Bloch, 'Siebenarmige Leuchter in Christlichen Kirchen', *Wallraf Richartz Jahrbuch*, 23 (1961) pp.55–190.

56. Bevan, *Symbolism*, pp.124–7.

57. D.R. Dendy, *The Use of Lights in Christian Worship*, London 1959, ch.III; J. Braun, *Das Christliche Altargerät*, Munich 1932, pp.492–530.

58. For a useful survey, see J.K. Hyde, *Society and Politics in Mediaeval Italy*, London 1973, and for a brilliant synthesis, L. Martines, *Power and Imagination: City-States in Renaissance Italy*, London 1979.

59. e.g. the Fontana Maggiore at Perugia, and Simone Martini's *Maestà* in the Palazzo Pubblico at Siena.

Notes to Chapter II

1. For illustrations, see W. Oakeshott, *The Mosaics of Rome from the Third to the Fourteenth Centuries*, London 1967; C. Cecchelli, *I mosaici della basilica di S. Maria Maggiore*, Turin 1956.

2. Katz 1935, pp.11,15 and passim. See also C.A. Padgham and J.E. Saunders, *The Perception of Light and Colour*, London 1975, p.135.

3. e.g. in the apse of SS. Cosmas and Damian, Rome (Oakeshott col.pl.XIII – though this shows large areas of restoration), and in the cupola of the Baptistery of the Orthodox in Ravenna (S.K. Kostof, *The Orthodox Baptistery of Ravenna*, New Haven and London 1965, especially figs.45–51).

4. For chronology, see P. Hetherington, *Pietro Cavallini*, London 1979; for plates, E. Matthiae, *Pietro Cavallini*, Rome 1972.

5. For a fifteenth-century description of the technique, see Antonio Filarete, *Trattato di architettura*, ed. A.M. Finoli and L. Grassi, Milan 1972, II, Bk 24, p.671.

6 Cavallini was painting in Santa Cecilia at the same time as, or shortly after, Arnolfo di Cambio was sculpting the ciborium (1293). The co-operation of sculptors and painters is indicated by the tomb of Acquasparta (d.1302) in Santa Maria d'Aracoeli, which was executed by Giovanni Cosma, while the Cavallini shop was employed to fresco the Madonna and Child with two saints beneath the canopy. For Arnolfo, see J. Gardner, 'A Relief in the Walker Art Gallery and 13th Century Italian Tomb Design,' *Liverpool Bulletin*, Museums No., 13 (1968–70) pp.5–19; J. Gardner, 'Arnolfo di Cambio and Roman Tomb Design,' *Burlington Magazine*, 115 (1973) pp.420–38.

7. O. Demus, 'Bisanzio e la pittura a mosaico del

duecento a Venezia', in *Venezia e l'Oriente*, Venice 1966, pp.125–55, esp. p.137.

8. Katz 1935, pp.49–50.

9. For recent research on edges and contours, see J.E. Hochberg, *Perception*, 2nd ed., Englewood Cliffs 1978, pp.194–5, and J.M. Kennedy, *A Psychology of Picture Perception*, San Francisco 1974.

10. Gibson 1968, pp.194,214. For Gibson's later view, which distinguishes between invariant and temporary sources of structure in the optical array, see his *The Ecological Approach to Visual Perception*, Boston 1979, pp.86–7.

11. Padgham and Saunders, *Perception*, p.32; C. Blakemore, 'The Baffled Brain', in *Illusion in Nature and Art*, ed. R.L. Gregory and E.H. Gombrich, London 1973, pp.9–47.

12. T.N. Cornsweet, *Visual Perception*, New York and London 1970, p.428 and passim.

13. My stress on the evolutionary approach derives from J.J. Gibson's work in perception and Karl Popper's in philosophy (see his *Objective Knowledge: An Evolutionary Approach*, Oxford 1972). Gibson points to the exploratory potential of perceptual systems; Popper shows how an open and critical attitude helps us to learn from our mistakes rather than become ensnared by a defensive attitude towards our hypotheses. For both, the study of evolution underlines the *potential* flexibility of the human organism.

14. Katz 1935, pt IX, 'Theories of Colour Constancy'; H. Wallach, 'Brightness Constancy and the Nature of Achromatic Colours', *Journal of Experimental Psychology*, 38 (1948) pp.310–24; Y. Galifret, 'Perception des sources lumineuses et des surfaces réfléchissantes', in *Problèmes de la couleur*, ed. I. Meyerson, Paris 1957, pp.29–44.

15 For the relationship between ornament, design and meaning, see E.H. Gombrich, *The Sense of Order*, Oxford 1979.

16. Katz 1935, p.201; Gibson 1968, p.215.

17. Also the altarpiece of St Francis at Pescia, dated 1235: A. Smart, *The Dawn of Italian Painting, 1250–1400*, Oxford 1978, col.pl.1.

18. For illustrations of San Vitale, see F.W. Deichmann, *Frühchristliche Bauten und Mosaiken von Ravenna*, Baden-Baden 1958, pls.311–75.

19. The lustre and tone of gold tesserae can be varied. G. Mango and E.J.W. Hawkins, 'The Apse Mosaics of St Sophia at Istanbul', *Dumbarton Oaks Papers*, 19 (1965) pp.115–48, describe first, a 'clear brown . . . obtained by turning gold tesserae on their sides. The colour of the clear glass varies considerably from amber to greenish brown. The gold heads are occasionally visible; at times, however, the mosaicists appear to have used trimmings that had no gold leaf on them from the edges of gold glass sheets.' Secondly, a 'mat brown . . . obtained by turning gold cubes upside down. The melted glass seems to have been poured on a sandy surface so that when it hardened its underside acquired a mat, slightly pitted appearance.' It is likely that Cavallini used some of these techniques. On early descriptions of gold mosaic technique, see R.P. Johnson, '*Compositiones variae* from Codex 490, Biblioteca Capitolare, Lucca, Italy', *Illinois Studies in Language and Literature* (Urbana), 23, no.3 (1939), pp.48–50.

20. W.D. Wright, *The Measurement of Colour*, 3rd ed., London 1964, pp.61–2.

21. For date, condition and iconography, see Hetherington, *Cavallini*, pp.37–58.

22. J. White, 'Cavallini and the Lost Frescoes in S. Paolo', *JWCI*, 19 (1956) pp.84–95; J. Gardner, 'S. Paolo fuori le Mura, Nicholas III and Cavallini', *Zeitschrift für Kunstgeschichte*, 34 (1971) pp.240–8; Hetherington, *Cavallini*, pp.81–106.

Notes to Chapter III

1. See O. Demus, *Byzantine Mosaic Decoration*, London 1948.

2. I. Hueck, 'Zu Enrico Scrovegni's Veränderung der Arenakapelle', *MKIF*, 17, (1973) pp.105–22.

3. See S. Sandström, *Levels of Unreality*, Uppsala 1963, pp.22–7.

4. R.M. Toulmin, 'L'ornamento nella pittura di Giotto', in *Giotto e il suo tempo*, Rome 1971, pp.177–89, observes that the marbling of the dado is similar to Tuscan Romanesque architecture, whereas the Cosmati mosaic above is of Roman origin.

5. L. Gowing, *Vermeer*, London 1952, p.67.

6. *De pictura*, para. 47 (Grayson 1972, p.89).

7. Katz 1935, p.226; for a general discussion, see M. Minnaert, *Light and Colour in the Open Air*, London 1940.

8. Gibson 1968, p.156.

9. e.g. in the *Homage of a Simple Man*, the *Vision of the Chariot of Fire*, the *Death of the Knight of Celano*. On illusionism, see I. Lavin, 'The Ceiling Frescoes in Trier and Illusionism in Constantinian Painting', *Dumbarton Oaks Papers*, 21 (1967) pp.99–113. H.W. Kruft, 'Giotto e l'Antico', in *Giotto e il suo tempo*, Rome 1971,

observes that the coffering of flat architraves at Assisi is without mediaeval precedent but common in Pompeian painting. The survival of antique motifs in Carolingian and Ottonian illuminated manuscripts should not be overlooked; see, for example, the Reichenau MSS in A. Goldschmidt, *Die deutsche Buchmalerei*, Florence and Munich 1928, II, pls.35,37,40. Another common motif at Assisi is a tondo with central boss in a concave disc (see the walls of Arezzo in the *Expulsion of Devils*). It was popular elsewhere in the Duecento, occurring in fresco on the spandrels of the arcades at San Piero a Grado, above a Madonna and Child on the left-hand pier of the chancel arch in the Duomo at Pistoia, and in mosaic in the Florentine Baptistery. Such a tondo, placed upon a plain wall, 'realizes' the illumination of the surface. Whereas at Padua Giotto felt no need of this shorthand, Gentile da Fabriano revived it over a century later in three-dimensional gilded relief on the surface of his panel of the *Presentation in the Temple* (col.pl.XXVIII).

10. D. Gioseffi, *Giotto architetto*, Milan 1963, p.158, fig.12, presents diagrams of Giotto's systems of foreshortening architecture; none required theoretical consideration of viewing distance, the perspective merely *implies* that objects are viewed from a consistent distance.

11. Such as is found in the frescoes from San Zan Degolà in Venice; see *Venezia e Bisanzio*, Venice 1974, cat.nos.60–2.

12. J.P. Richter, *The Literary Works of Leonardo da Vinci*, 2nd ed., London 1939, I, para.520, p.316.

13. S. Rees-Jones, 'The History of the Artist's Palette in Terms of Chromaticity', in *Applications of Science in Examination of Works of Art*, Boston 1966, pp.71–7; N.F. Barnes, 'Spectrophotometric Study of Pigments', *Technical Studies*, 7 (1938) pp.120–38.

14. c.f. C. Gnudi, 'Su gli inizi di Giotto e i suoi rapporti col mondo gotico', in *Giotto e il suo tempo*, Rome 1971, pp.3–23.

15. J. Beck, *Surface Color Perception*, Ithaca 1972, p.167; Y. Galifret, 'Perception des sources lumineuses et des surfaces réfléchissantes', in *Problèmes de la couleur*, ed. I. Meyerson, Paris 1957, pp.29–44; Katz 1935, pp.49–50.

16. German writers have contributed most to our understanding, particularly H. Jantzen, 'Uber Prinzipien der Farbengebung in der Malerei', *Vortrag auf dem Kongress für Aesthetic und Allgemeine Kunstwissenschaft, Berlin 1913*, Stuttgart 1914, pp.322–9, reprinted in *Uber den*

gotischen Kirchenraum und andere Aufsätze, Berlin 1951, pp.61–7; T. Hetzer, *Tizian, Geschichte seiner Farbe*, 2nd ed., Frankfurt 1948, and *Giotto*, Frankfurt 1941; H. Siebenhüner, *Uber den Kolorismus der Frührenaissance*, Schramberg 1935. I have omitted to deal with some aspects of Giotto's colour penetratingly discussed in E. Strauss, 'Uberlegungen zur Farbe bei Giotto', in *Koloritgeschichtliche Untersuchungen zur Malerei seit Giotto*, Munich 1972.

17. Throughout, the cycle interiors are differentiated from exteriors by the tone of the floor or ground. The following scenes where an interior is implied all show a dull olive or umber floor: the *Expulsion of Joachim*, the *Presentation of the Virgin*, the *Presentation of Christ*, the *Last Supper*, the *Washing of the Feet*, *Christ before the High Priests*, the *Mocking*, the *Presentation and the Prayer for the Flowering of the Rods*, the *Sposalizio* and *Christ among the Doctors*. The *Feast at Cana* and *Judas receiving the Thirty Pieces of Silver* also have dark floors. All the explicitly open-air scenes have a light grey ground. In the *Kiss of Judas* it is a darker olive and umber, to indicate that it is night.

18. J. White, *The Birth and Rebirth of Pictorial Space*, London 1957, p.59.

19. R. Oertel, 'Wandmalerei und Zeichnung in Italien', *MKIF*, 5 (1940) pp.217–314; L. Tintori and M. Meiss, *The Painting of the Life of St Francis*, New York 1962.

20. See L. Tintori, Proceedings of the conference on Color in the Renaissance held at Temple University, ed. M.B. Hall (forthcoming).

21. Ch. LXVII.

22. Bk I, ch.XVI (Dodwell (see ch.I, n.47) p.16); 'Omnes colores, qui aliis supponuntur in muro, calce misceantur propter firmitatem. Sub lazur et sub menesc et sub viridi ponatur veneda, sub cenobrio rubeum, sub ogra et folio iidem colores calce mixti.' *Veneda* is a grey mixture: see S.M. Alexander's useful glossary of technical terms in the Dover 1967 edition of M.P. Merrifield, *Original Treatises on the Arts of Painting*.

23. Ch.LXXI.

24. Ch.LXVII.

25. See E.G. Millar, *The Parisian Miniaturist Honoré*, London 1959.

Notes to Chapter IV

1. See D.C. Lindberg, 'Lines of Influence in Thirteenth Century Optics', *Speculum*, 46 (1971)

pp.66–83. I am indebted to David Lindberg's many authoritative studies on the history of optics.

2. E. Tea, 'Witelo: Prospettico del duecento', *L'arte*, 30 (1927) p.3.

3. S. Ferrari, *I Tempi, la vita, le dottrine di Pietro d'Abano*, Genoa 1900 (Atti della Università di Genova XIV), pp.80,83. For the Aristotelian tradition at Padua, see P. Marangon, *Alle origini dell'aristotelismo padovano (sec.xii–xiii)*, Padua 1977.

4. In addition to Ferrari, *Pietro d'Abano*, see N. Siraisi, *Arts and Sciences at Padua: The Studium of Padua before 1350*, Toronto 1973, who gives a rather negative assessment of Paduan geometry: 'The knowledge of geometry displayed in the *Perspectiva* of Witelo is not paralleled in the works of any other doctor known to have studied or taught at Padua before 1350' (p.74). 'Geometry was not, however, wholly neglected by Paduan doctors of the generation after Witelo' (p.75). Pietro d'Abano's discussions of light and colour are chiefly in *Expositio problematum Aristotelis*. Giotto's learning, and hence the possibility of him fraternizing with scholars, is drawn attention to by I. Hueck in 'Giotto und die Proportion', in *Festschrift W. Braunfels*, Tübingen 1977, pp.143–55, who remarks that when Giotto was called to be the cathedral and city master-builder of Florence he was noted for *Scientia et doctrina* (document printed in G. Gaye, *Carteggio inedito d'artisti dei secoli XIV, XV, XVI*, Florence 1839, I, p.481).

5. *Perspectiva communis*, Pt I, prop. 7 (Lindberg 1970, pp.73–5).

6. *Ibid.*, Pt I, prop.25 (Lindberg 1970, p.103).

7. *Opus maius*, Pt IV, dist.2, ch.II (Bridges 1900, I, p.117).

8. *Perspectiva communis*, Pt I, props.22–4 (Lindberg 1970, pp.99–103); *De multiplicatio specierum*, Pt I, ch.IX (Bridges 1900, II, p.495).

9. *Perspectiva communis*, Pt I, prop.9 (Lindberg 1970, pp.83–5).

10. *ibid*, Pt I, prop.51 (Lindberg 1970, p.133).

11. See M.F. Edgerton, Jr, 'A Mediaeval Tractatus de Coloribus', *Mediaeval Studies* (Toronto), 25, (1963) pp.173–208, esp. pp.198–9.

12. *Opus maius*, Pt IV, dist.4, ch.I (Bridges 1900, I. p.128).

13. *Perspectiva communis*, Pt I, prop.12 (Lindberg 1970, p.87).

14. Witelo's *Perspectiva* is printed with Alhazen, *Opticae thesaurus*, ed. F. Risner, Basel 1572 (now reprinted with an introduction by D.C. Lindberg, New York 1971).

15. *Perspectiva communis*, Pt I, props.59,60,62 (Lindberg 1970, pp.139–41).

16. Bridges 1900, II, p.105; for Witelo's discussion, *Perspectiva*, IV, 155.

17. For the Aristotelian theory, see S.Y. Edgerton, 'Alberti's Colour Theory: a Mediaeval Bottle without Renaissance Wine', *JWCI*, 32 (1969) pp.109–34; J. Gavel, *Colour; A Study of its Position in the Art Theory of the Quatro- and Cinquecento*, Stockholm 1979.

18. *Perspectiva communis*, Pt I, prop.2 (Lindberg 1970, p.63).

19. *ibid.*, Pt I, prop.63 (Lindberg 1970, p.141).

20. A sensitive reading is offered by J. White, *Duccio*, London 1979, p.186: 'In the Arena Chapel *Flight*, the sombre mountain of departing night upon the left is darker still, and the bright, hopeful, morning hillside on the right, which seems to pull the fleeing figures on to safety, is more obvious than ever. When the Virgin's cloak had not yet lost its dark blue colouring, the effect of moving out of darkness into light . . . must have been dramatic.'

21. See above, ch.I, n.21.

22. *Opus maius*, Pt V.i, dist.9, ch.I (Bridges 1900, II, p.62).

23. *De pictura*, Bk I.

24. e.g. Bacon, *Opus maius*, Pt V.ii, dist.3, ch.I (Bridges 1900, II, p.103).

25. *Perspectiva communis*, Bk I, prop.83a (Lindberg 1970, p.155). Modern students of perception would apply the less geometrical argument of a 'non-refuted test for simplicity': we assume instinctively that a surface extends at right-angles to the line of vision in the absence of clear information to the contrary. See E.H. Gombrich, 'The Sky is the Limit: The Vault of Heaven and Pictorial Vision', in *Essays in Honour of J.J. Gibson*, Ithaca 1974, pp.84–94, esp.p.91; reprinted in E.H. Gombrich, *The Image and the Eye*, Oxford 1982, pp.162–71.

26. *Perspectiva communis*, Pt I, prop.81 (Lindberg 1970, p.153); *Opus maius*, Pt V.ii, dist.3, ch.I (Bridges 1900, II, p.103).

27. For a late thirteenth-century view of the role of sacred images, see W. Durandus, *Rationale divinorum officiorum*, trans. R.M. Neale and B. Webb as *The Symbolism of Churches and Church Ornament*, London 1843.

28. *Perspectiva communis*, Pt I, prop.53 (Lindberg 1970, p.135).

29. *De pictura*, Bk I, paras.6–8.

1. The most recent discussion of the chapel, with bibliography, is A. Ladis, *Taddeo Gaddi: Critical Reappraisal and Catalogue Raisonné*, Columbia (Mo.) and London 1982, pp.22–36, 88–112; see also R.J.H. Janson-La Palme, *Taddeo Gaddi's Baroncelli Chapel* (Princeton Ph.D.1975), Ann Arbor 1979.

2. For Giotto's possible contribution, see J. Gardner, 'The Decoration of the Baroncelli Chapel in Santa Croce', *Zeitschrift für Kunstgeschichte*, 34 (1971) pp.89–114.

3. I am indebted to John Shearman for drawing my attention to the *Stigmatization*.

4. A convenient translation, revised by Thomas Okey, is *The Little Flowers of St Francis*, London 1947; the Third Consideration is on pp.140–9.

5. A. Smart, 'Taddeo Gaddi, Orcagna, and the Eclipses of 1333 and 1339', in *Studies in Late Medieval and Renaissance Painting in Honor of Millard Meiss*, ed. I. Lavin and J. Plummer, New York 1977, pp.403–14. For a convincing dismissal of the supposed influence of the Augustinian preacher, Fra Simone Fidati, on Taddeo, see Ladis, *Taddeo Gaddi*, pp.89–90. For photopic and scotopic vision, M.H. Pirenne *Vision and the Eye*, 2nd ed., London 1967, is authoritative and intelligible to the layman.

6. This point was made by E. Frödl Kraft in a lecture at the Courtauld Institute in 1974. For the relationship of physiology to coloured glass, see J.S. Johnson, *The Radiance of Chartres*, London 1964.

7. L. Grodecki, 'La Couleur dans le vitrail du XIIe au XVIe siècle', in *Problèmes de la couleur*, ed. I. Meyerson, Paris 1957, pp.183–206, esp. p.195.

8. Pointed out to me by Julian Gardner. On the use of yellow, as for other colours, the best survey is still D.V. Thompson, *The Materials and Techniques of Medieval Painting*, London 1936 (now a Dover paperback), but this must be updated by reference to the article 'Lead-tin Yellow' in the series, Identification of the Materials of Painting, in *Studies in Conservation*, 13 (1968) pp. 7–33. Thompson's summary (p.175) is worth citing: apart from in glass painting 'the Middle ages were wary of the use of bright yellows. They admired the golden, but abhorred the bilious. A greater freedom in the use of yellows marks the approach of the Renaissance; and this is reflected in the palette by the introduction of many new forms of yellow in the course of the fourteenth and fifteenth centuries.'

9. Y. Galifret, 'Perception des sources lumineuses et des surfaces réfléchissantes', in *Problemes de la couleur*, ed. I. Meyerson, Paris 1957, pp.29–44, esp. p.37.

10. In ch.CXLV. For the etymology of Cennini's 'biffo', see *Il libro dell'arte*, ed. F. Brunello, Vicenza 1971, p.16, n.3; the notes to this edition are extremely informative of the history of pigments, as is the same author's *L'arte della tintura nella storia dell'umanità*, Vicenza 1968, and his *De arte illuminandi e altri trattati sulla tecnica della miniatura medievale*, Vicenza 1975, which contains a dictionary of the colours used in mediaeval miniatures.

11. Translated from old German by V. and R. Borradaile, London 1966, p.53.

12. ed. D.V. Thompson and G.H. Hamilton, New Haven 1933, pp.20–1.

13. Ch.LXVII.

14. A good example is ch.LXXVIII: 'If you want to make a shot drapery in fresco, take lime white and black, and make a minever colour which is known as ash grey (*cignerognolo*). Lay it in; put the lights on it, using *giallorino* (Naples yellow) for some and lime white for others, as you please. Apply the darks with black or with violet (*biffo*) or with dark green.' Note the unabashed use of black, and the choice of white or yellow for the lights, violet or green for the darks. This is the type of palette introduced by Taddeo.

15. *ibid.*, p.30.

16. H.B. Maginnis, 'Cast Shadows in Pietro Lorenzetti's Assisi cycle', *Gazette des Beaux-Arts*, 77 (1971) pp.63–4; H.B. Maginnis, 'Assisi Revisited', *Burlington Magazine*, 117 (1975) pp.511–17.

17. White, *Birth and Rebirth*, ch.I.

18. E.H. Gombrich, *Meditations on a Hobby Horse*, London 1963, pp.1–11. On the Strozzi altarpiece, see M. Meiss, *Painting in Florence and Siena after the Black Death*, New Haven 1951, pp.9–14.

19. *ibid.*

20. *Epistolario di Pier Paolo Vergerio*, ed. L. Smith, Rome 1934, p.177; the passage is commented upon by M. Baxandall, *Giotto and the Orators*, Oxford 1971, pp.43–4.

21. B. Cole, *Agnolo Gaddi*, Oxford 1977, p.83. M. Boskovits, *Pittura fiorentina alla vigilia del Rinascimento, 1370–1400*, Florence 1975, pls.126a–b, illustrates pairs of saints on two panels in the Museo Nazionale di San Matteo in Pisa, which he reconstructs as one of the

wings; he dates the altarpiece *c*.1380–5 (p.300). There is general agreement that it is an early work: M. Davies, *National Gallery Catalogues: The English Italian School*, 2nd ed., London 1961, p.208.

22. For Giotto's altarpiece in its setting, see Gardner, 'Baroncelli Chapel'.
23. On Byzantine colour, see O. Demus, *Byzantine Art and the West*, London 1970, p.237; for opalescence in tempera, see D.V. Thompson, *The Practice of Tempera Painting: Materials and Methods*, New Haven 1936.
24. This was standard Trecento practice. There are good examples in the work of Bernardo Daddi: e.g. Or San Michele *Madonna* (Fremantle 1975, pl.116); Bigallo triptych (*ibid.*, pl.94); *Madonna and Child with SS. Peter and Paul and Eight Angels*, Uffizi (*ibid.*, pl.99); *Madonna and Child with SS. Matthias and George and Four Angels*, San Giorgio a Ruballa (*ibid.*, pl.100).

Notes to Chapter VI

1. Translated by C.T. Davis in 'Il Buon Tempo Antico', *Florentine Studies*, ed. N. Rubinstein, London 1968, pp.66–7.
2. *Paradiso*, XV, 99–102.
3. e.g. Florentine legislation of 1373: *I capitoli del commune di Firenze*, ed. C. Guasti and A. Gherardi, Florence 1866–93, II, pp.173–4.
4. S.M. Gromberger, 'St Bridget of Sweden', *American Catholic Quarterly Review*, 42 (1917) p.97.
5. *The Lives of St Francis of Assisi*, trans. A.G. Ferrers Howell, London 1908, First Life, pt III, para.125.
6. M. Schuette and S. Müller Christensen, *The Art of Embroidery*, trans. D. King, London 1964, pp.VII–VIII; A. Santangelo, *The Development of Italian Textile Design from the 12th to the 18th Century*, London 1964, especially the account of the *diaspri* fabrics of Lucca, pp.18–19.
7. On oriental motifs: G. Soulier, *Les Influences orientales dans la peinture toscane*, Paris 1924. Renewed links were important for the supply of colouring material for enamelling: M.M. Gauthier, *Emaux de moyen-age occidental*, Fribourg 1972, p.22, n.4.
8. F.B. Pegolotti, *La pratica della mercatura*, ed. A. Evans, Cambridge, Mass. 1936, p.28.
9. My account is based upon N.A. Reath, *The Weaves of Hand-Loom Fabrics*, Philadelphia 1927, pp.33–4.
10. B. Klesse, *Seidenstoffe in der Italienischen Malerei des 14 Jahrhunderts* (Schriften des Abegg-Stiftung, I), Bern 1967, pp.18–21.
11. For accounts of his work and further bibliography, see J. White, *Duccio*, London 1979; J. Stubblebine, *Duccio and his School*, Princeton 1979; H. van Os, *Sienese Altarpieces, 1215–1460*, Gröningen 1984, I, pp.39–57. F. Deuchler, *Duccio*, Milan 1984, esp. pp.161–5, 'Colori e luce'.
12. F. Deuchler, 'Duccio: zum Gold als Farbe', in *Von Farbe und Farben: Albert Knoepfli zum 70. Geburtstag*, Zurich 1980, pp.303–7. B. Klesse, *Seidenstoffe*, reproduces outline drawings of the patterns of the cloaks of Catherine (cat.27), Agnes (cat.388) and Savinus (cat.389).
13. Bk III, ch.IV, 375a, 20–8; trans. H.D.P. Lee, London 1952. Aquinas translated it into Latin (Venice 1561). Alexander Aphrodisaeus wrote a commentary which was translated into French by William of Moerbeke: *Commentaire sur les météores d'Artistote, traduit de Guillaume de Moerbeke* (Corpus Latinum commentariorum in Aristotelem Graecorum, no.4), ed. A.J. Smet, Louvain and Paris 1968.
14. Katz, 1935, p.31.
15. White, *Duccio*, p.37.
16. See J. Gardner, 'Arnolfo di Cambio and Roman Tomb Design', *Burlington Magazine*, 115 (1973) pp.420–39, esp. p.438.
17. Other early examples of foreshortened pattern in paintings: Assisi, St Francis cycle, *Dream of Innocent III*, the curtain (Klesse, *Seidenstoffe*, pl.16); *The Crib at Greccio*, St. Francis and friar in white vestments – rudimentary breaking of the white circles (A. Martindale, *The Complete Paintings of Giotto*, London 1969, pl.XI); Assisi Magdalen Chapel, the cope of Bishop Pontano (G. Previtali, *Giotto e la sua bottega*, Milan 1967, fig.145).
18. R. Brentano, *Rome before Avignon*, London 1974, chapters VI, VII.
19. For a general survey, see M. Frinta, 'An Investigation of the Punched Decoration of Mediaeval Italian and Non-Italian Panel Paintings,' *Art Bulletin*, 47 (1965) pp.261–5.
20. J. Gardner, 'St Louis of Toulouse, Robert of Anjou and Simone Martini', *Zeitschrift für Kunstgeschichte*, 39 (1976) pp.12–33.
21. Ch.CXL (Thompson 1932, p.83).
22. Lecture by E. Skaug at Kunsthistorisches Institut, Florence, May 1974; see also E. Skaug, 'Contributions to Giotto's Workshop', *MKIF*, 15 (1971) p.141–60.
23. Ch.CXLI–CXLIII (Thompson 1932, pp.86–9).
24. According to F. Brunello ed., *Il libro dell'arte*, Vicenza 1971, p.144, *allaciato* is an architec-

tural term denoting a frieze or other ornament; Cennini uses it several times as counterpart to *campo*, 'field'.

25. Ch.CXLIII (Thompson 1932, p.85).

26. For comparable techniques in murals, see L. Tintori, '"Golden Tin" in Sienese Murals of the Early Trecento', *Burlington Magazine*, 124 (1982) pp.94–5.

27. For examples in the Ashmolean Museum, see J.W. Allan, *Mediaeval Middle Eastern Pottery*, Oxford 1971, pls.14–17.

28. White in Tuscan painting: Giotto introduced it in the vest of the Ognissanti *Madonna* (Uffizi); Bernardo Daddi followed suit in his *Madonna* in San Giusto at Signano (Fremantle 1975, pl.109). Pietro Lorenzetti, as we have noted, used it for the vest and robe of his *Madonna* in Arezzo, and again for the curtain behind the bed in the *Birth of the Virgin*. Simone Martini's Angel Gabriel is white. The Master of San Martino alla Palma robed in white his *Madonna della Ninna* (Fremantle 1975, pl.129).

29. G. Ryan and H. Ripperger, *The Golden Legend of Jacobus de Voragine*, London and New York 1941, p.206. For Simone's *Annunciation*, see van Os, *Sienese Altarpieces*, pp.79–82.

30. Ch.VIII, 'Ma fa' che quando disegni abbi la luce temperata . . .'

31. My comments are confined to the main panel: for the altarpiece as a whole, see van Os, *Sienese Altarpieces*, pp.91–9, and H.B.J. Maginnis, 'Pietro Lorenzetti's Carmelite Madonna: A Reconstruction', *Pantheon*, 23 (1975) pp.10–16; for documents, see P. Bacci, *Dipinti inediti e sconosciuti di Pietro Lorenzetti; Bernardo Daddi, ecc., in Siena e nel contado*, Siena 1939, pp.83–6.

32. A note of caution is necessary, since the panel has had a rough time. Fine modelling has been lost. In photographs taken before the recent cleaning no clear whites are to be seen!

33. Petrarch, *Canzone* LXXII, 1–3.

Notes to Chapter VII

1. For Gentile's first documented presence in Florence, see K. Christiansen, *Gentile da Fabriano*, London 1982, document VI, pp.161–2. Christiansen argues, pp.93–6, that the *Stigmatization*, together with a *Coronation of the Virgin*, formed part of a double-sided processional standard.

2. From the Third Consideration of the Most Holy Stigmas of St Francis.

3. Christiansen, *Gentile*, cat.no.IX, pp.96–9.

4. Para. 49 (Grayson 1972, p.93).

5. D. Ekserdjian, 'Gentile da Fabriano's "Journey from Bethlehem to Jerusalem"', *Burlington Magazine*, 124 (1982) p.24.

6. Ch.IX (Thompson 1932, p.6).

7. R. Jones, 'Palla Strozzi e la sagrestia di Santa Trinita', *Rivista d'arte*, 37 (1984) pp.9–106, esp. p.50.

8. For information about the site and the patron, and further bibliography, see the informative article by Jones.

9. *ibid.*, p.52.

10. S.M. Newton, *Renaissance Theatre Costume and the Sense of the Historic Past*, London 1975, pp.73–7.

11. Jones, 'Palla Strozzi', pp.50–1.

12. For what follows I am indebted to M. Baxandall, *Giotto and the Orators*, Oxford 1971, especially Ch.II.

13. Trans. Baxandall, p.82; Greek text on p.151.

14. For antitheses, see D. Summers, 'Contrapposto: Style and Meaning in Renaissance Art', *Art Bulletin*, 59 (1977) pp.336–61.

Notes to Chapter VIII

1. L. Berti, *Masaccio*, University Park (Pa.) and London 1967, pp.87–91.

2. C. Gardner von Teuffel, 'Masaccio and the Pisa altarpiece: A New Approach', *Jahrbuch der Berliner Museen*, 19 (1977) pp.23–68; J. Beck, *Masaccio: The Documents*, New York 1978, Appendix, document 1, pp.31–2.

3. c.f. Hegel on viewpoint and subject: M. Podro, *The Critical Historians of Art*, New Haven and London 1982, pp.22–4.

4. For comparisons with Antique painting, see R. Offner, 'Light on Masaccio's Classicism', in *Studies in the History of Art dedicated to W.E. Suida*, London 1959, pp.66–72; J. Polzer, 'Masaccio and the Late Antique', *Art Bulletin*, 53 (1971) pp.36–40.

5. Ch.IX.

6. 'Proemio al commento Dantesco', in C. Landino, *Scilti critici e teorici*, ed. R. Cardini, Rome 1974, I, p.124.

7. For the influence of sculpture at Pisa, see E. Borsook, 'A Note on Masaccio at Pisa', *Burlington Magazine*, 103 (1961) pp.212–25.

8. U. Schlegel, 'Observations on Masaccio's Trinity Fresco in S. Maria Novella', *Art Bulletin*, 45 (1963) pp.19–33; J. Coolidge, 'Further Observations on Masaccio's Trinity', *Art Bulletin*, 48 (1966) pp.382–4; O. von Simson 'Uber die Bedeutung von Masaccios Trinitätsfresko in S. Maria Novella', *Jahrbuch der Berliner Museen*,

8 (1966) pp.119–59; H.W. Janson, 'Ground Plan and Elevation in Masaccio's Trinity Fresco', in *Essays for R. Wittkower*, London 1967, pp.83–8; J. Polzer, 'The Anatomy of Masaccio's Holy Trinity', *Jahrbuch der Berliner Museen*, 13 (1971) pp.18–59; C. Dempsey, 'Masaccio's Trinity: Altarpiece or Tomb?', *Art Bulletin*, 59 (1972) pp.279–81; E. Borsook, *The Mural Painters of Tuscany*, 2nd ed., Oxford 1960, pp.58–63; E. Hertlein, *Masaccios Trinität*, Florence 1979.

9. Janson, 'Masaccio's Trinity Fresco', p.88, n.26.

10. Kindly pointed out to me by John Shearman.

11. J. White, *The Birth and Rebirth of Pictorial Space*, London 1957.

12. Even the faces of the women – in the *Death of Ananias* – are undisguised by make-up. Cennini criticized the young Tuscan women for pandering after 'alcuno colore del quale hanno vaghezza', but the *vaghezza* of a young complexion displayed in a *luce temperata* was the feminine ideal for Trecento painters. For later treatises on make-up, see *Cennino Cennini: Il libro dell'arte*, ed. F. Brunello, Vicenza 1971, p.198, n.2.

13. L. Watkins, 'Technical Observations on the Frescoes of the Brancacci Chapel', *MKIF*, 17 (1973), pp.65–74.

14. Katz 1935, pp.49–50.

15. U. Procacci, *Sinopie e affreschi*, Milan 1961, figs. XXXVII, XXXIX and pl.47.

16. Cennini's elementary instructions are given in ch.LXXXVII (Thompson 1932, p.55).

17. Para.4 (Grayson 1972, p.39).

18. Para.5 (Grayson 1972, p.40).

19. Para.7 (Grayson 1972, p.43). Alberti's mediaeval sources are discussed in S.Y. Edgerton, 'Alberti's Colour Theory: A Mediaeval Bottle without Renaissance Wine', *JWCI*, 32 (1969) pp.109–34.

20. I owe a great deal to J. Shearman's unpublished thesis, 'Developments in the Use of Colour in Tuscan Paintings of the Early 16th Century', London University Ph.D. 1957, and to his article, 'Leonardo's Colour and Chiaroscuro', *Zeitschrift für Kunstgeschichte*, 25 (1962) pp.13–47.

21. T.N. Cornsweet, *Visual Perception*, New York and London 1970, p.236.

22. J.E. Hochberg, *Perception*, 2nd ed., Englewood Cliffs 1978, pp.194–5; J.M. Kennedy, *A Psychology of Picture Perception*, San Francisco 1974, p.132.

23. The apothegm is Berenson's from *Florentine Painters of the Renaissance*, Fontana ed., London 1960, p.64. See also M. Boskovits, 'Giotto Born Again – Beiträge zu den Quellen Masaccios', *Zeitschrift für Kunstgeschichte*, 29 (1966) pp.51–63.

24. The Baptism of Christ is depicted in mosaic in the vaults of the baptisteries of the Arians and the Orthodox in Ravenna. On the Resurrection symbolism of baptisteries, see R. Krautheimer, 'Introduction to an "Iconography of Mediaeval Architecture"', *JWCI*, 5 (1945) pp.1–33; reprinted in R. Krautheimer, *Studies in Early Christian, Mediaeval, and Renaissance Art*, New York 1971, pp.115–50.

25. Suggested by John Shearman.

26. Ch.LXVII (Thompson 1932, pp.40–5).

27. R. Wollheim, *Art and Its Objects*, 2nd ed., Cambridge 1980, para.45.

28. These points were made by Lawrence Gowing in his 1984 television programme on Masaccio.

29. Pliny, *Natural History*, XXXV, 30, had condemned florid colours, *colores floridi*, as opposed to *colores austeri*. Vitruvius also condemned the lavish use of expensive colours on walls: 'The fact is that the artistic excellence which the ancients endeavoured to attain by working hard and taking pains, is now attempted by the use of colours and the brave show which they make, and the expenditure by the employer prevents people from missing the artistic refinements that once lent authority to works. For example, which of the ancients can be found to have used vermilion otherwise than sparingly, like a drug? But today whole walls are commonly covered with it everywhere. Then, too, there is malachite green, purple, and Armenian blue' (*The Ten Books on Architecture*, trans. M.H. Morgan, VII, v, 7–8). See J. Gage, 'A *Locus Classicus* of Colour Theory: The Fortunes of Apelles', *JWCI*, 44 (1981) pp.1–26.

30. G. Brucker, *The Civic World of Early Renaissance Florence*, Princeton 1977, p.290.

31. H. Baron, *The Crisis of the Early Italian Renaissance: Civic Humanism and Republican Liberty in an Age of Classicism and Tyranny*, 2nd ed., Princeton 1966. For criticisms of 'the Baron thesis', see Brucker, *Civic World*, pp.300ff.

32. Brucker, *Civic World*, p.300.

33. The clearest survey is Q. Skinner, *The Foundations of Modern Political Thought*, Vol.I, The Renaissance, Cambridge 1978, pp.69–112.

34. Brucker, *Civic World*, pp.403–4.

INDEX

Illustration numbers are italicized